DRAWING
LIFELIKE SUBJECTS

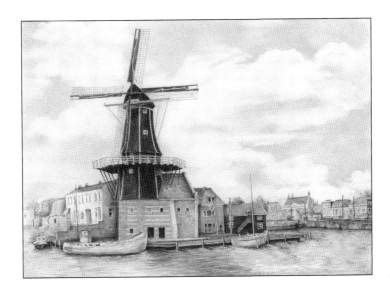

With Diane Cardaci, Nolon Stacey, Linda Weil, and Diane Wright

Quarto is the authority on a wide range of topics.
Quarto educates, entertains and enriches the lives of our readers—
enthusiasts and lovers of hands-on living.
www.quartoknows.com

© 2009 Quarto Publishing Group USA Inc.
Published by Walter Foster Publishing, a division of Quarto Publishing Group USA Inc.
Artwork on front cover and pages 43–75, and photographs on page 5 (drawing tools) © 2007 Diane Cardaci. Artwork on page 6 (shapes and forms) © 2007 Christopher Speakman. Artwork on back cover and pages 5 (dog), 8–42 © 2007 Nolon Stacey. Artwork on pages 3, 110–143, and photographs on page 4 (work station, sketchbooks, erasers) © 2008 Linda Weil. Artwork on pages 1, 76–109 © 2007 Diane Wright. All rights reserved. Walter Foster is a registered trademark.

6 Orchard Road, Suite 100
Lake Forest, CA 92630
quartoknows.com
Visit our blogs at quartoknows.com

Printed in China
17 19 20 18 16

CONTENTS

Tools and Materials. 4

The Elements of Drawing. 6

Basic Pencil Techniques. 7

Chapter 1: Dogs & Puppies with Nolon Stacey. **8**

Rendering Hair. 10

Focusing on Features. 12

Understanding Basic Proportions. 14

Project 1: Golden Retriever. 16

Project 2: Shih Tzu Puppy. 20

Project 3: German Shepherd. 26

Project 4: Parson Russell Terrier. 32

Project 5: Basset Hound Puppy. 36

Chapter 2: Flowers & Botanicals with Diane Cardaci. **42**

Anatomy of the Flower. 44

Blocking in Basic Shapes. 45

Shading Techniques. 46

Sketching Basic Flower Parts. 48

Project 1: Calla Lily. 50

Project 2: Tulips. 52

Project 3: Hibiscus. 54

Project 4: Ornithogalum. 56

Project 5: Water Lily. 58

Project 6: Hydrangeas. 60

Project 7: Sunflower. 62

Project 8: Landscaped Gate. 68

Project 9: Arrangement. 72

Chapter 3: Beautiful Landscapes with Diane Wright. **76**

Landscape Textures. 78

Drawing Trees & Foliage. 80

Drawing Leaves. 82

Skies and Clouds. 83

Project 1: Kirkwall Harbour Basin. 84

Project 2: House Portrait. 88

Project 3: Molen de Adriaan. 92

Project 4: Honey Creek . 96

Project 5: Venice Canal . 100

Project 6: Before the Storm . 106

Chapter 4: Lifelike Animals with Linda Weil. **110**

Animal Textures. 112

Drawing from Life. 114

Sketchbook Selections . 116

Project 1: Asian Elephant . 118

Project 2: Tiger Cub. 122

Project 3: Koala . 126

Project 4: Dingo. 132

Project 5: Lion . 136

Project 6: Giraffes . 138

Project 7: Zebra . 140

Closing Words. **144**

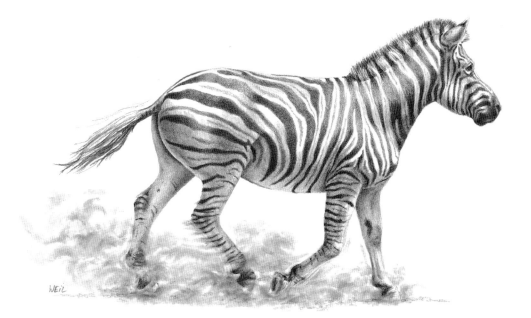

TOOLS & MATERIALS

Drawing is not only fun, but it also is an important art form in itself. Even when you write or print your name, you are actually drawing! If you organize the lines, you can make shapes; and when you carry that a bit further and add dark and light shading, your drawings begin to take on a three-dimensional form and look more realistic. One of the great things about drawing is that you can do it anywhere, and the materials are very inexpensive. You do get what you pay for, though, so purchase the best you can afford at the time, and upgrade your supplies whenever possible. Although anything that will make a mark can be used for some type of drawing, you'll want to make certain your magnificent efforts will last and not fade over time. Here are some materials that will get you off to a good start.

▶ **Sketch Pads** You can buy spiral-bound, stitched, or gum-bound sketchbooks in a variety of sizes. The paper in most sketchbooks is not designed for finished works—sketching is a form of visual note taking, and you should not worry about producing masterpieces with them. You may want to carry a small notebook-sized sketchbook with you so you can sketch whenever the mood strikes. It's a good idea to carry a larger sketchbook when drawing on location.

▲ **Work Station** You don't need a professional drafting table to start drawing—many brilliant drawings have been created on a kitchen table! You'll need a hard surface to use as a drawing board (or purchase a drawing board from an art supply store), and something to prop up the board with, such as a brick or a stack of books. Good lighting is essential—it's best to work in natural light, but you can also purchase a daylight bulb, which gives off a good white light and eliminates the yellow glare of standard bulbs. Make sure the lighting is direct and that there are no shadows falling across your work area. Also, you'll want to have a comfortable chair that supports your back.

▶ **Paper** Drawing paper is available in a range of surface textures: smooth grain (plate finish and hot pressed), medium grain (cold pressed), and rough to very rough. Rough paper is ideal when using charcoal, whereas smooth paper is best for watercolor washes. The heavier the weight of the paper, the thicker it is. Thicker papers are better for graphite drawings because they can withstand erasing far better than thinner papers can. Be sure to purchase acid-free paper, as acid causes paper to turn yellow over time.

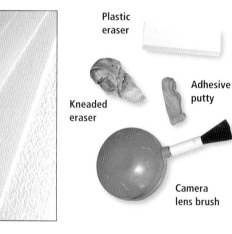

Plastic eraser

Adhesive putty

Kneaded eraser

Camera lens brush

◀ **Erasers** Plastic art erasers are good for removing harder pencil marks and for erasing large areas. Be careful when using this type of eraser, as rubbing too hard will damage the surface of the paper. This eraser also leaves crumbs, so be sure to softly brush them away with a makeup or camera lens brush. Kneaded erasers are very pliable; you can mold them into different shapes. Instead of rubbing the kneaded eraser across the paper, gently dab at the area to remove or lighten tone. Another great tool is adhesive putty, made for tacking posters to a wall. Like a kneaded eraser, it can be molded and won't damage the paper. You may also want to try a battery-operated eraser, which is a quick and efficient option.

◀ **Sharpeners** Clutch pencils (see page 5) require special sharpeners, which you can find at art and craft stores. A regular handheld sharpener can be used for wood-cased and woodless pencils, but be sure to have several sharpeners on hand as these pencils can become dull. You can also purchase an electric sharpener, but it affords less control over the shape of the pencil tip.

▶ **Blending Tools** Paper stumps (also called "tortillons") are used to blend or smudge areas of graphite into a flat, even tone. Be careful when using blending tools, as they tend to push the graphite into the paper, making the area difficult to erase. Another good way to blend is to wrap a chamois cloth around your finger. Never use your finger alone for blending—the oils in your skin can damage the paper.

Pencils

Soft pencils (labeled "B") produce strong, black tones; hard pencils (labeled "H") create lighter marks. The higher the number that accompanies the letter, the harder or softer the lead. (For example, a 4B pencil is softer than a 2B pencil.) HB and F pencils are used for middle grades. We recommend starting with the following range of wood-cased pencils: 2H, H, HB, F, B, and 2B. As your skills develop, you can experiment with different types of pencils. Some artists like to use clutch pencils (also called "mechanical pencils"), which require special sharpeners (see page 4). You can also purchase woodless graphite pencils, which are great for covering large areas with tone or for making quick sketches. These pencils are usually very soft, and the graphite breaks easily. Charcoal pencils are also good for making very dark black marks. Keep in mind that tones vary among manufacturers—one brand's HB may look very different from another brand's, so try to stick with one brand of pencil for a consistent range of tones.

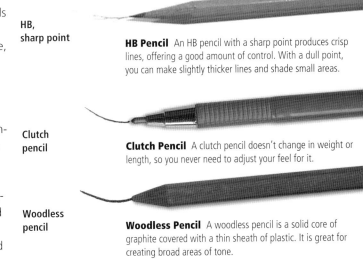

HB, sharp point

HB Pencil An HB pencil with a sharp point produces crisp lines, offering a good amount of control. With a dull point, you can make slightly thicker lines and shade small areas.

Clutch pencil

Clutch Pencil A clutch pencil doesn't change in weight or length, so you never need to adjust your feel for it.

Woodless pencil

Woodless Pencil A woodless pencil is a solid core of graphite covered with a thin sheath of plastic. It is great for creating broad areas of tone.

Transferring Tools

When drawing from reference photos, you may want to transfer the basic outlines from the photo to your drawing paper. You can do this using the grid method, which helps you break down the image into smaller, more manageable segments (see box below), or by using transfer paper. You can either purchase transfer paper, which is coated on one side with graphite (much like carbon paper), or you can make your own by covering one side of a piece of tracing paper with an even layer of graphite. Place a sheet of transfer paper over the drawing paper (graphite-side down); then place the photograph (or a photocopy of the image) over the transfer paper. Use heavy pressure and a hard 2H pencil to trace the major shapes of the image directly on the photograph or photocopy—the lines will transfer to your drawing paper.

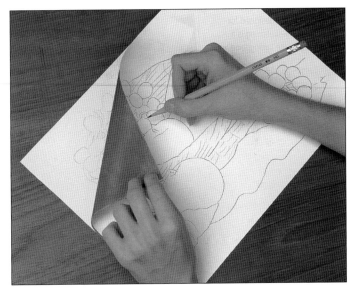

▶ **Checking Your Lines** You may want to occasionally lift the corner of your tracing paper to make sure the lines that are transferring aren't too dark or too light.

Using the Grid Method

First draw a grid of squares over the reference photo; then draw a corresponding square grid over your drawing paper. The reference and your drawing paper must have the exact same number of squares, so even if they're not the same size, the original image and the drawing paper must have the same proportions. Now simply draw what you see in each square of the reference in each square of the drawing paper. Draw in one square at a time until you have filled in all the squares. One-inch squares are great to start with, but just remember that the larger the squares, the more freehand drawing is required.

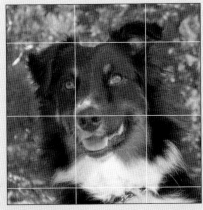
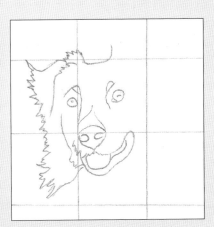

Grid Method Using the lines of the grid squares as reference points, you can accurately position the features of your subject. But make the grid lines light; you'll need to erase them when you finish transferring the drawing.

THE ELEMENTS OF DRAWING

Drawing consists of three elements: line, shape, and form. The shape of an object can be described with simple one-dimensional line. The three-dimensional version of the shape is known as the object's "form." In pencil drawing, variations in *value* (the relative lightness or darkness of black or a color) describe form, giving an object the illusion of depth. In pencil drawing, values range from black (the darkest value) through different shades of gray to white (the lightest value). To make a two-dimensional object appear three-dimensional, you must pay attention to the values of the highlights and shadows. When shading a subject, you must always consider the light source, as this is what determines where your highlights and shadows will be.

Moving from Shape to Form

The first step in creating an object is establishing a line drawing or outline to delineate the flat area that the object takes up. This is known as the "shape" of the object. The four basic shapes—the rectangle, circle, triangle, and square—can appear to be three-dimensional by adding a few carefully placed lines that suggest additional planes. By adding ellipses to the rectangle, circle, and triangle, you've given the shapes dimension and have begun to produce a form within space. Now the shapes are a cylinder, sphere, and cone. Add a second square above and to the side of the first square, connect them with parallel lines, and you have a cube.

Adding Value to Create Form

A shape can be further defined by showing how light hits the object to create highlights and shadows. First note from which direction the source of light is coming. (In these examples, the light source is beaming from the upper right.) Then add the shadows accordingly, as shown in the examples below. The *core shadow* is the darkest area on the object and is opposite the light source. The *cast shadow* is what is thrown onto a nearby surface by the object. The *highlight* is the lightest area on the object, where the reflection of light is strongest. *Reflected light,* often overlooked by beginners, is surrounding light reflected into the shadowed area of an object.

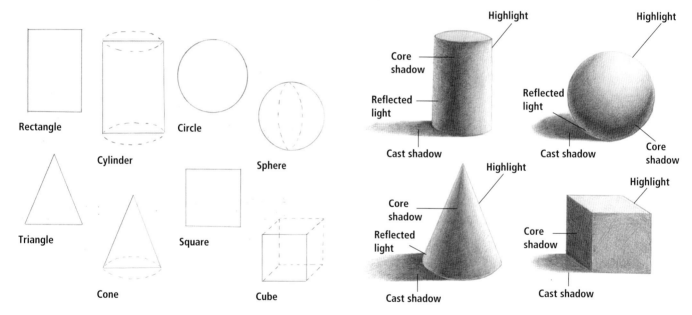

Rectangle · Cylinder · Circle · Sphere · Triangle · Cone · Square · Cube

Highlight · Core shadow · Reflected light · Cast shadow

Highlight · Reflected light · Cast shadow · Core shadow

Highlight · Core shadow · Reflected light · Cast shadow

Highlight · Core shadow · Cast shadow

Creating Value Scales

Just as a musician uses a musical scale to measure a range of notes, an artist uses a value scale to measure changes in value. You can refer to the value scale so you'll always know how dark to make your dark values and how light to make your highlights. The scale also serves as a guide for transitioning from lighter to darker shades. Making your own value scale will help familiarize you with the different variations in value. Work from light to dark, adding more and more tone for successively darker values (as shown at upper right). Then create a blended value scale (shown at lower right). Use a tortillon to smudge and blend each value into its neighboring value from light to dark to create a gradation.

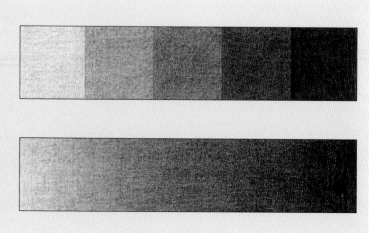

BASIC PENCIL TECHNIQUES

You can create an incredible variety of effects with a pencil. By using various hand positions and shading techniques, you can produce a world of different lines and strokes. If you vary the way you hold the pencil, the mark the pencil makes changes. It's just as important to notice your pencil point. The point is every bit as essential as the type of lead in the pencil. Experiment with different hand positions and techniques to see what your pencil can do!

Gripping the Pencil

Many artists use two main hand positions for drawing. The writing position is good for very detailed work that requires fine hand control. The underhand position allows for a freer stroke with more arm movement—the motion is almost like painting. (See the captions below for more information on using both hand positions.)

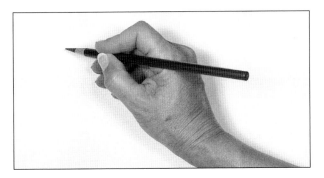

Using the Writing Position This familiar position provides the most control. The accurate, precise lines that result are perfect for rendering fine details and accents. When your hand is in this position, place a clean sheet of paper under your hand to prevent smudging.

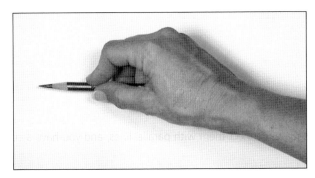

Using the Underhand Position Pick up the pencil with your hand over it, holding the pencil between the thumb and index finger; the remaining fingers can rest alongside the pencil. You can create beautiful shading effects from this position.

Practicing Basic Techniques

By studying the basic pencil techniques below, you can learn to render everything from the rough, wrinkled skin of an elephant to the soft, fluffy fur of a bunny. Whatever techniques you use, though, remember to shade evenly. Shading in a mechanical, side-to-side direction, with each stroke ending below the last, can create unwanted bands of tone throughout the shaded area. Instead try shading evenly, in a back-and-forth motion over the same area, varying the spot where the pencil point changes direction.

Hatching This basic method of shading involves filling an area with a series of parallel strokes. The closer the strokes, the darker the tone will be.

Crosshatching For darker shading, place layers of parallel strokes on top of one another at varying angles. Again, make darker values by placing the strokes closer together.

Gradating To create gradated values (from dark to light), apply heavy pressure with the side of your pencil, gradually lightening the pressure as you stroke.

Shading Darkly By applying heavy pressure to the pencil, you can create dark, linear areas of shading.

Shading with Texture For a mottled texture, use the side of the pencil tip to apply small, uneven strokes.

Blending To smooth out the transitions between strokes, gently rub the lines with a tortillon or tissue.

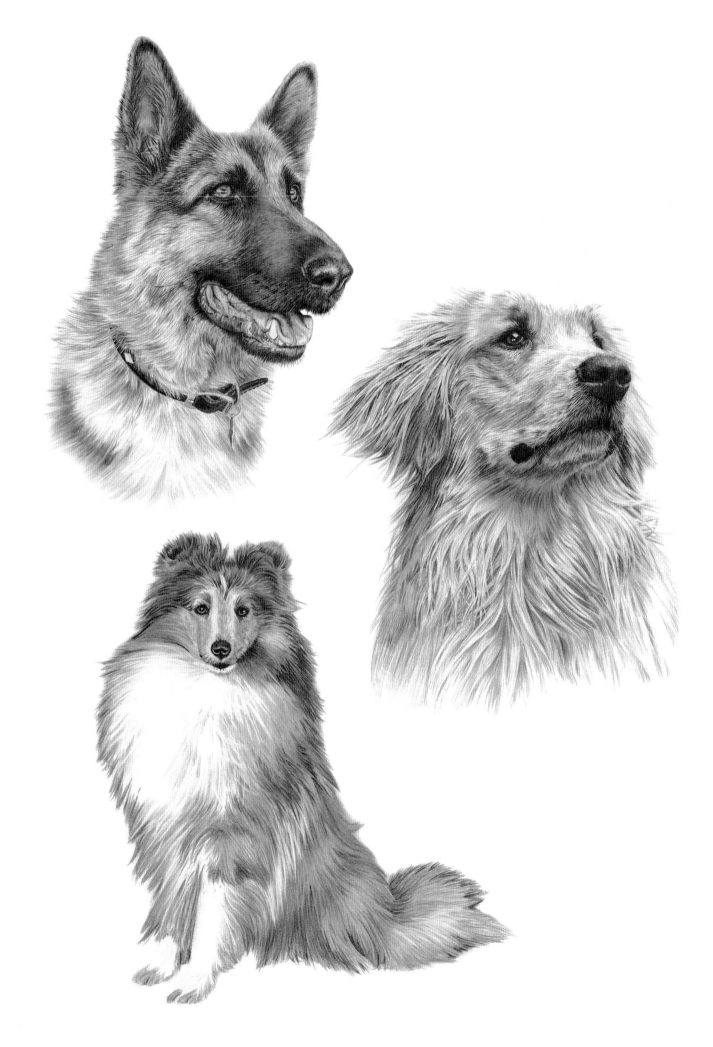

CHAPTER 1
DOGS & PUPPIES

with Nolon Stacey

Possibly the simplest, cheapest, and most fundamental instrument at an artist's disposal is the pencil. Merely a piece of graphite used to make markings on paper, the pencil provides the cornerstone of any artist's creativity. The size of the pencil makes it extremely portable; together with a small pad of paper, it is the perfect tool for sketching while on the move. Because of its versatility, it can serve to roughly outline a painting or to create fantastic and intricate artwork in its own right.

Over the years, I have tried a number of media, including paint, pastel, and crayon, but nothing has rewarded me with the instant results that are attainable with pencil. The fact that I can pick up the pencil and immediately begin transferring my ideas to paper holds great appeal for me, as does the challenge of representing a three-dimensional, colorful world using a flat sheet of paper and a tool that produces only a range of grays! In this chapter, I will share what I have learned through years of trial and error. I will also demonstrate the basic techniques that I have found work best for me to compose and render the special characteristics specific to canines, as well as five step-by-step dog and puppy portrait lessons that will help you begin creating your own lifelike artwork.

—Nolon Stacey

Nolon Stacey is a self-taught graphite artist who specializes in realistic portraits of animals, people, and landmarks. As a child in South Yorkshire, England, Nolon cultivated his interest in drawing throughout school. He eventually earned a degree in mathematics from Warwick University, but he soon returned to his artistic passion. He currently lives in Boroughbridge, England, and undertakes a variety of commissioned work, ranging from portraits of people and pets to buildings and street scenes. Prints of Nolon's celebrity portraits are published through Kadinsky Art. His work is also sold through Braithwaites Gallery in York, England.

RENDERING HAIR

The basic categories of dog hair are long and curly, long and straight, short and curly, and short and straight. Roughness or smoothness of the hair also affects its appearance. There are many variations within each basic type of hair, but you should be able to adapt one of the techniques demonstrated in this section to draw any dog hair you wish. For the longer hair types, I'll show both a detailed method with definite areas of shadow and highlight and a quicker, sketchier method created simply with lines.

Long, Curly Hair

Detail Method

▶ **Step 1** Long, curly hair tends to flow in waves. Begin drawing wavy lines using an HB pencil, roughly following a consistent pattern of curvature while ensuring that the pattern isn't too rigid and exact. Be sure to overlap some hairs for realism.

▶ **Step 2** Darken the areas in between the main clumps of hair using a soft pencil. Then suggest the strands within the clumps of hair nearest the viewer, using long strokes to communicate the length. Leave some areas nearly free of graphite to bring them forward visually.

Sketch Method

▶ **Step 1** To draw the same hair with a freer, looser style, don't worry about positioning the hairs or other details; just sketch long, wavy lines, again following a general S-shaped pattern.

▶ **Step 2** Now rough in texture using lines. Rather than creating definite areas of highlights and shadows, simply place the lines closer together in shadowed areas and farther apart in lighter areas. When drawing any type of hair, always stroke in the direction of growth.

Long, Straight Hair

Detail Method

▶ **Step 1** Long, straight hair doesn't necessarily lay in perfectly parallel lines. In fact, the longer the hair, the more haphazard it's likely to be. With this in mind, draw long sections of hair, stroking in different directions and overlapping strokes.

▶ **Step 2** Carefully shade the dark areas among the hairs, and apply long, light strokes on top of the sections of hair. Then use tack adhesive to lift out some individual hairs, giving depth to the coat.

Sketch Method

▶ **Step 1** Draw light, rough, lines to provide guidelines for the sections of hair. Then use long, wispy strokes to gradually build up the strands along the guidelines. Place lines closer together for dark areas and farther apart for light areas.

▶ **Step 2** As with the detail method, add highlights and depth by lifting out additional hairs using tack adhesive formed to a point.

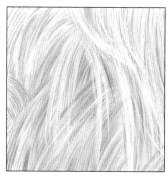

Short Hair

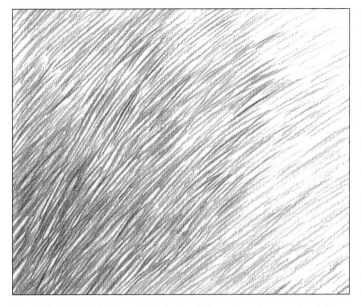

Short, Straight Hair From a Dalmatian to a Doberman Pinscher, many breeds have coats with short, straight hair. This is the simplest type of hair to draw, as it generally is made up of only short lines. For a detailed rendering, draw many straight lines, all running in the same direction (in this example, on a diagonal). To give the impression of individual short hairs, draw pairs of lines, tapering the ends together to form a point for each hair. Keep your strokes quite free; try not to think about each hair, but let your hand randomly draw the lines.

Short, Curly Hair A few breeds, such as Poodles and Bichon Frises, have coats with short, soft, tight curls. A good way to draw this type of hair is to fill the area with even shading using an HB pencil, then blend with a tissue. For the highlights, use an eraser to lift out graphite using a random, circular motion. In this view, the light is coming from above, so the shadows are on the underside of each highlighted curl.

Other Types of Hair

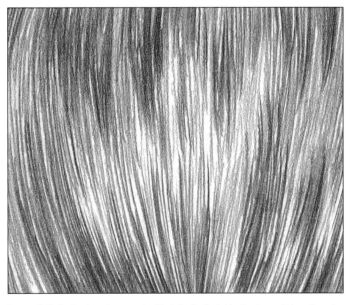

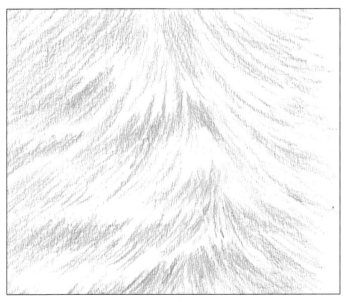

Smooth Hair To draw the smooth, silky hair of a Yorkshire Terrier or Afghan Hound, you must make your strokes more uniform. Unlike the long hair of a Golden Retriever, the shiny hair of a Afghan Hound lays very straight. Draw long, sweeping, parallel lines, leaving lighter areas for highlights. As with any type of hair, avoid drawing the lines too uniformly in direction or value, which produces an unnatural look.

Fluffy Hair A puppy's hair is generally fluffier than a mature dog's hair. I've found that the same method I use for short, curly hair works well for puppies, although it will not work for every breed. Another approach is to create rough rows of hair that give the impression of hair fluffing outward, as shown above. Draw lines close together, following rows across the paper, and make some strokes longer than others to break up any distracting patterns.

FOCUSING ON FEATURES

Before creating a full canine portrait, it's a good idea to get to know the general shapes that make up each feature. As you practice rendering the features of a variety of dogs, notice the subtle changes in shape, value, and proportion that distinguish each breed.

Eyes

The eyes are possibly the most important feature when it comes to capturing the personality and character of an animal. Below I provide two basic viewpoints for drawing the eyes: a three-quarter view (turned slightly away from center) and a side view.

Noses

There is a tremendous variation in size, shape, and even color of noses from one breed to the next. Below I'll draw the nose from two common viewpoints: a frontal view and a three-quarter view. Be sure to observe your subject from a variety of angles to truly understand the shape of its features.

Three-Quarter View of the Eye

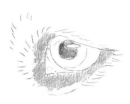 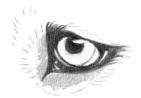

Step 1 Using an HB pencil, begin by outlining the main areas of the eye—the pupil, the iris, the eyelids, and the highlight. Also sketch the hair around the eyes. Almost all dog breeds have a very dark area of bare skin surrounding the eyeball, so shade this area with solid tone.

Step 2 Next, using a 2B pencil, block in the darkest values of the eye, including the pupil (avoiding the highlight) and the area surrounding the eyeball. As you shade, leave small highlights in the corners of the eye to convey the impression of a moist, glistening surface.

Front View of the Nose

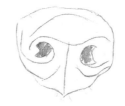 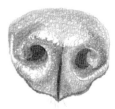

Step 1 Begin by using an HB pencil to sketch the shape of the nose, including the nostrils. Be sure to study your subject and draw the shape you really see—not the shape you expect it to be. Then add rough guidelines to show where the main areas of light and shadow will be.

Step 2 Next add tone with a 2B pencil, using tiny circular strokes to emulate the unique texture of a dog's nose. Darken the nostrils and the vertical crease through the middle of the nose. Then begin shading the rest with lighter layers of circles. Leave the highlight areas free of graphite.

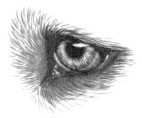 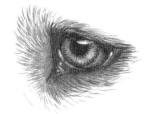

Step 3 Begin creating the pattern of the iris using an HB pencil, drawing lines that radiate outward from the pupil toward the outer edge of the iris. Also use the HB pencil to add more hair around the eye, following the direction of growth.

Step 4 Finish the eye with an H pencil, adding more tone to the iris and then lifting out some graphite to indicate reflected light. Also soften the highlight with a tortillon. Then continue developing the hair, stroking over the top of the lid and over the outer corner.

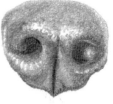 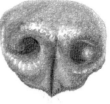

Step 3 Go over the entire nose with small circles to soften the texture slightly, but keeping the bumpy effect. Leave the top of the nose and the area under the nostril light to suggest the reflected light. To create the appearance of a wet nose, avoid blending the darks into the lights, instead allowing harsh separations.

Step 4 To connect the nose to the rest of the dog's face, begin adding the surrounding hair. As with the eyes, the hair grows away from the nose, with the darkest areas directly under and above the nose. The hair just below the nose is generally coarse, so keep these lines dark and short.

Side View of the Eye

 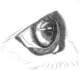 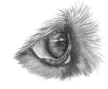

Step 1 From the side, the shapes that make up the eye are quite different. The iris and pupil appear elliptical, but the overall eye has a triangular shape. Start by delineating the main areas of the eye, including the highlights.

Step 2 Before blocking in darks, indent some lashes along the upper eyelid using a blunt needle or stylus. Then apply dark tone to exactly the same areas as in the front view. When you shade over the lashes, the indented lines remain white.

Step 3 Now add the midtones and lights. Use radial lines for the iris, covering it with a midtone. Then emphasize the highlights using tack adhesive, noting the direction of light. Finally, add the hair with short, tapering strokes.

Three-Quarter View of the Nose

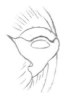 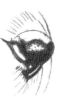

Step 1 Viewed from this angle, a dog's nose almost forms a V. Begin this puppy's nose by blocking in the light and dark areas using a 2B pencil. Also suggest the direction of hair growth.

Step 2 Use a 2B pencil to fill in the darkest areas and start establishing texture around the highlight with half-circle strokes. Indicate the position of the nostrils by placing a subtle highlight beneath them.

Step 3 Further build up the darks, and shade the slightly lighter curve along the left side of the nose. Then suggest the very fine, short hairs above the nose with a 2B pencil.

Ears

Ears vary greatly in the canine world—they can be long or short, dropped or upright, and long haired or short haired. Here I provide examples of two basic types of ears: the upright ear of a German Shepherd Dog and the dropped ear of a Pug.

Upright Ear

 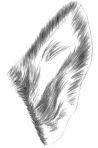 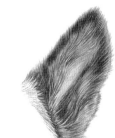

Step 1 The German Shepherd Dog has relatively large ears—especially given that they stand upright. In this example, we're viewing the dog's left ear straight on, so the shape is triangular. Begin by sketching the ear shape with an HB pencil, outlining the folds and mapping out some of the darker tones.

Step 2 Using a 2B pencil, begin adding hair to the ear, starting with the darkest hair around the base and along the uppermost edge. Let the hair dictate the form of the ear from now on, using very little shading. The hair grows upward and outward across the ear, with a hairless area along the inside flap of the ear.

Step 3 Go over the dark hairs with an HB pencil; this fills in the gaps with a slightly different tone, providing depth and thickness to the hair. Fill in most of the remaining gaps with strokes of a 2B pencil, applying very little pressure for the lighter areas. Finish by lightly shading the hairless area using a 2H pencil.

Dropped Ear

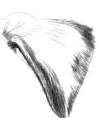

Step 1 In this example, we are again looking straight at the ear, so it appears triangular. Sketch a rough outline of the ear and scribble in shading to indicate the darkest areas using an HB pencil. Because the small ear of a Pug flaps over the side of the head, the skin around the ear canal is not visible.

Step 2 As with the example above, you want the hair, rather than shading, to dictate the form; so begin by adding the darkest hairs, which run along the shadowed underside of the ear and along the outer edge where the ear curls under. Keep your pencil strokes short to imply short hair.

Step 3 Finally, add the midtone hairs. Continue stroking in the direction of the hair growth, but try to make your lines a little erratic to avoid unrealistic patterns; for example, place the hairs closer together in places. To unify the hair, apply a layer of 2H graphite over the entire ear, except for the very top left corner, where the light is strongest.

Paws

Paws vary in size and are covered with different types and lengths of hair, but the general structure is similar across all breeds.

Top View of Paw

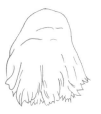 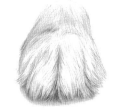

Step 1 Paws viewed from above vary, depending primarily on the dog's type of coat. For this paw with medium-length hair, use an HB pencil to outline and sketch in the direction and shape of the hair. The areas that indicate the shape are the shadowed gaps between each toe and the knuckles between the gaps.

Step 2 Next simply sketch in the hair using light strokes that mimic the length of the hair. The hair toward the bottom of the paw is darker because it is in shadow. Use diverging lines to part the hair between each toe, lightening your strokes as you move outward.

Underside of Paw

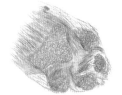 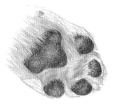

Step 1 The main features of the underside view are the dark pads. There is one large, central pad, plus a pad for each of the four toes. The texture of the pads is similar to that of a dog's nose, so make the same type of circular strokes with a 2B pencil. Sketch short lines for the hair around and between the pads.

Step 2 Continue adding small circles to the pads using a 2B pencil, gradually building up the shadow along the edges and leaving the lighter areas with just one layer of circular strokes. This texture contrasts nicely with the smooth strokes of the surrounding hair.

Whiskers

There are a number of ways to suggest whiskers—but many whiskers are light in color and often nearly translucent, so two of the three methods at right involve *not* drawing them.

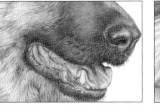 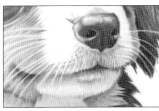 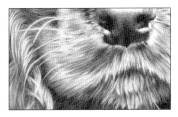

Indenting For light whiskers against dark hair, use a blunt tool to indent the whiskers; then shade over them. Create the whiskers in lighter areas with an HB pencil.

Erasing For thicker whiskers, remove the graphite with the point of an eraser. This method is best suited for large or close-up drawings.

Negative Drawing To create whiskers without disturbing the paper's surface, outline the parallel shapes of each whisker. Avoid stroking over them when adding hair.

UNDERSTANDING BASIC PROPORTIONS

Proportion refers to the relationship of size between two or more elements of a composition. The proportions of an adult dog—for example, the size of its head relative to the size of its chest—differ from those of a puppy. And the proportions vary from breed to breed. To effectively communicate the age and breed, you must learn to depict the proportions accurately.

Adults Versus Puppies

When drawing a puppy, people commonly make the mistake of simply drawing a small adult dog. Although a puppy possesses all the features of a mature dog, its proportions are quite different, as illustrated in the side-by-side comparison below.

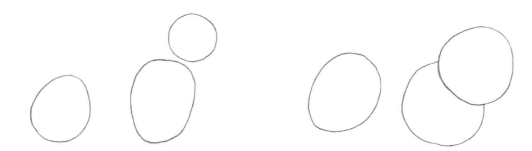

Building the Basic Shapes Compare the sizes and relationships of the head, chest, and hips of an adult Golden Retriever (left) with those of a puppy (right). The puppy's head is much larger in relation to its body, and the three parts are closer together.

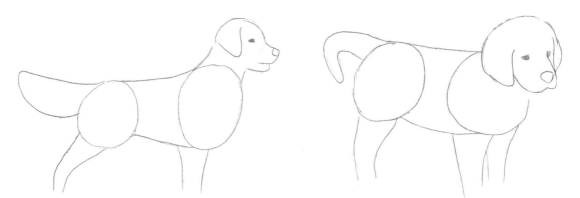

Outlining the Torso and Extremities After connecting the basic shapes and adding the legs and tail, it's easy to see that the adult dog on the left has a leaner build with longer legs, and its muzzle is longer and narrower.

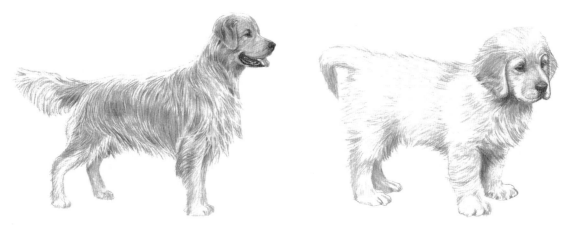

Adding the Coat and Features In these finished sketches, the differences between the puppy and the adult are unmistakable: The puppy's features—ears, eyes, nose, and paws—are all much larger in relation to its body, and the puppy's hair is softer and fluffier.

Breed Differences

To learn the subtleties of a breed's proportions, it's helpful to compare several different breeds side by side. When comparing adult dogs of different breeds, it's often the relative size and details of the features—for example, the shape of the muzzle or the length and color of the coat—that differentiate one breed from another, rather than the relationships of the head, chest, and pelvis. There are more numerous dog breeds that can be covered in this chapter, but these few examples will help you practice identifying the subtle but essential differences that give each breed its own look.

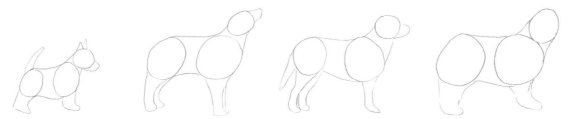

Basic Shapes Comparing the basic shapes of (from left to right) a West Highland White Terrier, a Border Collie, a Labrador Retriever, and a Bearded Collie, you can see that there is little difference in the size relationships of the head, chest, and hips, even though these breeds vary in overall size.

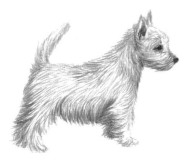

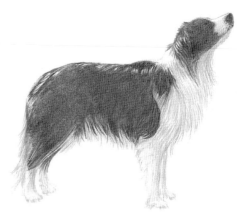

West Highland White Terrier The Westie is a small, fairly compact dog with short legs and an upright tail. The ears are small, pointed, and erect, adding to its alert expression. It has a coarse white coat of medium length.

Border Collie A medium-sized dog, the Border Collie has a long body and a low-set tail that hangs down. Its long muzzle tapers slightly to its nose. The ears are usually held half-erect.

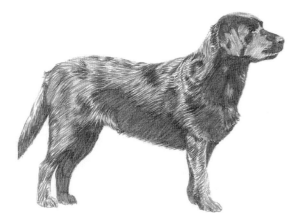

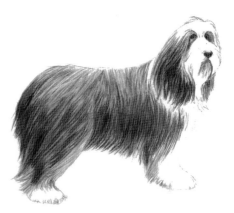

Labrador Retriever The Lab can be black, chocolate, or yellow. It is similar in size to the Border Collie, but it's heavier, thicker, and blockier with a short, dense coat. This dog's powerful neck supports a broad head with a wide nose. The tail is thick near the body but tapers to a point.

Bearded Collie The Bearded Collie is a medium-sized dog with a shaggy coat. It has a broad head with a strong muzzle and a squarish nose. The ears lie close to the head, and its long, ever-wagging tail is carried low with an upward curl at the tip.

APPROACHING PORTRAITURE

Capturing the character of a subject is in many ways more important—and more challenging—than rendering a strict photographic image. Although a full-body portrait may take advantage of stance to reveal a dog's character, a head-and-shoulders composition relies on the tilt of the head and the facial expression, allowing the artist to focus on highlighting the features that give the dog its personality, such as this Golden Retriever's alert ears and affectionate eyes.

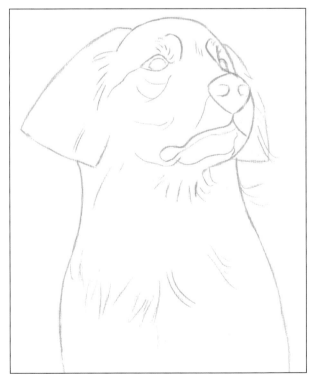

▶ **Eliminating Distractions** This background is full of repetitive diagonal lines that may lead the viewer's eye away from the face and out of the drawing. Also it is a similar value to the dog's hair, so the dog may get lost in the drawing. For these reasons, I chose to draw the dog without a background.

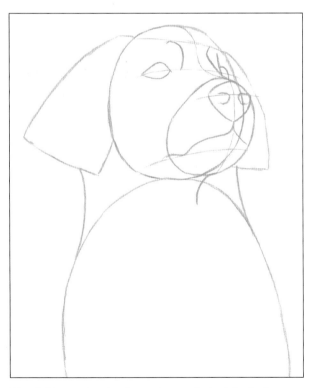

Step 1 Using my photo for reference, I create a freehand sketch using an HB pencil. I begin with the basic shapes, indicating the chest, head, ears, and muzzle. Once I'm satisfied with the general layout, I place the eyes, nose, mouth, and brows. I stand back from the sketch, eye it as a whole, and adjust accordingly.

Step 2 Once I have all the features placed accurately, I erase the pencil lines that are no longer needed. Using an HB pencil, I add some guidelines to map out the direction of the hair growth in key areas, such as on the neck and chest, around the eyes, and on the ears. I also begin to refine the shapes of the eyes.

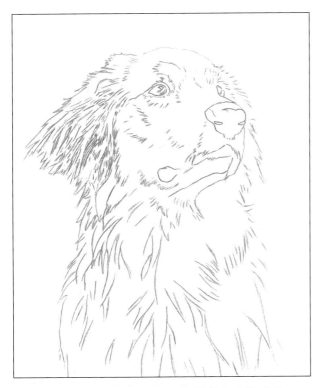

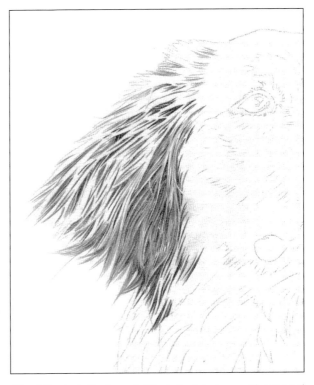

Step 3 At this point, I use the general layout of features and proportions as a map to create a detailed line drawing of the Golden Retriever. Using short, tapering strokes that correspond with the length of the dog's hair, I indicate the clumps and layers of hair. As I refine the line drawing, I erase the harsh guidelines.

Step 4 I begin shading the ear by filling in the darkest areas with a 2B pencil and defining the light hair through *negative drawing*, or creating the form of an object by drawing the area around the object. Switching to an HB pencil, I add midtones in the lower ear. Then I shade with an H pencil, gradually decreasing the pressure as I work toward the top of the ear. I leave the lightest hairs unshaded.

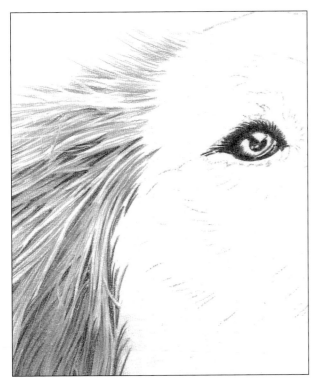

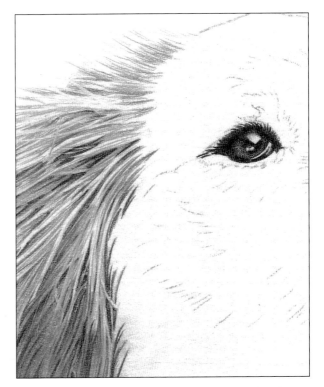

Step 5 Moving on to the eyes, I use a 5B pencil to add tone to the dog's right pupil, shading around the highlight. I also build up the dark values around the eyes. Then I address the dog's left eye in the same manner.

Step 6 Still using the 5B, I darken the iris using lines radiating from the pupil, and I add a light layer of shading over it. I use the tip of a tortillon to softly blend the strokes, creating a crescent of lighter tone in the corner of the eye.

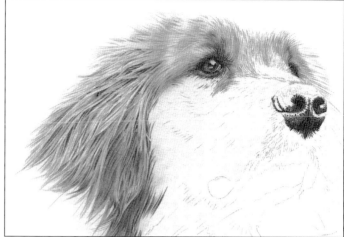

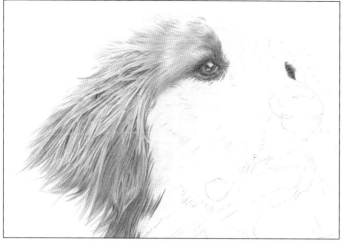

Step 7 Now I switch to a 2H pencil to add hair around the dog's right eye, connecting it to the ear using strokes that follow the direction of growth. I make the hair in the dimple of the dog's brow a bit darker, as shown in the photo.

Step 8 I continue with the same pencil and technique as I work across the forehead and around the other eye, paying careful attention to the pattern of hair growth. I fill in the darks of the nose using a 2B pencil and small, circular strokes (see page 12).

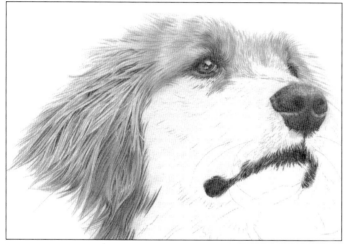

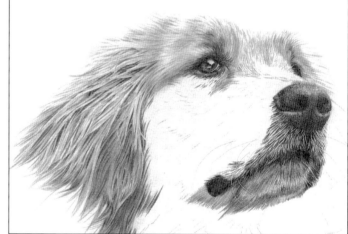

Step 9 I switch to an HB pencil and apply light layers of circular strokes over the nose, working around the highlights on the lower edges of the nostrils and the top of the nose. I add very dark tone to the mouth, keeping the edges jagged to create the impression of hair growing over the lips.

Step 10 Using a 2B pencil, I continue adding the hair, filling in the area around the mouth with midtones. The hair under the nose and just above the mouth is short and coarse, so I reflect this with darker, thicker, and shorter strokes.

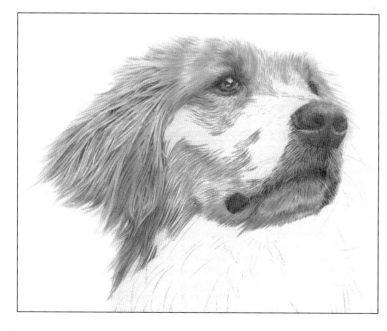

◄ **Step 11** I use a 2H pencil to carry the tone under the eye and on the lower cheek. As you add the hair, make sure the value of each area corresponds to the form of the subject. I also examine my reference carefully so I can re-create the pattern of hair growth. I notice that it scoops under the eye and moves downward into the neck.

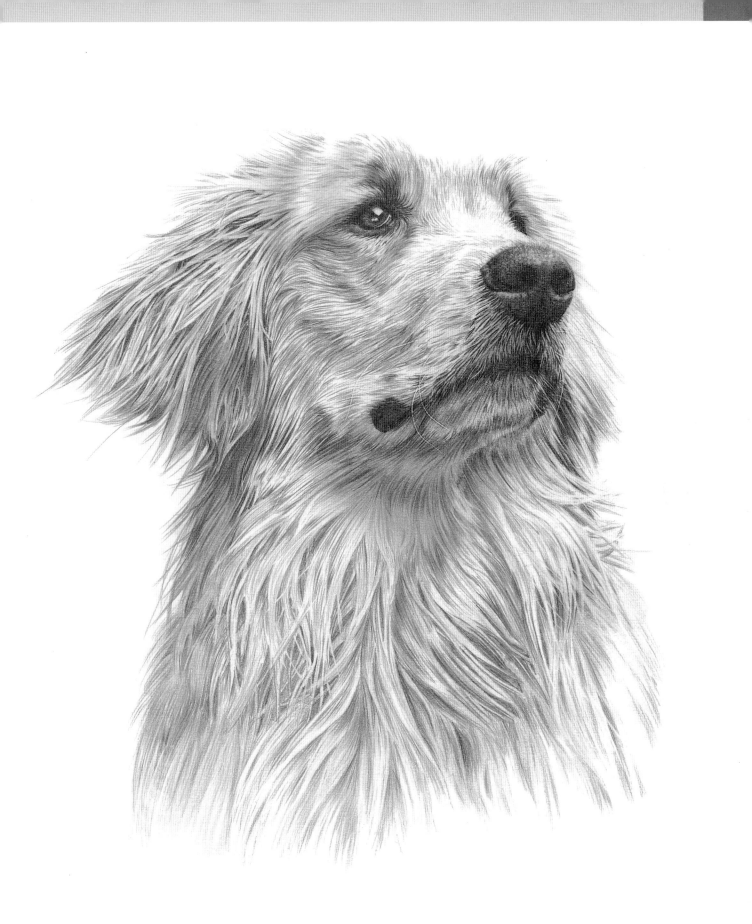

Step 12 I finish filling in the hair on the cheek, around the nose, on the muzzle, and under the jaw using an HB pencil, varying the pressure to create shadows and highlights that reflect the underlying skeletal structure. As I move toward the bridge of the nose, I switch to an H pencil and lighten my strokes until they are almost indiscernible. The remainder of the body is fairly straightforward. I revert to more negative drawing, filling in the darker areas first using a 2B pencil. As this area isn't in shadow, the darkest areas are in the midtone range. I use long, sweeping strokes to suggest the texture of the chest, using an H pencil and light strokes in the direction of hair growth. To complete the drawing, I gradually fade out the bottom area of hair by lifting out graphite with tack adhesive (also called "adhesive putty" and "tacky eraser"), creating a soft edge.

INCORPORATING BACKGROUNDS

To add interest to your composition, try working elements of the canine's environment into the drawing. You'll want these extra elements to enhance the focal point (the dog)—not overwhelm it. To keep the environmental elements in check, avoid giving them too much visual contrast. Render them with middle values, reserving the lightest lights and darkest darks for the main subject. Here, incorporating the grass and flowers adds a variety of textures and patterns that effectively contrast the Shih Tzu puppy's soft coat.

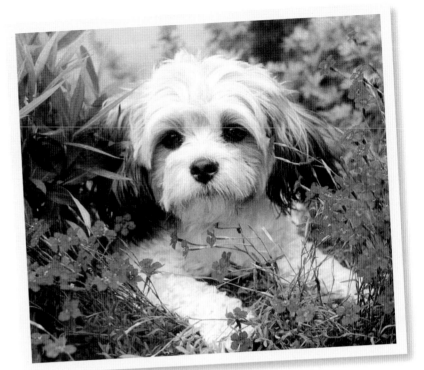

▶ **Framing the Face** The center of interest in a pet portrait is almost always the face, so it's a good idea to use elements of the background to "frame" the face. For example, in this photo, the foliage cups the face with a U shape.

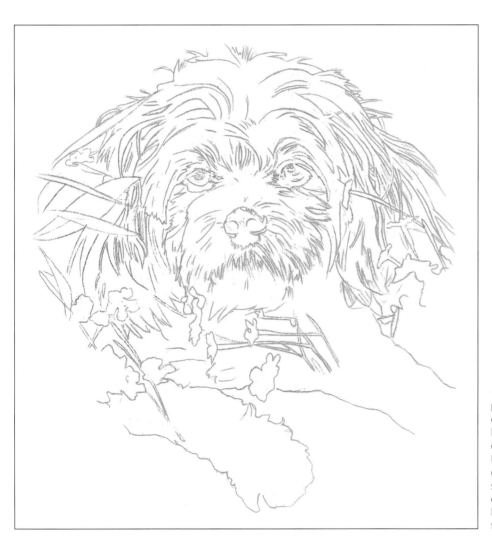

◀ **Step 1** First I use the grid method (see page 5) to transfer the outlines of the Shih Tzu onto my drawing paper. I include all the major lines, describing the direction of hair growth and delineating some of the long leaves on the left. Using an HB pencil, I sketch only the foliage that directly affects the Shih Tzu, as my priority at this stage is to define the dog. I always avoid excessive erasing as I want my final drawing to have a clean look, so it's important that I make any adjustments to the line drawing now.

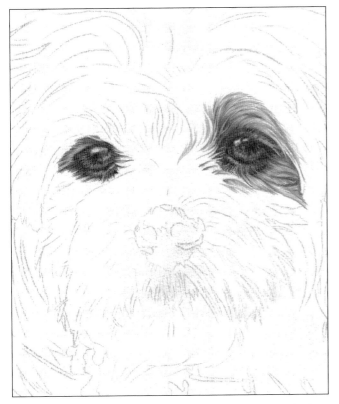

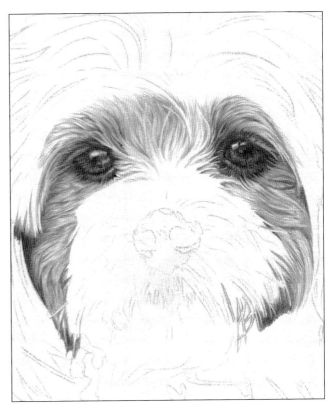

Step 2 Using a 5B pencil, I render the eyes. I apply the darkest tones on the rims around the eyes and in the pupils. Working around the highlights, I apply radial lines in the irises and smooth over them with a tortillon. I move into the surrounding hair with an HB pencil, stroking in the direction of hair growth.

Step 3 I use the same method to complete the hair in shadow, following the wave pattern of the hair and tapering the strokes at the ends. I avoid making uniform strokes, instead varying the thickness and spaces between them. As this is the darkest area of hair, I build up another layer of shading with an HB pencil.

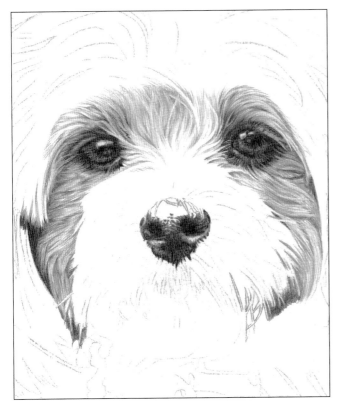

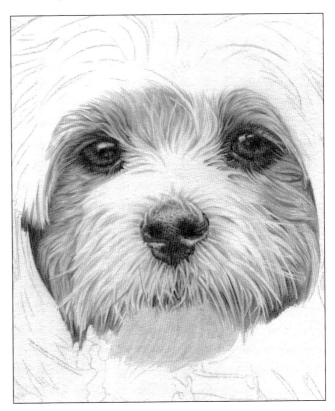

Step 4 After I finish the shadow areas on the face, I move onto the nose. Keeping in mind the direction of light, I use a 2B pencil to place the darkest values, applying circular strokes to the lower, shadowed part of the nose and in the nostrils. I'm careful to maintain the highlights on the top of the nose and along the bottom edges of the nostrils.

Step 5 Once I'm satisfied with the values in these first features, I "ground" them by adding hair detail over the entire face, keeping the top of the muzzle light. Using an HB pencil, I apply heavier strokes for the line of the mouth and stroke an even layer of graphite over the chin. I notice that the nose highlight is too strong, so I add a layer of graphite over the top to tone it down.

▶ **Step 6** Still using an HB pencil, I strengthen the values where needed as I work—it is easier to darken a value than it is to lighten it, so you don't want to start out too dark. Next I work on the ears, starting with the darkest values. Using my reference as a guide, I keep the hair lightest where it catches the most light. Next I stroke in some hair on top of the head, leaving the majority white, as it's directly in the path of the light. As I draw the hair, I stroke around the outlines of the leaves and flowers, defining their shapes with negative drawing.

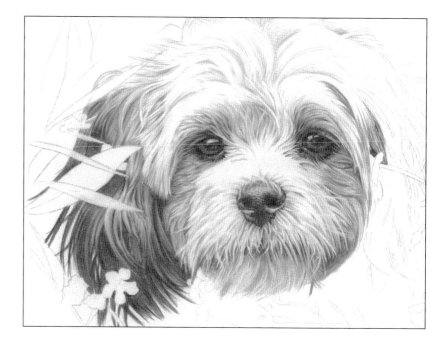

▶ **Step 7** I complete the ears, creating a gradation from light to dark as I move toward the tips by switching to a 2B and applying more pressure as I move down. I give the longer hair on the ears a messier look by adding thick, slightly curving chunks of hair. When I add the hair of the dog's left ear, I again draw around the outlines of the foliage to create their shapes. Then I add a thin layer of graphite below the chin and over the neck, toning the area evenly by smudging with a tortillon. (See "Smudging" below.) Then I use tack adhesive to pull out the shapes of the flowers and foliage in this area.

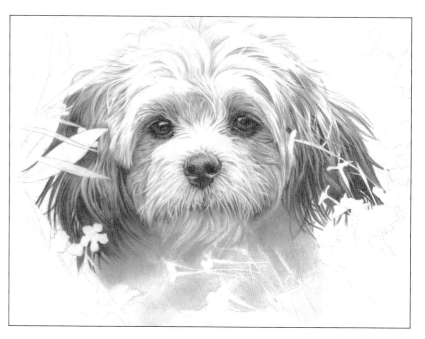

Smudging

Smudging creates soft blends that are perfect for depicting shadows on fluffy hair. Simply use a tortillon, blending stump, or chamois cloth to rub the graphite gently into the grain of the paper. If needed, you can easily lift out areas of smudging using tack adhesive, as shown.

► **Step 8** With the head nearly complete, I begin filling in the flowers and leaves in the foreground with an HB pencil. I give them a medium value between the lights and darks of the puppy's hair so they stand out. I make the flowers in front of the neck a bit darker to contrast with the light hair. I give the flowers and stems some dimension by darkening the undersides and keeping the upper areas light, as they're highlighted by the light source above.

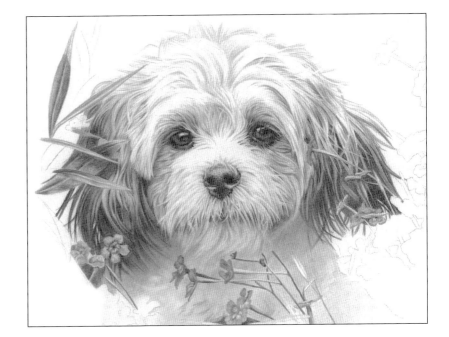

► **Step 9** Now I use negative drawing to add the grass in the foreground. Using an HB pencil and a dark value (about the same value as the darks of the ears), I shade around the blades of grass, filling in all of the negative space to define the edges.

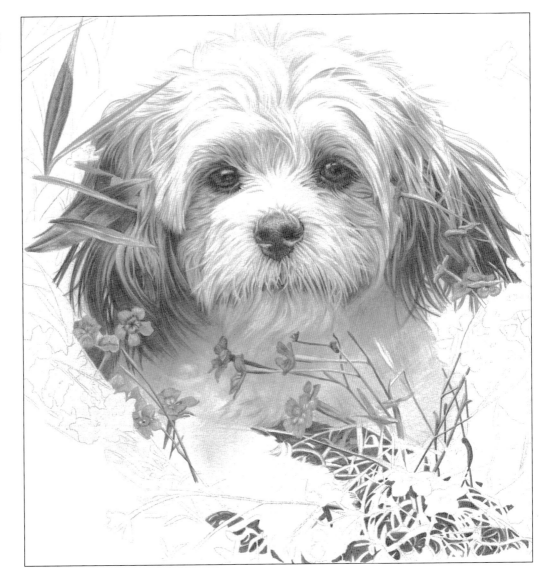

▶ **Step 10** I continue using an HB pencil to add tone to the grass in the foreground, varying the values on the blades to suggest depth. I keep the range of foliage values lighter than the darkest darks of the puppy (the eyes and nose) but darker than the puppy's lightest values (the top of the head and the muzzle). This keeps the greatest contrasts on the center of interest—the puppy's face.

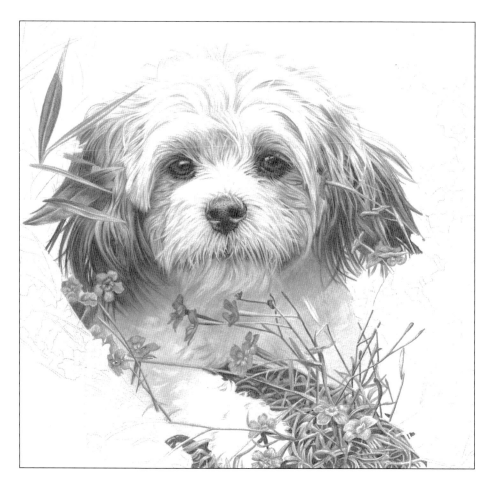

▶ **Step 11** I continue developing the foreground flowers and grass with an HB pencil. There is an interesting texture emerging, with the long, straight blades and stems contrasting with the round, delicate petal shapes. Then I add the long leaves and flowers on the right side of the composition. I set these elements off from the ears, making sure that the values of the leaves and flowers don't blend into the values of the hair.

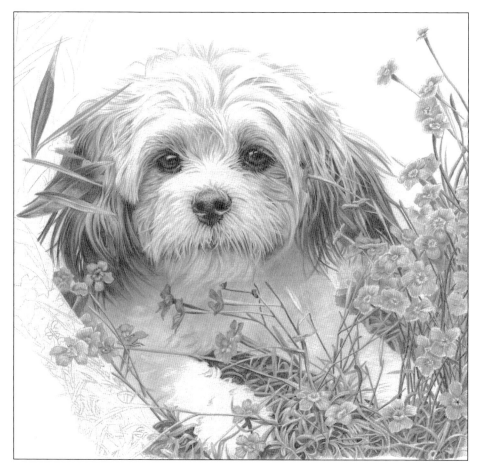

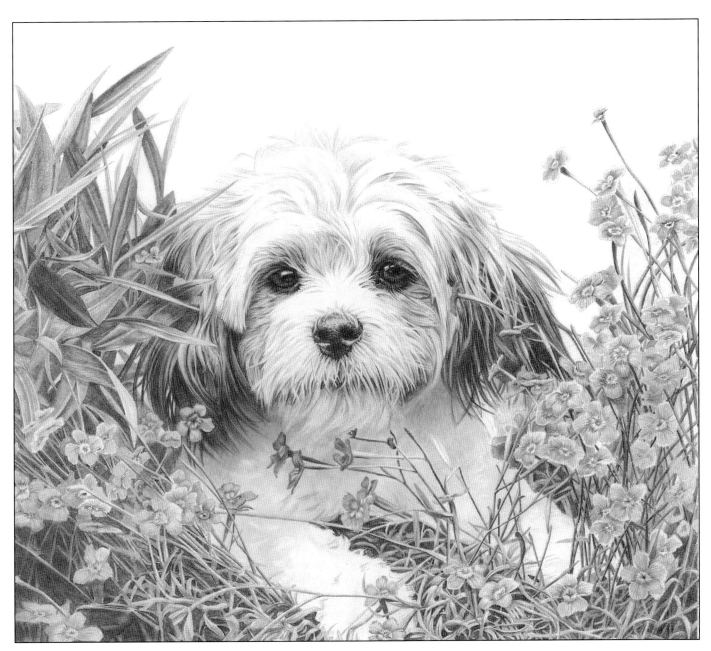

Step 12 I complete the leaves and foreground flowers on the left, maintaining the range of middle values as mentioned in step 10. The more simple, uniform texture of the puppy is now framed with intricate details and lines. Additionally, the darkest and lightest areas have been reserved for the puppy's face, drawing in the viewer's eye with extreme contrasts. Now I assess each area, adjusting the values as necessary. To darken an area, I simply use a 2B pencil to add layers of graphite; to lighten an area, I gently dab with tack adhesive to pull out graphite.

Incorporating Clusters of Leaves

Clusters of leaves provide a dramatic background with opposing lines and contrasting values. The resulting diagonals move the viewer's eye throughout the area and ultimately act as a tool to guide the viewer's eye toward the center of interest: the puppy's face.

ACHIEVING A LIKENESS

Capturing a likeness can be one of the greatest challenges for an artist, yet it can also be incredibly rewarding. The foundation of a successful portrait is careful observation coupled with a thorough understanding of the head's form. Take time to study the subject's shapes and proportions. The German Shepherd Dog's high-set ears take up almost half of the vertical area of the face. The large muzzle narrows gradually toward the blunt tip of the nose, with a gentle sloping along the bridge. The short hair of the face closely follows the form of the head and neck. In addition to breed characteristics, take notice of any elements that make this particular dog unique, such as the mole next to its mouth.

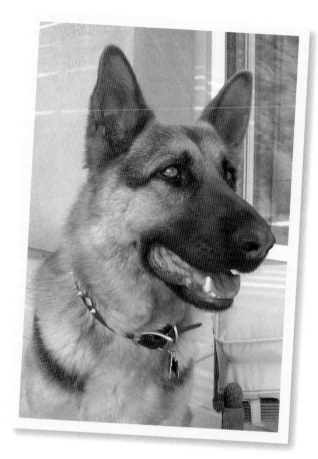

▶ **Focusing on Details** Including a dog's accessories, such as a collar and tag, can help you personalize a portrait even more!

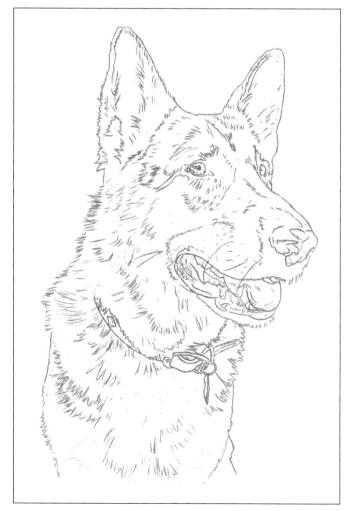

◀ **Step 1** For this drawing, I decide to leave out the background and focus solely on the Shepherd's noble expression. I use a sharp HB to create a freehand outline, beginning with basic shapes and then honing them into a detailed outline. I use a drawing compass to compare proportions from the reference photo with the proportions in my sketch to ensure that they match. This can also be done with a ruler, but I find the compass to be quicker and easier. Once I'm happy with the basic outline, I draw short lines to indicate the growth direction of the hair, and I map out the areas of greatest contrast.

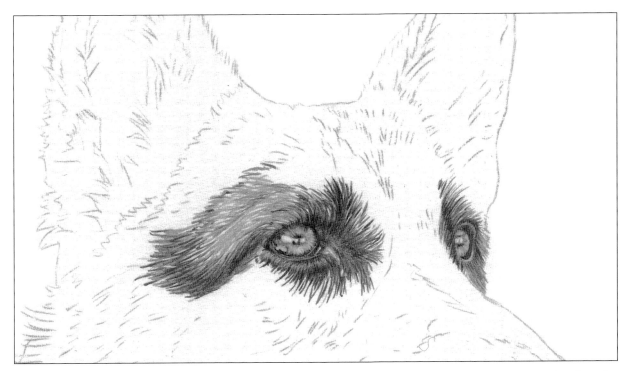

Step 2 I shade the darkest parts of each eye using a 2B pencil, leaving a highlight across the pupil and iris. Then I add midtone lines radiating from the pupil for the iris. Working around the highlight, I use an H pencil to cover the eye with a layer of shading. I indicate the hair surrounding the eyes with lines curving outward, switching to an HB for the lighter areas of the eyebrow. The gaps between the lines provide highlights.

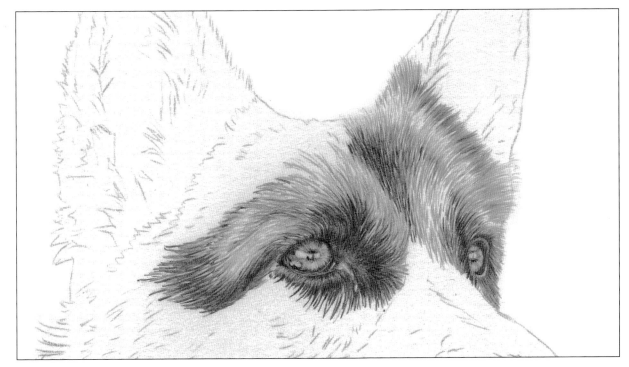

Step 3 I progress outward from the eyes, working up and over the forehead and into the dog's left ear. There is a darker patch of hair in the middle of the forehead, so I apply this first, using a 2B pencil to draw the lines in the direction of hair growth. Then I switch to an HB for middle-value areas of the hair, and I use an H to create the lightest sections. For the lightest highlights, I let the white of the paper show through.

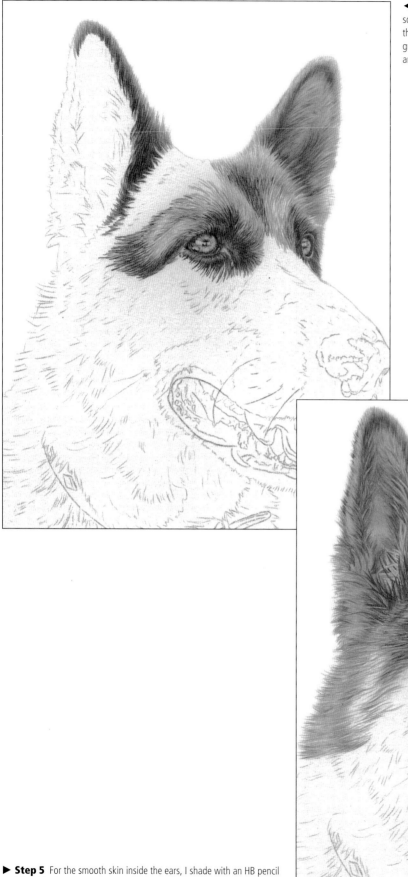

◄ **Step 4** The outer edge of the dog's right ear is very dark, so I use heavy pressure and a 2B pencil to apply tapering strokes that suggest small tufts of hair. I leave the rest of the ear free of graphite for now; I will finish it in the next step. Now I switch to an HB pencil to render the left ear, which is lighter in value.

▶ **Step 5** For the smooth skin inside the ears, I shade with an HB pencil and then blend with a tortillon. Then I draw the hair over this shading, varying the values within the hair and adding shadows between the clumps of hair. I progress down the side of the head using an HB pencil, letting some of the paper show through for lighter areas.

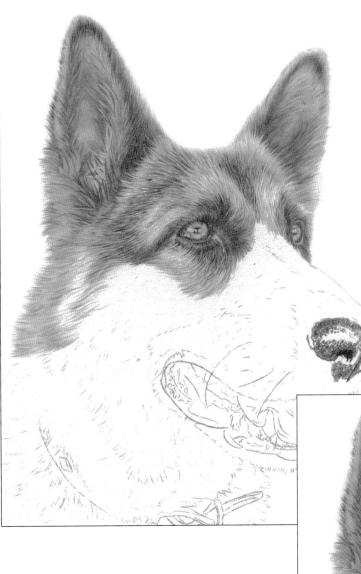

◄ **Step 6** I use a 2B pencil to draw the nose, making a series of small, dark circles to create the unique texture. I leave the highlight areas white. Next I concentrate on darkening the nostrils and the crease down the middle of the nose. Then I finish the nose by applying some lighter circles to the "white" sections on top and under the nostrils. Before I move on to the muzzle, I use a blunt tool to indent some whiskers and coarse, longer hairs below the nose. (See step 7 for placement.)

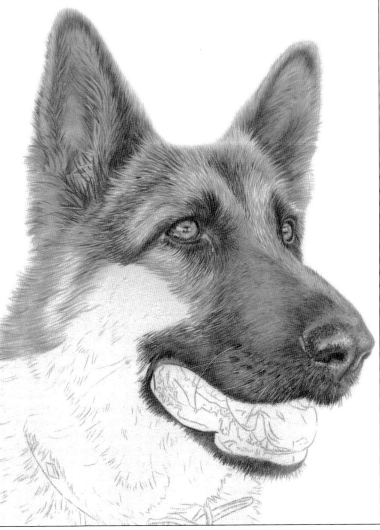

► **Step 7** Using close, short strokes that move away from the nose, I fill in the muzzle, changing the direction of my strokes near the mouth. There is actually little detail involved in the hair; accurately depicting the direction of hair growth is the key. Now I use a 5B pencil to darken the hair along the edge of the mouth.

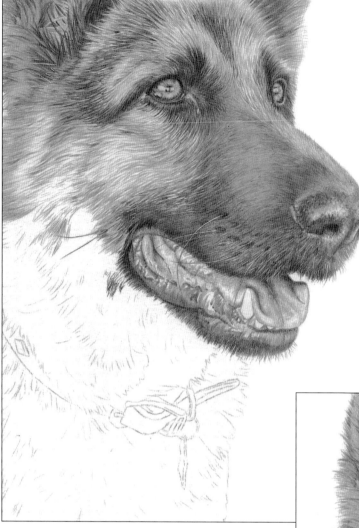

◄ **Step 8** With the muzzle defined, I move on to the inside of the mouth, shading the tongue with an HB pencil and blending with a tortillon for smooth transitions. I add tone to the gums and lips using a 2B pencil, taking care to leave patches of white for strong highlights that suggest wetness. I darken the whiskers where they overlap the mouth for continuity. I leave the teeth free of graphite. Still using an HB pencil, I fill in more hair on the cheek, darkening two lines to form a V shape near the corner of the mouth. (This suggests whiskers sprouting from the mole seen in the reference photo.)

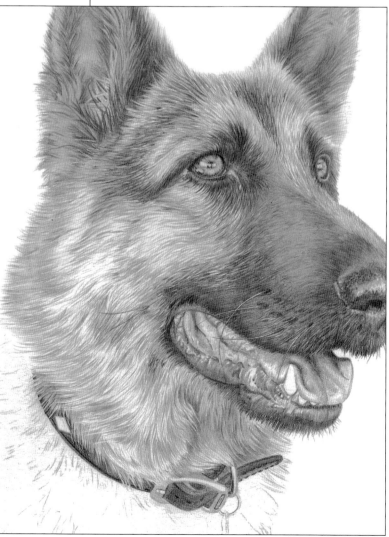

▶ **Step 9** I finish filling in the hair on the cheek with an HB pencil, lightly shading over the V shape so it's visible underneath. I continue the hair pattern down the neck, drawing sections of hair that roughly follow the direction of growth. As the hair is longer here, it's important to show its flowing nature by making the strokes less uniform. The German Shepherd's collar adds a bit of interest to the lower area of the drawing. I use a 2B to shade it, working around the hair that flows over the top of the collar. Then I switch to an H pencil for the shiny metal pieces.

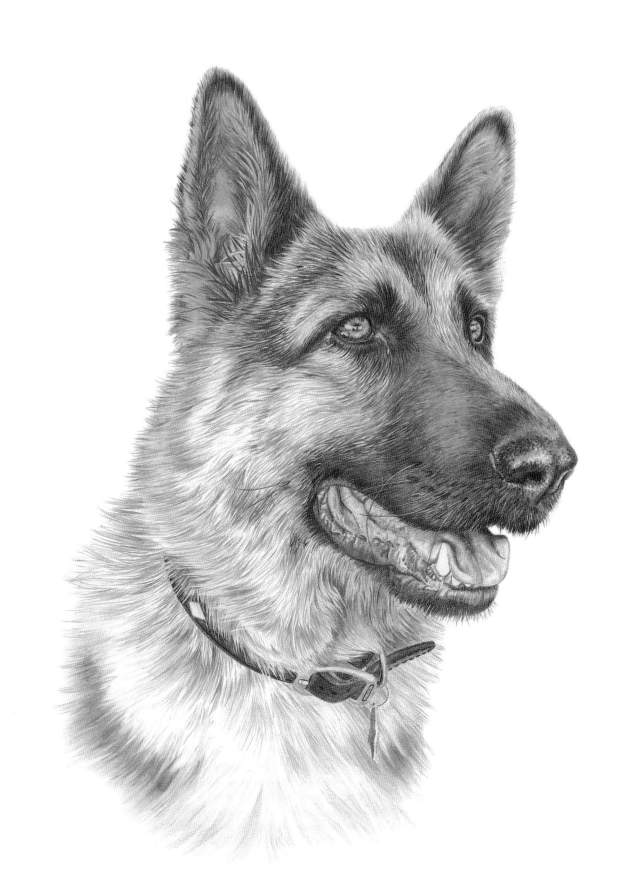

Step 10 I complete the drawing by blending the pencil strokes along the base of the neck, creating a soft transition from the hair to the white background. The bottom section is actually more paper than it is pencil—there are just enough pencil strokes to imply the shape and direction of the hair; this allows me to avoid a harsh finish line to the drawing and reinforces the German Shepherd Dog's happy, attentive expression as the focal point of the piece.

FOCUSING ON CONTRAST

When working with a light-colored dog, it's particularly important to diminish the level of detail in the background. Light-colored dogs don't have much contrast in their hair, so the background elements easily can attract the eye. Keep any intricate elements lighter in value and refrain from adding fine details, such as veins in leaves. This will keep the viewer's focus on the dog.

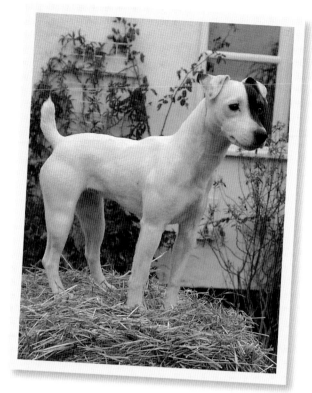

▶ **Emphasizing the Subject** As is, the photograph has too much detail. I decide to take the background "out of focus" by blurring, lightening the overall values but maintaining enough contrast with the dog's coat. This emphasizes the sleek shape and muscular stature of this mostly white Parson Russell Terrier.

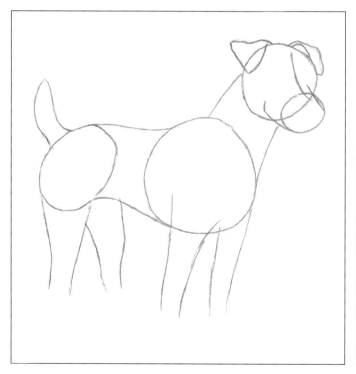

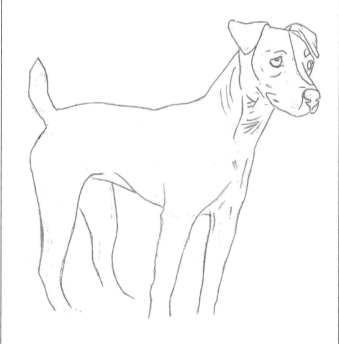

Step 1 Using an HB pencil, I sketch circles for the skull, chest, hips, and muzzle. Once I'm sure the relationships of these circles match the reference, I join the circles to create the outline of the dog's body. Then I indicate the position of the legs, tail, and ears. I also add a guideline up the center of the dog's face to help me position the features. At this early stage, the sketch is already recognizable as a Parson Russell Terrier!

Step 2 Next I focus on refining the outline, following the subtle curves that make up the shapes of the dog. Then I erase the circular guidelines that I no longer need. I indicate the shadowed area of the neck and head with a few short strokes, which will speed up the shading process later. I also block in the eyes, nose, and brows. I don't indicate the paws because they will be hidden in the hay.

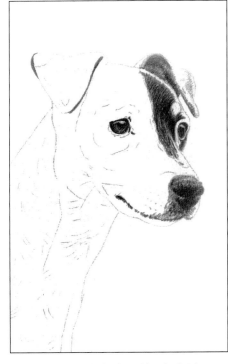

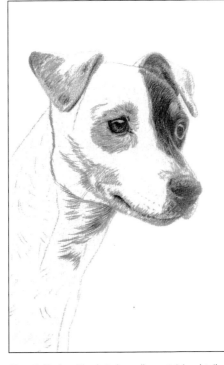

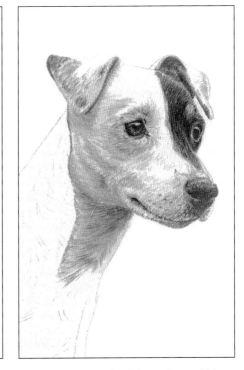

Step 3 I begin the shading by tackling the facial features. At this stage, I use a 5B pencil and only block in the darkest areas, including the eyes, the shadow on the nose, the mouth, and edges of the ears. The dog has a black patch around its left eye, which I darken as well.

Step 4 The head is relatively small, so attaining detail will be a challenge. With a sharp H pencil, I apply midtones to add hair around the eyes and on the mouth, cheekbone, jaw line, and ears, applying short lines that follow the direction of hair growth.

Step 5 I use an H pencil and short strokes to add the lightest areas of hair over the face, gradually fading out the strokes as I progress toward the top of the head. Then I add mid-value dots near the mouth to represent the areas from which the whiskers grow.

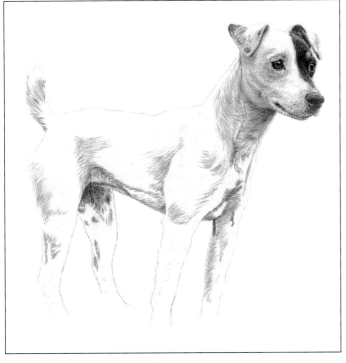

Step 6 Now I switch to an HB pencil and begin stroking in areas of hair on the torso, first addressing the darkest areas in shadow, such as along the insides of the far legs. Every stroke I make on the body is short and follows the direction of the hair growth, accurately communicating the feel of this dog's short, smooth coat.

Step 7 Still using the HB, I continue stroking in hair across the entire torso, layering my strokes smoothly and evenly. I develop the shadows of the dog's form that indicate the muscles beneath, such as on the hind and front legs.

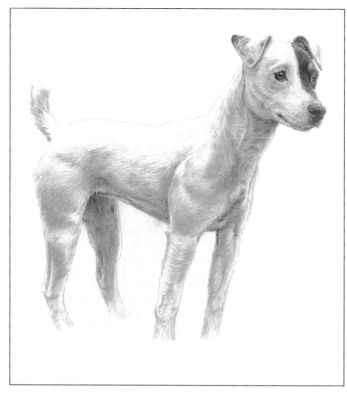

Step 8 I take a second sweep across the body using a 2H pencil, adding the subtle middle and light tones, and reducing the pressure on the pencil for the lightest areas. The muscle definition of the Parson Russell Terrier is an important characteristic of the breed, so I pay great attention to where the muscles sit, particularly around the shoulder and hind legs. I emphasize them by shading the undersides of the muscles.

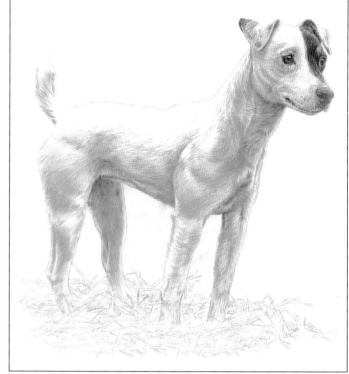

Step 9 At this point, I add tone to the hay with an HB pencil. This is the only area that directly touches the dog, so I need to get its tone and value to sit well with those of the dog. I use negative drawing to begin, just as I do for intricate hair. Because hay doesn't follow any particular pattern or direction, I sketch it in using random pairs of parallel lines that cross each other.

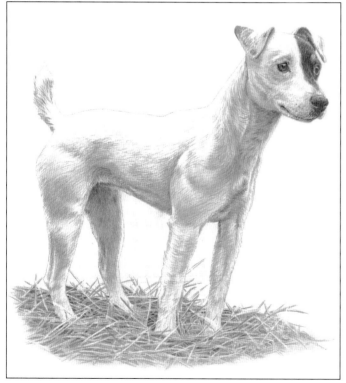

Step 10 With a 2B pencil, I fill in the negative areas of the hay with the tone of its darkest shadows. You can see that this simple approach immediately produces the impression of hay. As I continue to add the shadows, I gradually fade out the edge of the hay along the bottom and sides. If any part of the edge is too harsh, I roll tack adhesive over the area to lift out some graphite and lighten the overall tone.

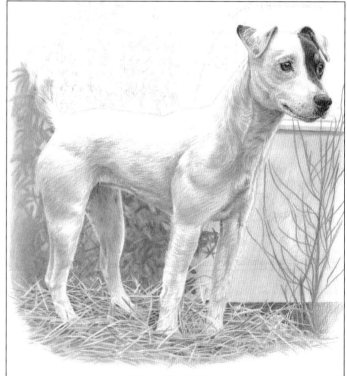

Step 11 Switching to an HB pencil, I begin adding the wall and foliage in the background, pushing the dog forward and creating a sense of depth. I add tone to the wall on the right, giving the area interest by adding a cluster of twigs. Then I draw ivy growing up the left two-thirds of the wall. To avoid attracting too much attention to the background elements, I keep them indistinct by blurring them slightly with a blending stump.

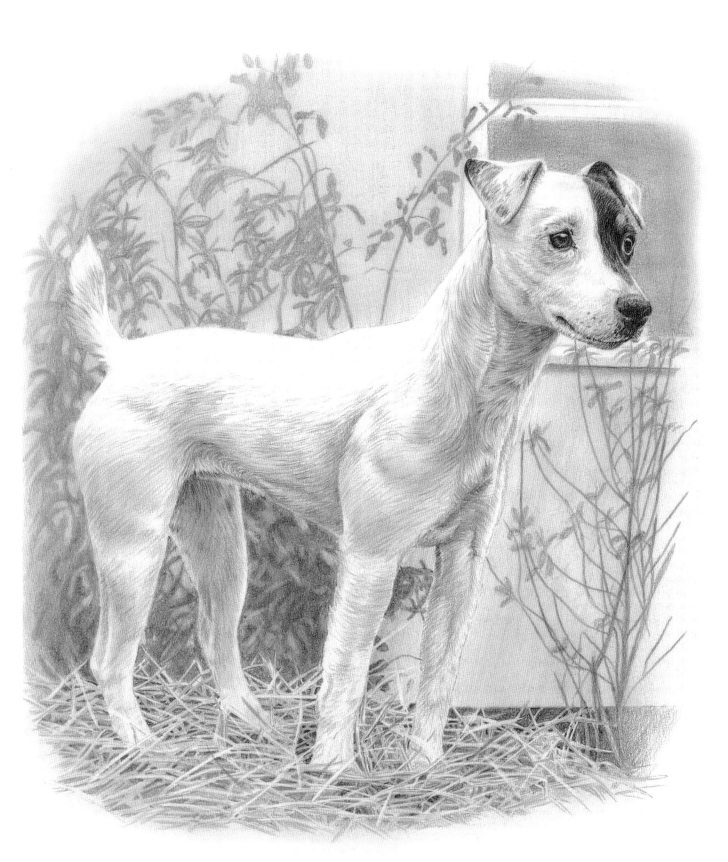

Step 12 I continue addressing the background of the drawing, working upward with an HB pencil as I finish the ivy, ending just above the dog to contrast with the light value of its back. I add a middle value to the window behind the head to contrast with both the light and dark hair. Then I stand back from the drawing and focus on areas where the dog blends into the background, darkening or lightening where needed. To finish, I sharpen details on the dog and blend any harsh lines of the background.

CONVEYING EXPRESSION

From this priceless shot of a Basset Hound puppy, I want to create a portrait wherein the expression stands out more than anything else. To do this, I ensure that none of the background elements overwhelm the focal point—the dog's innocent expression. I keep the details of the grass to a minimum, instead merely suggesting the grass with lighter tones. This keeps the focus on those classic "puppy-dog" eyes!

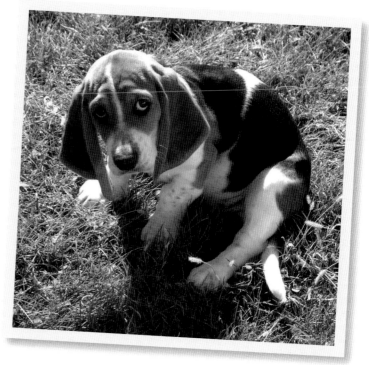

▶ **"Grounding" a Subject with Shadow** When rendering a full-body portrait from an unusual viewpoint, it's a good idea to "ground" the subject with a shadow. This prevents the dog from appearing to float above the drawing surface and also gives the viewer a better sense of the dog's form.

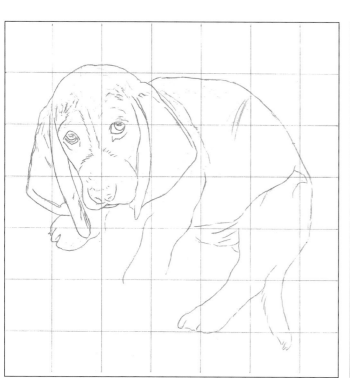

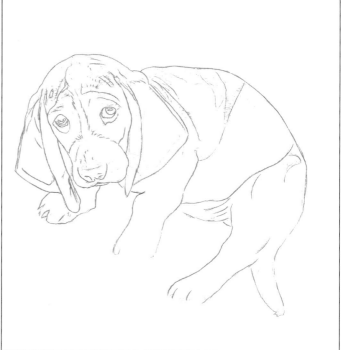

Step 1 I want to match the posture and expression of the pup as closely as possible, so I use the grid method to transfer the image to my drawing surface. I use an HB pencil to create a light grid made up of small boxes to ensure accuracy (see page 5). I also block in lines for the highlights and shadows, which will help me shade in later steps.

Step 2 Before erasing the guidelines, I make sure that I have copied over the exact shape of the puppy's eyes, as they are essential to communicating the dog's sweet, gentle expression. Then I erase the grid lines, being careful not to lose any of the dog's outline. I make sure no other adjustments are needed before progressing to the shading stage.

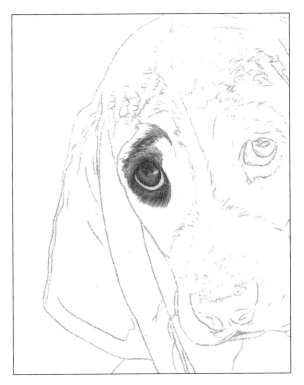

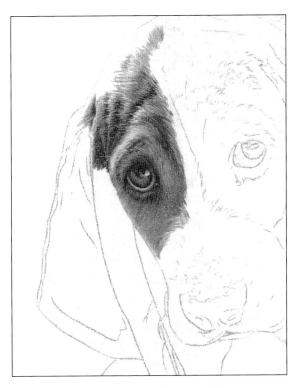

Step 3 Now I use a 2B pencil to block in the pup's right pupil, working around the highlight. I fill in the iris with a medium-dark value and create a darker outer ring, smoothing these tones with a blending stump. I darken the undereye area and begin developing the hair over the brow with short strokes.

Step 4 The skin of the brow is wrinkled. To express this, I create highlights along the tops of the folds by leaving the areas free of graphite. For the shadowed creases, I apply short strokes that are heavy and close to one another. As always, I make sure each stroke follows the direction of hair growth.

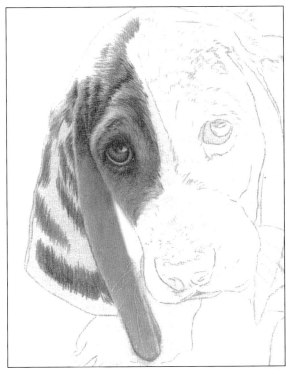

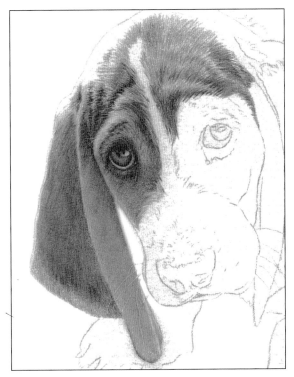

Step 5 Next I create the darkest areas on the ear using short, vertical hatching strokes. Then I apply a solid medium value of shading over the front flap of the ear, smoothing it with a tissue wrapped around my finger.

Step 6 I apply another layer of graphite over the ear (except the front flap) and blend with a tissue. I add hair over the left side of the puppy's head, stroking up and away from the eye and avoiding the white marking down the center of the head.

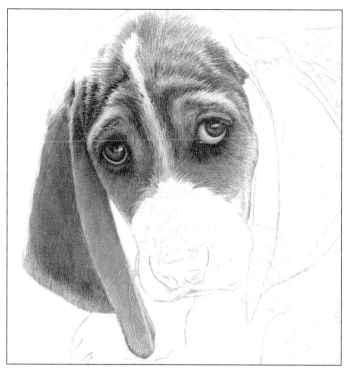

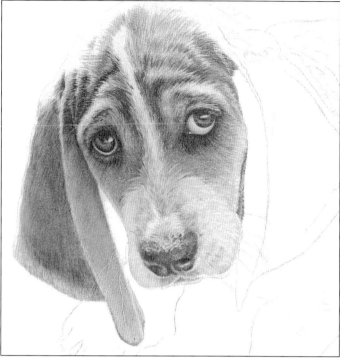

Step 7 Now I use a 2B pencil to shade around the pup's left eye. I place the iris and pupil high in the top outer corner of the eye, with more white showing in the inner corner. This emphasizes the submissive expression. To give the eye roundness, I lightly shade the inner corner of the eye, graduating to white around the outer edge of the iris. I draw the hair below the eye, gradually fading out as the hair becomes lighter.

Step 8 Still using a 2B pencil, I begin the nose by shading the darkest areas: the underside, the nostrils, and the side. I provide texture to the top using small dark circles, gradually increasing the gaps between the circles as I approach the highlight. I complete the nose by adding midtones over the circles around the front and a very light tone to the top. I finish the muzzle with very light H pencil strokes, and I indent the whiskers with a blunt tool.

▶ **Step 9** Now I use the same method that I used in step 6 to add tone to the puppy's left ear. When I shade over the whisker indentations, they become visible.

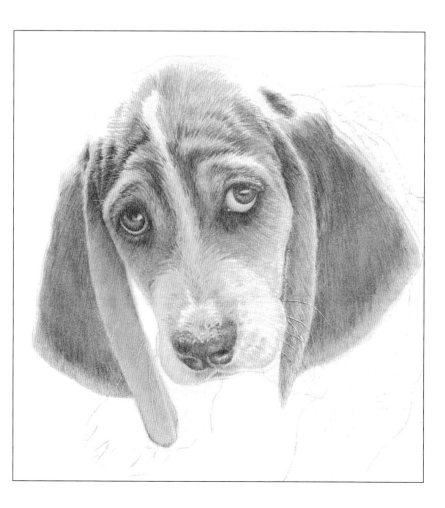

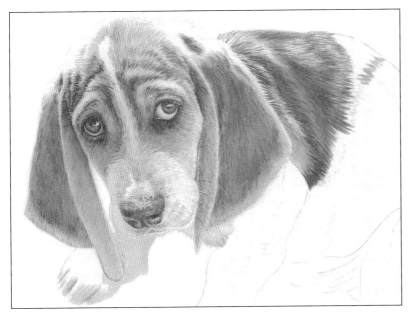

◄ **Step 10** With an HB pencil, I accentuate the fold of the pup's left ear by giving it a very light edge to contrast with the darker hair behind it. Then I add tone to the dog's right paw, shading in between the toes. Now I'm ready to begin the back and side of the body. I again draw a series of lines in the direction of hair growth, always drawing from dark to light. I create the ridges of hair near the middle of the body by alternating light and dark values in a bumpy, striped pattern.

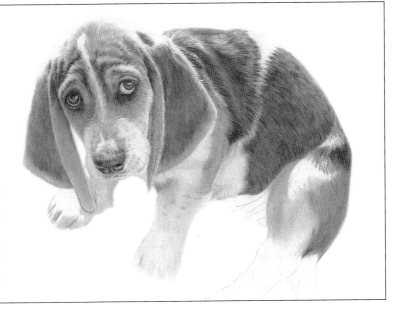

► **Step 11** I use an HB pencil to block in the rest of the hair on the back, leaving the white stripe very lightly shaded and the top of the back and the top of the left hind leg unshaded.

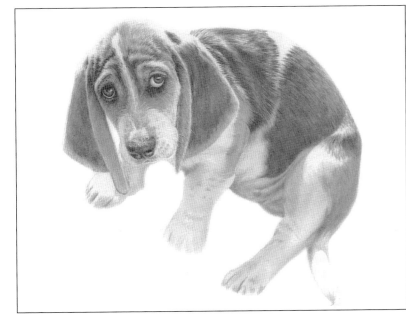

◄ **Step 12** With an H pencil, I add a shadow to the inner side of the hind leg and complete it and the left foreleg. I shade the stomach and blend with tissue paper to convey its nearly hairless surface. I leave the tip of the tail predominantly white.

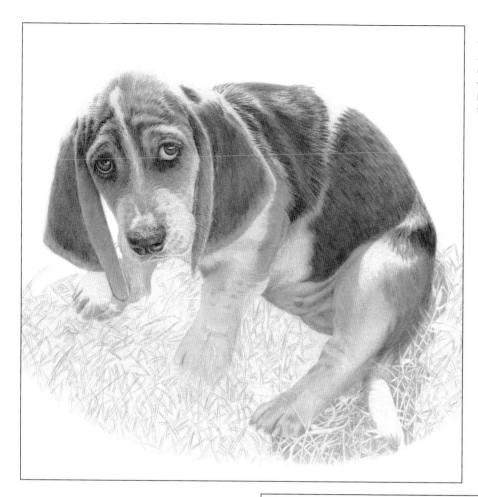

◄ **Step 13** With nothing underneath it, the pup appears to be floating in midair. To ground it, I add some grass and a cast shadow. I use an H pencil to draw each blade of grass as a pair of lines closing to a point. To contrast with the more uniform quality of the hair, I draw the blades in random directions. Then I shade around the tail, filling in the gaps between the blades of grass.

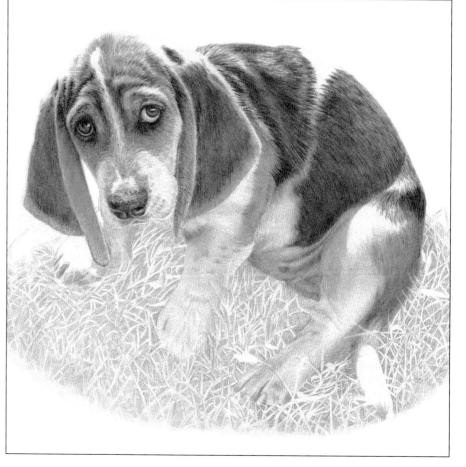

► **Step 14** Using the same method, I continue to surround the dog with grass. I want to keep the drawing from being too rigid, so I fade out the grass as I move away from the dog. The semicircular shape of the grass in the foreground keeps it from overpowering the drawing and serves to complement and emphasize the semicircular form described by the puppy's back.

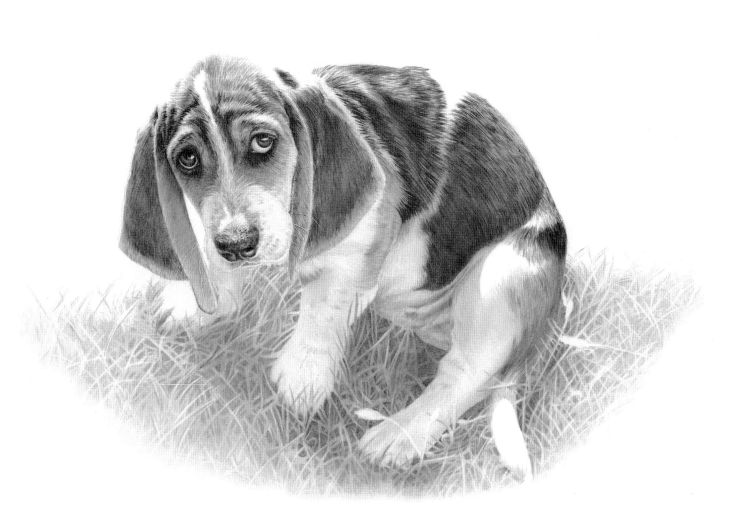

Step 15 To finish, I complete the grass (see "Creating Grass" below), creating shadows underneath the pup to ground it in the scene. Then I adjust the tone of the shadows to ensure that the Basset puppy still stands out as the focal point of the drawing.

Creating Grass

Rather than shading each individual blade of grass, I use a tissue to blend the graphite that is already there. I blend darker areas where there would be shadows, such as around the paws and under the pup's body. Then I use an eraser cut to a sharp angle to lighten some of the blades and bring them to the foreground.

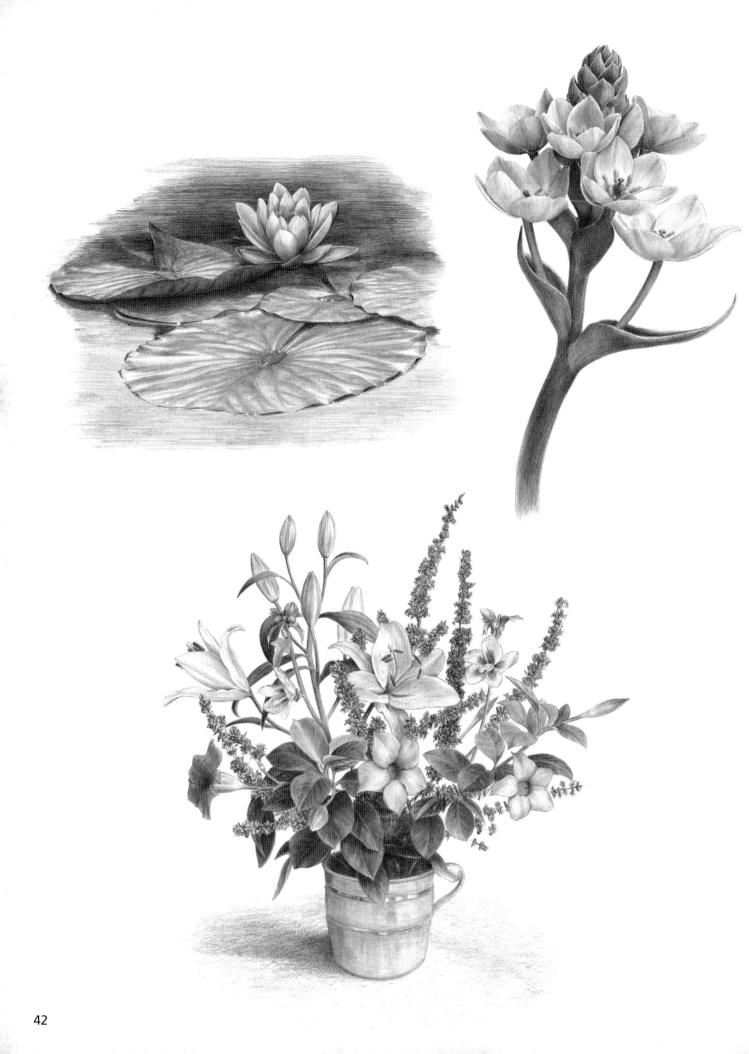

FLOWERS & BOTANICALS

with Diane Cardaci

Flowers hold a universal appeal for people all over the world. We use them to speak for us, giving flowers to express emotion, love, friendship, and sympathy. We are fascinated by their colors, but underneath the enchanting rainbow of hues is an incredible beauty of form, structure, and value. That beauty can be captured by the simplest of tools: the drawing pencil.

With the delicate touch of a pencil, we can capture the gentle fold of a bell flower or the intricate detail of an opening bud. We can develop the deep shadows of a twisted leaf or the dark center of a sunflower to make our drawings come to life.

It is with great pleasure that I invite you to look over my shoulder to see how I meet the challenge of portraying the splendor of the world of flowers and botanicals. The foundation of all drawing is observation. The lessons in this chapter are designed to help you simplify what you are seeing, first by using basic lines and angles, then progressing to depiction of the organic shapes, and finally adding the tonal shading to develop the forms. Throughout these pages, I share skills that I have learned from other artists, as well as some techniques that I have developed through my own experimentation. I encourage you to experiment on your own and approach the exercises with a joyful heart.

—*Diane Cardaci*

Diane Cardaci was classically trained at the Art Students League of New York City, Parsons School of Design, and the School of Visual Arts. She is a Signature member of the American Society of Portrait Artists, and has contributed writing for the organization's publications. Diane is also a member of the Colored Pencil Society of America, the Graphic Artists Guild, and the Illustrator's Partnership of America. Diane lives in Florida and spends her summers in Umbria, located in central Italy, where she furthers her studies of the Old Masters.

ANATOMY OF THE FLOWER

Although we are artists and not scientists, understanding the basic anatomy of a flower will help us sharpen our observational skills. Use a magnifying glass to study the very small parts of a flower to better understand the shape of the petal, how leaves connect to stems, how buds develop, and so forth. This will also help you recognize the individuality of each flower. As you train your eye to see more, you will gradually learn to pick out the important details that add realism to your drawing.

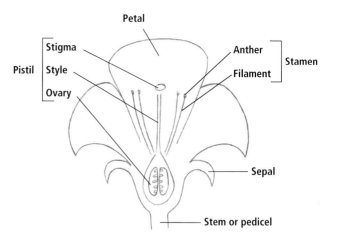

Stem Take care when drawing the point where a leaf joins the stem—this area has details that are different from the rest of the stem. For example, note the joints and the changes in shading around them.

Bud Before a flower blooms, it exists as a small bud. Without a proper highlight, the roundness of the teardrop shape may become lost.

Branch Branches are often thick and rough, with uneven surfaces. Their texture adds personality and variation to your drawings.

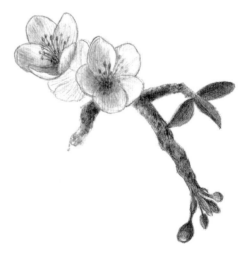

Tree Flowers Blossoms on trees are different from those growing out of the ground. The delicate petals on gnarled branches provide a lovely contrast.

44

BLOCKING IN BASIC SHAPES

Drawing flowers can seem challenging because of their intricate detail, but you will find it much easier if you start with the lines and angles that form the flower's basic shape—a process called "blocking in." Study the flower and look for its basic shape. Is it round or star shaped? Does it look like a cup or a tube? Start with an easy, familiar shape for the outline of the blossom—the most common shapes are the cup, trumpet, bell, star, and modified star. Block in the outside shape of the flower, and then begin to add more basic shapes for the individual petals and leaves. Break down everything into manageable forms, piece by piece. Take your time when blocking in; it is said that the biggest mistakes in a drawing are made in the first five minutes!

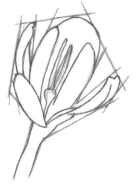

Cup Block in the outer shape of the crocus blossom with straight lines, creating a five-sided polygon. Check the proportion of the height to the width. Use straight lines to delineate the spaces between the petals; then go back in and use curved lines to draw the petals.

Trumpet Use long, diverging lines and then a polygon shape to block in the outermost part of the flower. Compare the length of the trumpet with its width and also with the size of the polygon. Draw lines to represent the *negative shapes*—the spaces between and around the actual object; then draw the curves of the flower.

Bell First draw five straight lines to define the shape of the tube of the bell. Then use a triangular shape to determine the opening of the bell, and refine the shape of the opening with three more straight lines. Next draw the curves.

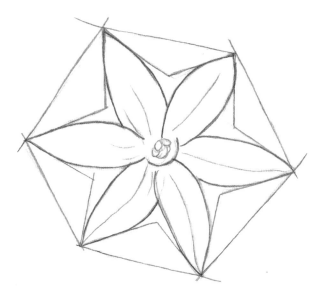

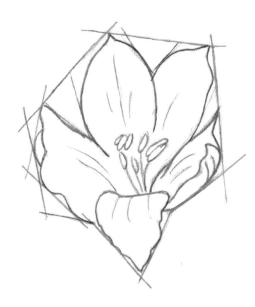

Star First draw a hexagon, which will encompass the entire blossom. Then draw some V-shaped lines between the points to indicate the negative space between the petals. These lines and angles should be fairly even, as this is a very symmetrical flower. Now you can start drawing the curves that define the petals.

Modified Star Block in this blossom with eight straight lines, again comparing length and width. Add lines to define the negative spaces between the petals, and finally draw the curves of the petals.

SHADING TECHNIQUES

It is a valuable exercise to try drawing a flower using different techniques for creating texture and values. You will find that specific techniques work better for certain flowers. For example, blending works well when there are subtle value changes, but crosshatching (see below) may be better if you want to add more detail to your shading. You may also find that you enjoy using some techniques more than others—this is the beginning of developing your own personal style. Here I've drawn five versions of the same violet, using different shading techniques for each.

Using Different Media

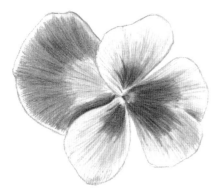
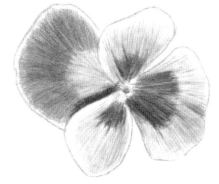
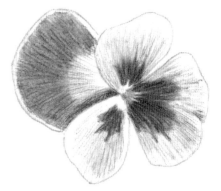

Graphite Powder I dip the tip of a blending stump into some *graphite powder*—dust collected from sharpening soft graphite pencils, such as a 2B. (You can also buy graphite powder in art stores.) I use light pressure and stroke with the stump as if I were shading with the side of a pencil, and I blend in a layer of tone on the shadowed areas of the flower.

Graphite Washes This time I add tone with water-soluble pencils. After applying some tone with the water-soluble pencil, I use a damp brush to blend the graphite, creating a thin application—or a *wash*—similar to watercolor paint. It is important to blot your brush on a paper towel to absorb the excess water before applying it to your drawing.

Carbon Pencil Carbon pencils create a very smooth, matte finish. The rich, velvety tones are great for depicting soft textures. For dark areas, I use a soft carbon pencil. For lighter areas, I use a hard carbon pencil with light pressure. The carbon pencil creates deeper darks, but it is harder to achieve very delicate details.

Using Different Strokes

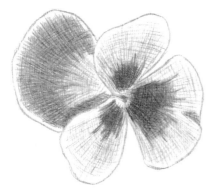
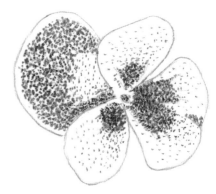

Crosshatching This technique involves hatching (making a series of parallel lines), and then crosshatching (criss-crossing the lines over one another) to create tone. By making the strokes closer together, the shading becomes darker. These strokes are all made with a very sharp point. I lay in some parallel strokes with an HB, following the direction of the petals. Then I go back over the strokes, changing direction and following the curve of the petal.

Stippling I create all the tonal shading in this example using *stippling*, where grouped dots visually merge to create tone when viewed from a distance. The closer the dots, the darker the value. I use a dull 4B pencil and keep adding dots to the drawing, using a greater concentration of them in the darkest areas and only a few dots to depict the lightest areas.

Using Special Techniques

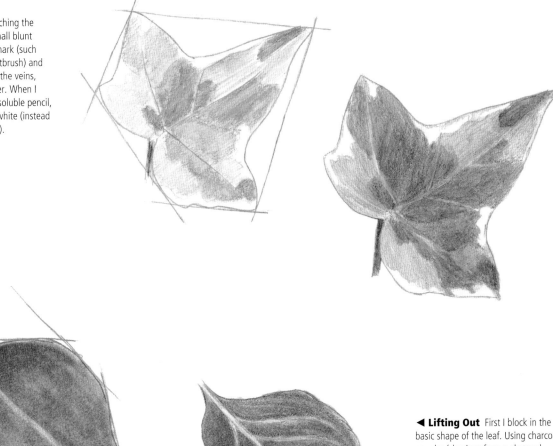

▶ **Impressing** After sketching the outline of the leaf, I use a small blunt object that doesn't make a mark (such as the chiseled end of a paintbrush) and medium pressure to "draw" the veins, indenting them into the paper. When I shade the leaf with a water-soluble pencil, the impressed veins remain white (instead of being covered by the tone).

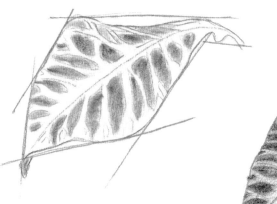

◀ **Lifting Out** First I block in the basic shape of the leaf. Using charcoal powder (shavings from a charcoal pencil) and a blending stump, I shade the leaf. To create the veins, I lift out tone by stroking over the charcoal with a kneaded eraser molded to a point. The white areas represent the veins.

▶ **Negative Drawing** Here I create the veins by shading only the dark areas *around* the veins (the negative spaces). I use charcoal powder and a stump to smudge the dark areas of the negative space. The stump is too large to be precise, so I go back in using a soft carbon pencil sharpened to a fine point to shade the veins.

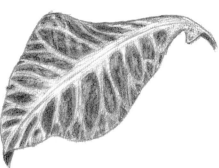

SKETCHING BASIC FLOWER PARTS

Just as it's a good idea to practice drawing facial features separately before drawing an entire portrait, it's beneficial to become comfortable drawing individual parts of a flower before creating an entire composition. For example, start out by sketching the head of the flower; then you can progress to the leaves and stems. When you've mastered drawing these basic parts, you can begin to add details. When I sketch, I like to use vellum-finish Bristol paper with a large-diameter, soft-lead pencil, which allows me to loosen up and capture the fluid lines of the flowers and botanicals.

Focusing on Flower Heads

Start your sketches with a simple three-step process. At first you can concentrate on the flower heads only, blocking in the basic shapes, drawing outlines, and then adding details and shading.

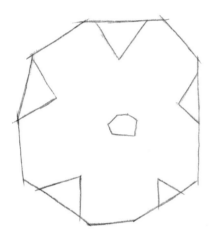

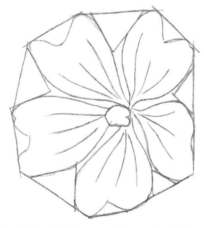

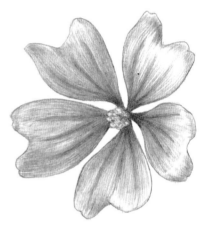

Step 1 Here I use straight lines to block in the overall shape of the flower. Then I draw five V shapes to delineate the negative space around the petals. I also draw a small circle to block in the pistil and stamens.

Step 2 Now I add the curves of the petals and draw some of the basic lines to indicate the deeper grooves within the petals. These lines help describe the form of the flower.

Step 3 I erase the guidelines and then refine the drawing. I add some tone using graphite powder and a narrow stump. Then I use a sharp HB to shade the petals with long, slightly curved strokes.

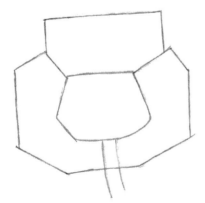

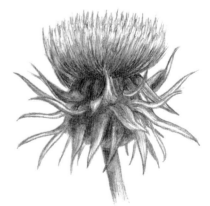

Step 1 I break down this flower into three basic shapes to block in the general shape, and I also indicate the top of the flower's stem.

Step 2 Next I define the curve at the top of the flower and then add long, needlelike sepals coming out at different angles at the base of the flower.

Step 3 I separate the petals and create their texture with long strokes and a sharp HB. I use a 2B and heavy pressure to shade the lower area. Lastly, I shade the sepals with an HB.

Adding Leaves and Stems

Once you're comfortable drawing the head of a flower, you can begin to work on drawing the leaves and stems. There's a lot more to a flower than the petals, so you'll want to pay careful attention to these important elements. Study their different shapes, the vein patterns of the leaves, and the way the leaves attach to the stems.

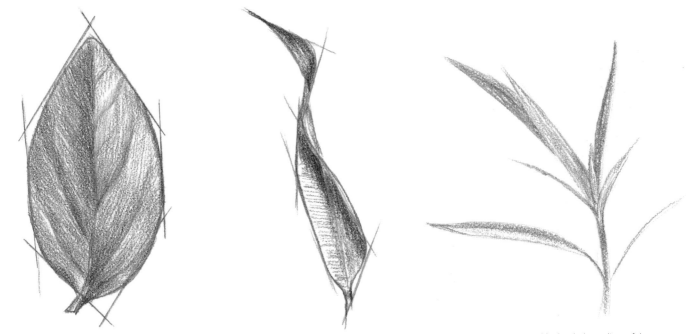

Basic Leaf First I use some straight lines to establish the basic shape of the leaf. Then I use these lines as a guide to draw the leaf's outline. I draw the main veins of the leaf and then add tone with loose hatchmarks.

Twisted Leaf I use straight lines to block in the shape; then I define the leaf's curves. Using the side of a 6B, I quickly add some tone. The deepest shadows accentuate the folds and bring out the leaf's shape.

Long Leaves I roughly sketch the outlines of these long, slender leaves, then go back and refine their shapes. Using the side of the pencil, I add tone with long, loose strokes to illustrate the thin, lilting leaves.

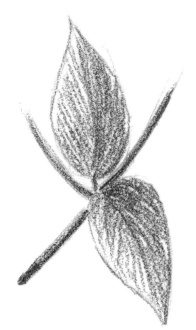

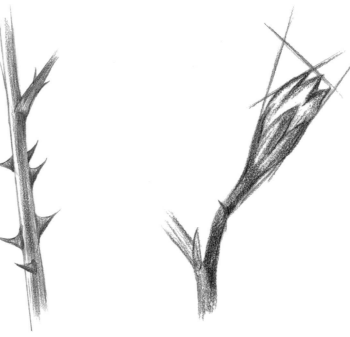

Thin Stem First I use a sharp point to block in the curving shape of the stem; then I draw the teardrop-shaped leaves. I add a lighter stem sprouting from the main stem. Finally, I add medium tone to the stem and delicate tone to the leaves.

Thorny Stem Here I use several long lines to establish the length, width, and direction of the stem. Then I draw the thorns, paying attention to where and how they connect to the stem. I use long, parallel lines to add tone to the stem.

Stem with Bud Many flowers have small buds growing along the stem. I block in the basic shape of the bud with straight lines and then draw the curves. I use the side of the pencil for lighter tones and heavy pressure for darker tones.

CALLA LILY

The glory of this flower lies in its simplicity and graceful lines. I found this perfect specimen growing on the side of the road, in front of an Italian country home. It had been planted by the man who lives there, placed perfectly so all who pass by can share in his enjoyment of this blooming beauty.

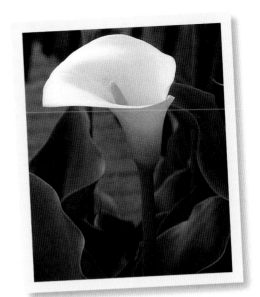

▶ **Taking a Closer Look** I decide to take a close-up photo of the calla lily blossom so I can focus on its large, graceful shapes and beautiful simplicity.

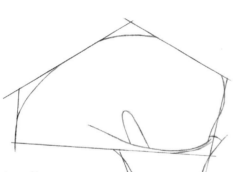

▶ **Step 1** I start this drawing on heavy tracing vellum, using an HB pencil and straight lines to block in the basic shapes. Then I refine the outline of the flower, rounding off the bottom of the blossom and transitioning into the straight, thick stem.

▶ **Step 2** I take a second piece of tracing vellum and trace over the outline, adding more variation to the overall shape to create a better sense of natural realism. Now I'm ready to transfer the outline to a sheet of smooth-finish Bristol paper using the method described on page 5.

▶ **Step 3** Using the side of an HB pencil, I lightly stroke in some initial tone for the flower. I use long, parallel strokes that gently curve and follow the direction of the delicate striations. I add tone to the stamen using small, circular strokes. I also begin to darken the stem.

▶ **Step 5** I continue to build up the tone of the flower head using only the HB pencil. Then I use an eraser to pull out some highlights along the outer edges of the petal. I further darken the stem and stamen. Finally, I use the point of the pencil to reinforce the edges of the flower, creating a subtle contrast between the white flower and the white background.

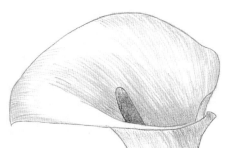

▶ **Step 4** I continue to build up the tone using the HB pencil. Then I switch to a 2B pencil and darken the stem using long, vertical strokes. With heavier pressure and small circular strokes, I deepen the tone of the stamen.

TULIP

Tulips come in many varieties and colors, and they are a lot of fun to draw. The stem often curves, so it creates a lovely movement in your drawing. A tulip has a simple cup shape, so if you understand the shading of a cup, it will be much simpler to draw. Try setting up a white teacup under the same lighting conditions to thoroughly understand the shadow patterns.

▶ **Combining References** Here I combine two different reference photos to create the most pleasing composition. I prefer the flower on the far right to be open, not closed as it is in the photo. So I find another photo of an open tulip and use it to alter the closed tulip in my original reference.

▶ **Step 1** Using an HB pencil and tracing vellum, I draw the curves of the stems using long, graceful lines. Then I block in ovals to represent the flower heads. I add irregular ellipses where the insides of the cups are visible. Next I carefully sketch the leaves.

▶ **Step 2** Now I draw the petals of the tulips, using the ovals and ellipses as guides. Each tulip is placed at a different angle, so I must be careful to show this. I use mainly curved lines and some oval shapes to draw the petals. Then I study the leaves and refine their shapes as needed.

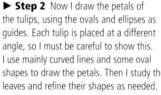

▶ **Step 3** I take a new piece of tracing vellum and place it on top of my drawing. Using my original drawing as a guide, I retrace and refine the flowers, leaves, and stems; then I erase the ellipses, which are no longer necessary. I add some lines to represent a few striations that are seen in the flowers and leaves. When I am satisfied with my drawing, I transfer it to smooth-finish Bristol paper, keeping the lines as light as possible. Then I clean up the drawing with a kneaded eraser.

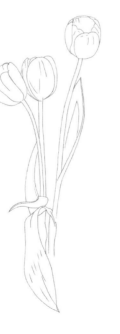

▶ **Step 4** Now it's time to start shading. The light is coming from the left, so I place the shadows and highlights accordingly. Using 2B graphite powder (see page 46), I apply tone to the darkest parts of the tulips with a paper stump. I use curved strokes that follow the form inside the cup and long strokes for the shadowed outer sides of the petals. I apply some graphite to the leaves, then add some tone to the stems near the base of the flower heads.

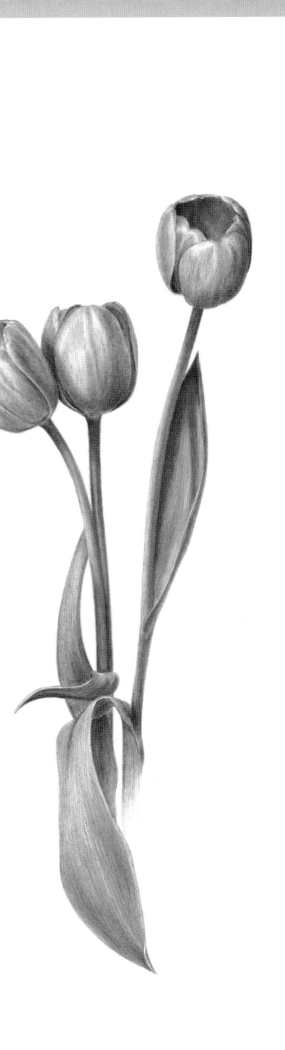

▶ **Step 5** I continue to develop the tone of the tulips with the graphite powder. I add another layer to the open areas of the flowers. I also darken the cast shadow on the middle tulip. Using a larger stump, I further shade the leaves.

▶ **Step 6** I use a sharp HB to continue shading the petals and a 2B for the darkest shadows and the insides of the flowers. I switch to a 2H to further define the petal edges. Then I lift out the highlights on the flower heads with a kneaded eraser. For the leaves, I use a 2B pencil and allow the individual strokes to remain visible to create a leaflike texture. I shade the stems like a cylinder, keeping the side facing the light much lighter. Finally, I look at my drawing in a mirror to view it from a fresh perspective so I can see if it needs any final adjustments.

HIBISCUS

This large, brightly colored flower has a distinct shape that makes it a popular choice for tropical designs and patterns. And the way this bloom's impressive size and rippled petals contrast against its long, slender pistil makes it a perfect reference for a portrait study.

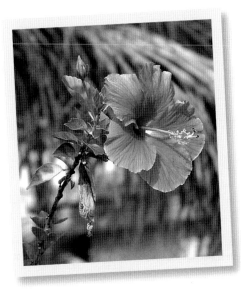

▲ **Taking Advantage of Your Surroundings** This tropical flower is very popular in gardens in Florida where I live. Look to your surroundings for inspiration and potential drawing subjects!

Step 1 I begin with heavy tracing vellum and use an HB pencil to block in the outer shape of the flower using six straight lines. I also block in the general shapes of the leaves and the closed bud. I check the angle of the stem and the distance between the leaves to be sure I have kept the proper proportions.

Step 2 I start to refine the petals, being mindful of their proportions and angles. At this stage, I still use straight lines to suggest the shapes. I draw a polygon to define the center of the flower, parallel lines for the long filament and style, and polygons to block in the stigma and anther.

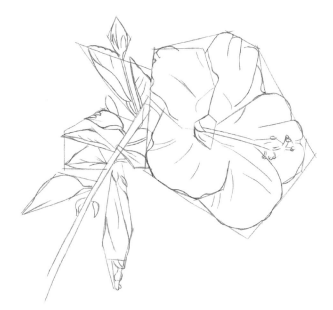

Step 3 Now I indicate the major folds of the petals as well as the details of the pistil and stamen. I also draw the details of the bud and sketch light lines to indicate venation on the leaves. At this point, I take another piece of tracing vellum, place it on top of my drawing, and retrace my lines. When I'm pleased with the outline, I transfer the drawing to smooth-finish Bristol paper. Then, with a kneaded eraser, I clean up any unwanted lines.

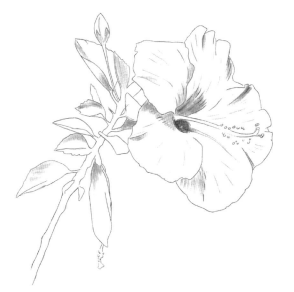

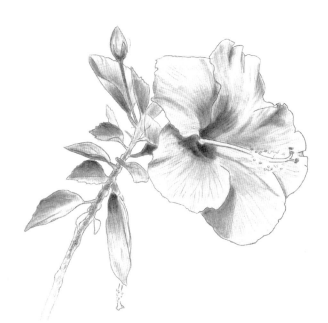

Step 4 To begin working in tone, I dip a large stump into graphite powder and stroke it into the areas that represent the deepest shadows on the petals and leaves. I apply the deepest tone in the center of the flower.

Step 5 After dipping the stump into graphite powder again, I continue adding lighter tone to the petals. I deepen the cast shadows on the petals and the center of the flower, and I do the same on the leaves. For the thin stems and bud, I use the point of the stump to blend the tone and soften the edges.

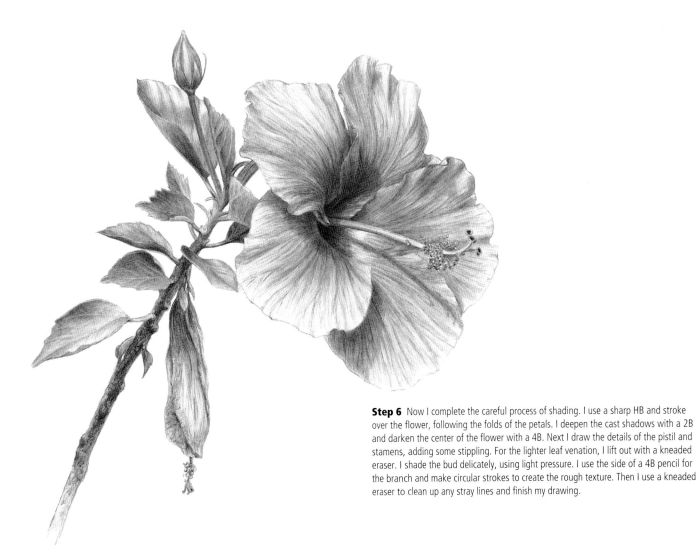

Step 6 Now I complete the careful process of shading. I use a sharp HB and stroke over the flower, following the folds of the petals. I deepen the cast shadows with a 2B and darken the center of the flower with a 4B. Next I draw the details of the pistil and stamens, adding some stippling. For the lighter leaf venation, I lift out with a kneaded eraser. I shade the bud delicately, using light pressure. I use the side of a 4B pencil for the branch and make circular strokes to create the rough texture. Then I use a kneaded eraser to clean up any stray lines and finish my drawing.

ORNITHOGALUM

The ornithogalum is an unusual flower in that it grows on several stalks that extend from the main stem, so each stem holds many flowers. The ornithogalum features bracts, which are colorful, modified leaves. Although it may look very complex, the flower becomes much more approachable when you think of the flowers as being shaped like wide cups.

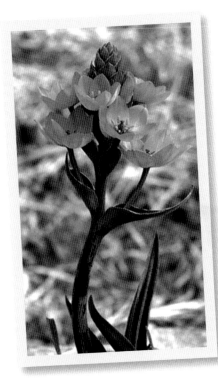

◄ Finding Inspiration
I spotted this flower in a local nursery and couldn't resist taking it home for a "photo shoot." This particular plant has an elegant curve to the stem, which leads the eye up to the naturally formed "bouquet" of flowers.

Step 1 Starting on my tracing vellum, I use an HB pencil to draw the stem and leaves, carefully mimicking the way the stalk bends and forks. The leaves have a triangular shape that ends in a curve. I block in cup shapes to represent the flowers, flattening some and making others more pointed.

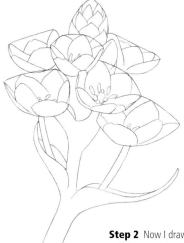

Step 2 Now I draw the individual petal shapes within the guidelines, using curved lines that come to a point. Think of each flower as a cup viewed from a slightly different angle. When the view is from above, the stamens and pistils are visible.

Step 3 I transfer my art to a new sheet of tracing vellum. I erase the guidelines and refine the petals, indicating subtle variations in their curves. I add a few curved lines to show the midline of some of the petals, which also helps give direction to the form. I do the same for the upper cluster. Then I move my work to a sheet of smooth-finish Bristol paper.

56

Step 4 I use graphite powder to apply dark tones on the stem, leaves, and upper part of the stalk. I also add some tone to the shadows on the upper cluster and the visible stigma, as well as to the insides of the leaves.

Step 6 I use a sharp HB to delicately shade the flower petals. I lift out areas that are directly in the light. Then I use a sharp 2B to darken areas of the flowers that are turned away from the light, and I draw the small cast shadows created by the petals. Still using the 2B, I draw the pistil and then use a 4B to add stippling to the anther for texture. Next I switch back to the 2B pencil to shade the upper part of the stalk with curved strokes. I also shade the stem and leaves, using long parallel strokes; then I switch to a 4B for the areas that turn away from the light. I use heavy pressure with the 4B to create the deep tones inside the leaves and for the cast shadows under the flowers. I go over the edges with my HB pencil to delineate the petals.

Step 5 I add another layer of graphite powder for the deepest shadows. Then I add very light tone to the flowers, paying careful attention to where the light hits. I make my strokes follow the form of each object.

WATER LILY

This lovely lily was floating in a small pond near my home. I use mostly horizontal strokes instead of curves for this pretty aquatic plant. The horizontal strokes show the flatness of the huge leaves as they float on the surface of the water.

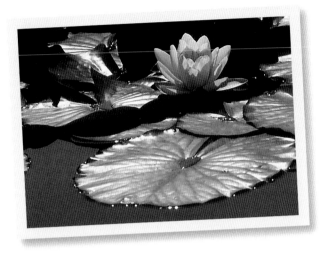

▲ **Revisiting Your Artist's Morgue** It's always a good idea to periodically scan your photo collection, often called an "artist's morgue." Storing your references digitally allows you to categorize and review your collection easily. I had taken this photo so many years ago that I nearly had forgotten all about it!

Step 1 I study my reference to look for the basic shapes; then, using an HB pencil on heavy tracing vellum, I block in the large oval shapes for the lily pads. I see the flower as a rounded triangular form, with two long oval shapes at the base.

Step 2 Using the initial guidelines, I draw the basic shapes of the flower petals. Then I use ovals to delineate the centers of the lily pads where some water collects. I use long wavy lines to indicate folds in the lily pads and then indicate some of the major veins.

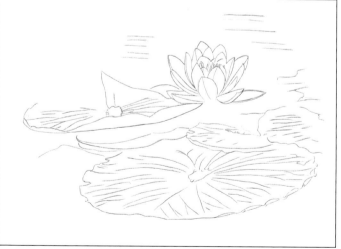

Step 3 Now I transfer the art to a new piece of tracing vellum, excluding the guidelines. I carefully render the flower and the stamens peeking out in the center. I also add the major venation lines of the lily pads and draw in some small circles to indicate the highlights. Then I use a few horizontal strokes to begin the water. Now I move my drawing to a piece of smooth-finish Bristol paper.

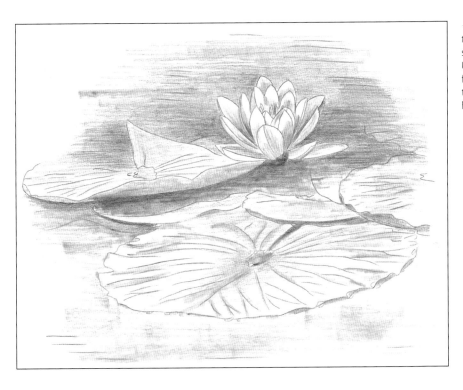

◄ **Step 4** I use a stump and graphite powder to lay down tone across the water and lily pads, always using horizontal strokes. I add a few additional strokes along the venation lines. Using the point of the stump, I lightly shade the flower petals, following their form. I then switch to a 2B pencil and continue to deepen the tones on the water and lily pads, using mostly horizontal strokes.

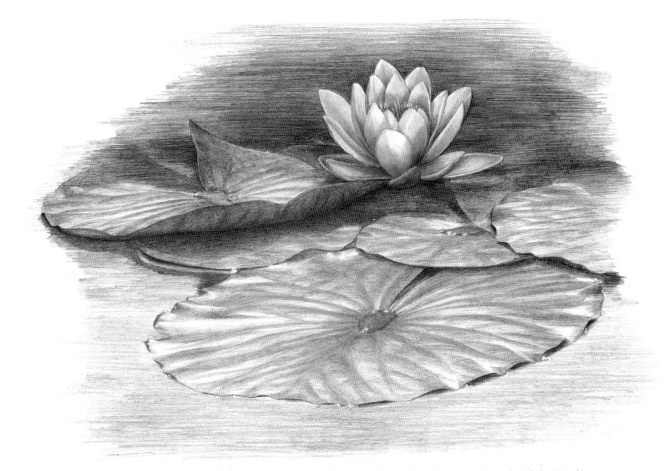

Step 5 I continue to refine and deepen the tones, now using only the pencil and horizontal strokes. I work mostly with the 2B and the 4B, using the HB pencil only for edge details. I shade the flower with an HB and a 2B, again using strokes that follow the form of the petals. I am careful to add the dark shadows where the pads lift up a bit and where they fold. To finish, I lift out the highlights using the tip of a kneaded eraser.

CREATING TEXTURE

Hydrangeas are a sturdy perennial shrub found in many gardens. Their large flowers actually are made of many little florets. Rather than draw each tiny floret, I want to create the illusion that there are many small blossoms. To do so, I use vellum-finish Bristol paper, which has a slight texture; the fine tooth of this paper provides a grainy quality to pencil strokes that can enhance the surfaces of many subjects. In this case, the paper boosts the textures of the flowers and the pot.

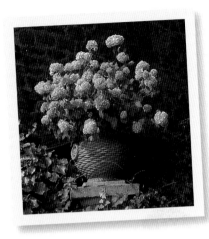

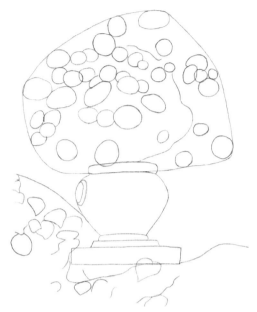

Finding a Good Composition This pretty pot bursting with flowers was sitting on top of a wall covered with vine. The perfect still-life setup was there waiting for me—all I had to do was draw!

Step 1 I begin this drawing on heavy tracing vellum. Picking up an HB pencil, I start with the vase, using a simple outline. I represent the hydrangea with an irregular circular shape. Then I block in bubble shapes to indicate where the flowers will be. Next I add a few heart shapes to represent the leaves.

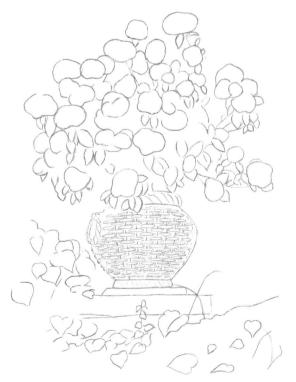

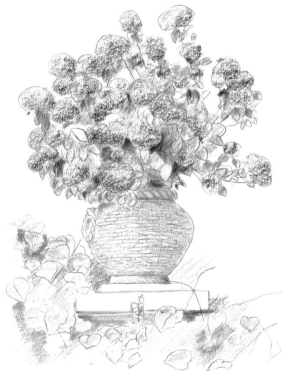

Step 2 I transfer my drawing to a new piece of tracing vellum. Now I create the woven texture of the pot, using small ellipses and lines that curve around the pot. I add more irregular flower shapes and draw the most prominent leaves. I place some leaves and branches for the ivy. Then I move the drawing to vellum-finish Bristol paper.

Step 3 With a 6B pencil, I lightly shade the flowers. Then I darken the shadowed side of the vase. Using the point of the pencil, I add tone to the darkest areas of the leaves. I switch to my stump and graphite powder to smudge the darker leaves. Where the light hits the leaves, I use a lighter touch. I use the same method to smudge the ivy, and I add more tone with a 2B.

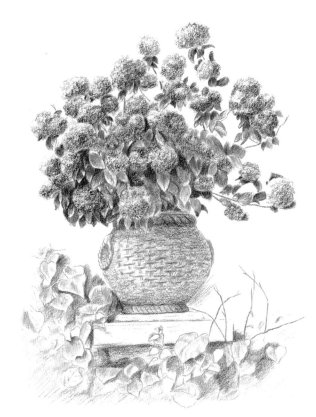

◄ Step 4 Using the 6B, I focus on refining the outline of each individual flower. I use my kneaded eraser to pick out the light areas of the flowers. Then I trace over the outlines of the leaves using a sharp HB. Alternating between a 2B pencil and the point of a narrow stump, I add darker tone to the leaves. I pick out a few light areas with my eraser and then follow the same process to shade the ivy. I add form shading to the vase with a 6B and then draw short, curved strokes with a 2B to create the texture.

► Step 5 I use a dull 6B pencil to stipple additional texture on the flowers. I refine the leaves, adding more detail and tone with a sharp 2B. With a very sharp HB, I reinforce the vertical lines of the weave of the vase. I allow some of the texture to be lost in the shadows. For the ivy, I use a 4B in the deepest shadow areas. I add the details of the leaves with a sharp HB pencil, and then I use a 2B to draw in the branches. To complete my drawing, I add some light diagonal lines along the side of the pot to create the background, adding more depth to the image.

SIMPLIFYING A DRAWING

Looking at a field of sunflowers is like looking at field of happy faces. When choosing a viewpoint for this cheerful flower, I decide on a straight-on view to better capture the flower's personality. Because I want to focus on the unique features of this flower and showcase its character, I simplify the composition and draw just one flower, adding a nondescript scene in the distance for the background.

► **Using Multiple References** I use a composite of three photos for this drawing: one for the flower head, another for the stalk, and another for a background that won't draw attention away from the focal point—the single sunflower.

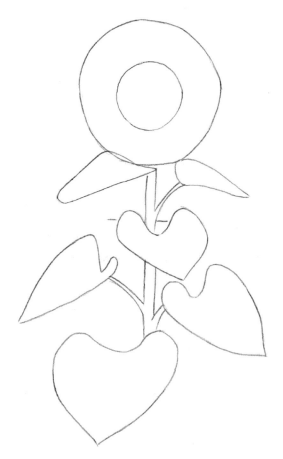

Step 1 I start this drawing on tracing vellum by making a lollipop shape—a circle on a stick—with an HB pencil. Within the circle, I draw another circle to represent the center of the flower. I block in the very large, wide leaves, and I add a horizontal line behind the stem to approximate where I want to place the horizon.

Step 2 I extend the horizon line, making it curvy to represent hills. Then I add a few outlines for the trees in the distance. Next I place a few more details, such as the center veins on the leaves.

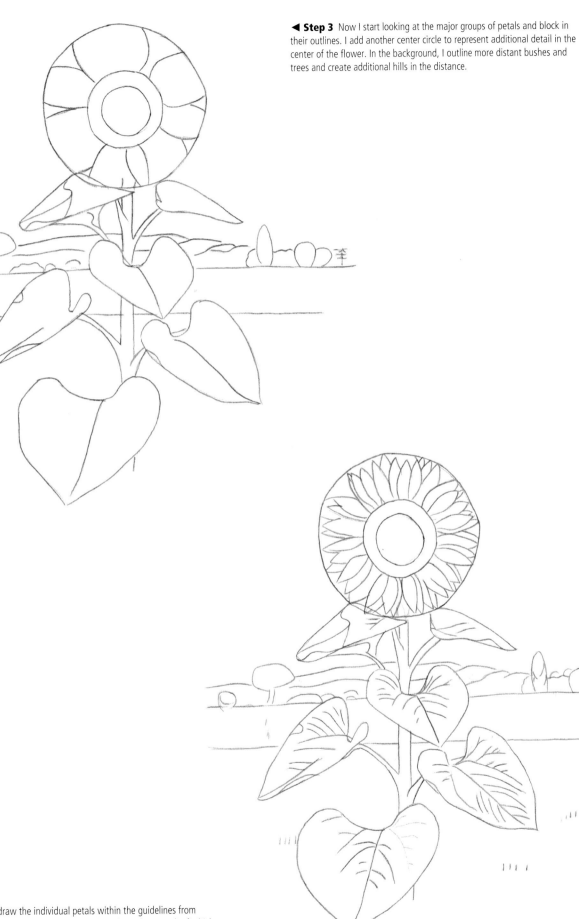

◄ **Step 3** Now I start looking at the major groups of petals and block in their outlines. I add another center circle to represent additional detail in the center of the flower. In the background, I outline more distant bushes and trees and create additional hills in the distance.

▶ **Step 4** I draw the individual petals within the guidelines from step 3. By breaking them into groups, it is easier to keep track of which petals I am drawing. I also add the prominent venation to the leaves.

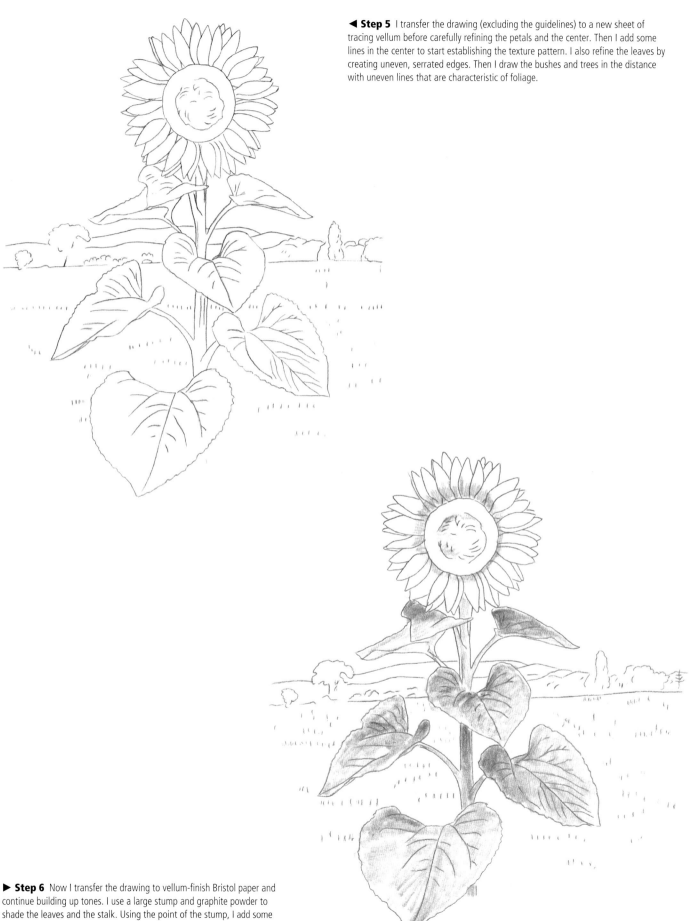

◀ **Step 5** I transfer the drawing (excluding the guidelines) to a new sheet of tracing vellum before carefully refining the petals and the center. Then I add some lines in the center to start establishing the texture pattern. I also refine the leaves by creating uneven, serrated edges. Then I draw the bushes and trees in the distance with uneven lines that are characteristic of foliage.

▶ **Step 6** Now I transfer the drawing to vellum-finish Bristol paper and continue building up tones. I use a large stump and graphite powder to shade the leaves and the stalk. Using the point of the stump, I add some tone to delineate the large shadowed areas of the petals.

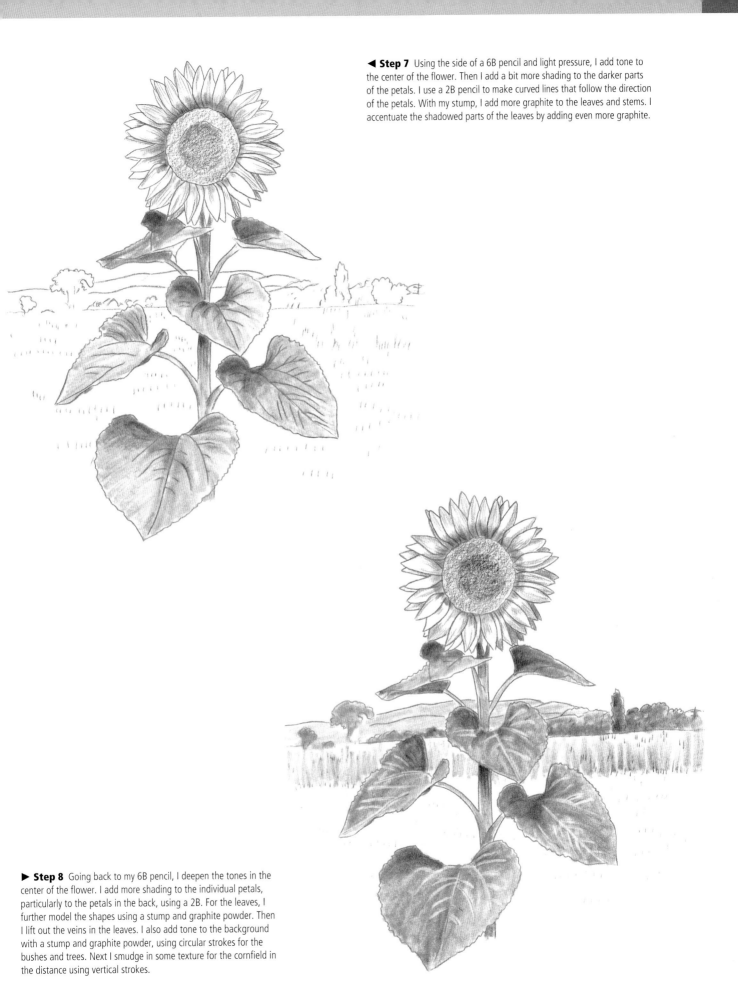

◄ **Step 7** Using the side of a 6B pencil and light pressure, I add tone to the center of the flower. Then I add a bit more shading to the darker parts of the petals. I use a 2B pencil to make curved lines that follow the direction of the petals. With my stump, I add more graphite to the leaves and stems. I accentuate the shadowed parts of the leaves by adding even more graphite.

► **Step 8** Going back to my 6B pencil, I deepen the tones in the center of the flower. I add more shading to the individual petals, particularly to the petals in the back, using a 2B. For the leaves, I further model the shapes using a stump and graphite powder. Then I lift out the veins in the leaves. I also add tone to the background with a stump and graphite powder, using circular strokes for the bushes and trees. Next I smudge in some texture for the cornfield in the distance using vertical strokes.

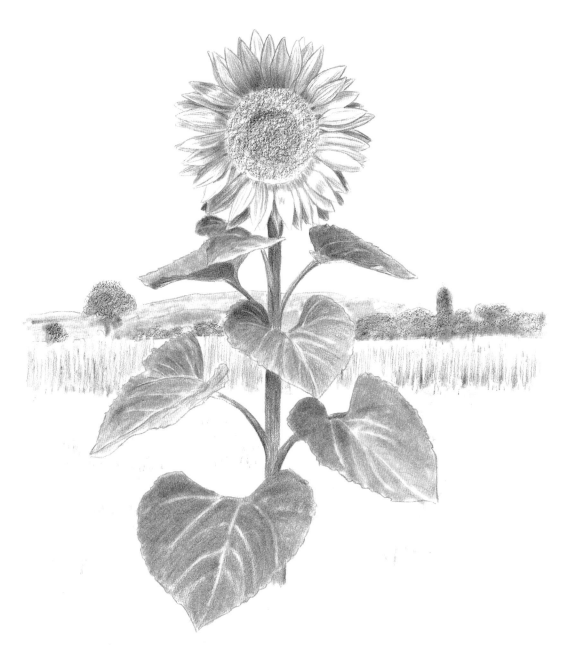

Step 9 I go back and refine the petals with the 2B pencil and the center of the flower with the side of the 6B. I add more tone to the leaves and stems with a 2B, then smear them with a stump. I use my kneaded eraser to again lift out any veins that begin to get lost. I work on the landscape, first with the stump and graphite powder and then with the side of a 4B to add some texture to the bushes and trees. I also add vertical lines to the cornfield using the side of a 2B.

Portraying Distance

Atmospheric perspective dictates that as objects recede into the distance, they become less and less detailed. The illustration here is a good example of this concept. For the foreground flower, I draw every petal with extreme detail. On the middle-ground flower, I roughly draw the petals, but not every single one. For the three distant flowers, I pencil circular shapes, darkening only the centers. The most distant flowers are just stippled dots.

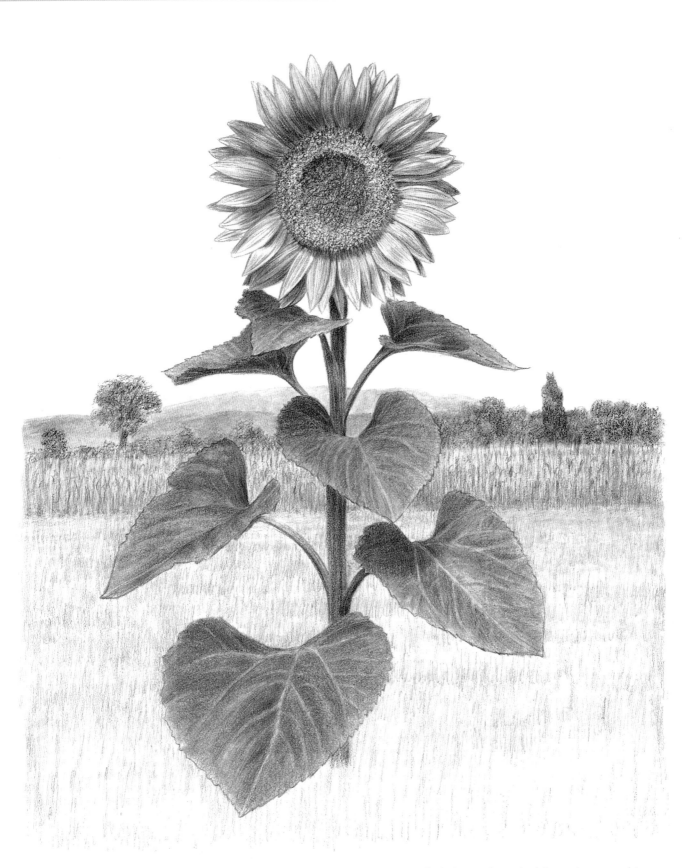

Step 10 Now I refine the drawing by using a sharp 2B to continue modeling the petals. I do the same for the leaves and stems, but I alternate between smudging and using the pencil to achieve a somewhat smoother texture. I accentuate the shadows and use the kneaded eraser to lift out the highlights of the leaves. Then I make short lines to create the small shadow cast underneath the flower's center. I further refine the texture of the center using the side of a 4B. Next I define the distant bushes and trees, still using the 4B, and I add a few branches to the tree on the left. I continue to build up the cornfield texture using both vertical lines and short, curved lines. For the texture of the middle ground and foreground, I lightly smudge some tone and then draw short vertical lines. Lastly, I check for any final adjustments and clean up my drawing with a kneaded eraser.

INCORPORATING INK WASHES

For this project, I want to achieve a soft, dark appearance, so I decide to incorporate an ink wash. The ink wash works like watercolor paint, creating a loose, blended look. I also decide to use vellum-finish Bristol paper to include some built-in texture.

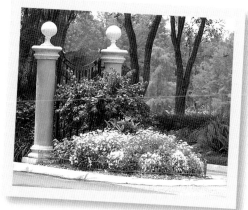

▶ **Taking Advantage of Landscaping** Stylish landscaping is a wonderful source of inspiration for botanical drawings. Often the plants and flowers already are arranged in a pleasing manner, with contrasting textures and values waiting for you to replicate them!

◀ **Step 1** After studying my photo reference, I break down the scene into a few basic shapes on a piece of tracing vellum. With an HB pencil, I block in the groups of flowers and foliage with two large oval shapes. Then I add the tall shapes of the columns. I draw a horizontal line under the trees for the ground and add the general outlines of the two main trees.

▶ **Step 2** I add detail to the columns and break up the foliage by adding smaller ovals to indicate the main groups of leaves and flowers. I create the border around the plants and add a few lines to map out the main shapes of the middle ground. I also add the upper outline of trees in the distance.

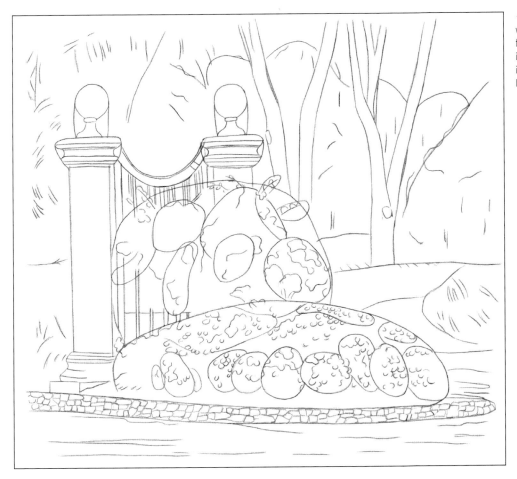

◀ **Step 3** After adding details on the iron work and columns, I further delineate the foliage and flower masses. I use lines to indicate the direction of the foliage masses in the middle ground and background. Then I add the stone detail of the border.

▶ **Step 4** I place another piece of tracing vellum on top of my drawing and trace the scene, leaving out the original guidelines. Then I add some more flowers in the foreground. When I'm happy with the drawing, I transfer it to vellum-finish Bristol paper.

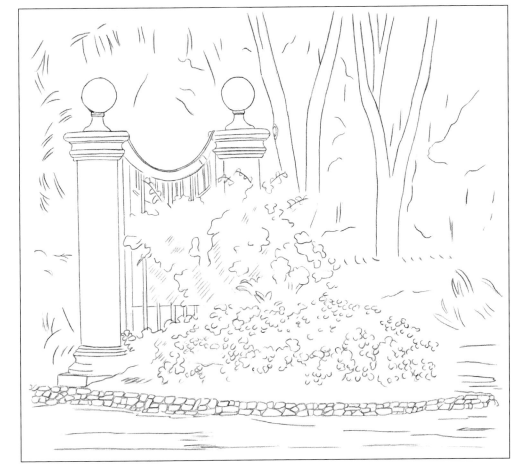

◄ **Step 5** Now I apply an extremely light ink wash over the background area. (See "Mixing Ink Washes" on page 71.) I dilute some India ink with water and apply a thin layer of the mixture over the deeper shadowed areas of foliage. After washing some tone over the two prominent trees in the background, I apply a light wash on the path.

▶ **Step 6** I apply a very light wash to the columns. Then I mix a slightly darker wash (more ink and less water) and apply it to the shadowed areas of the foliage, as well as to the background. I also add some tone over the border stone. I switch to a small brush and use a fairly dark wash to "draw" the ironwork. When the ink and paper are dry, I use a 6B pencil to shade the trees in the background.

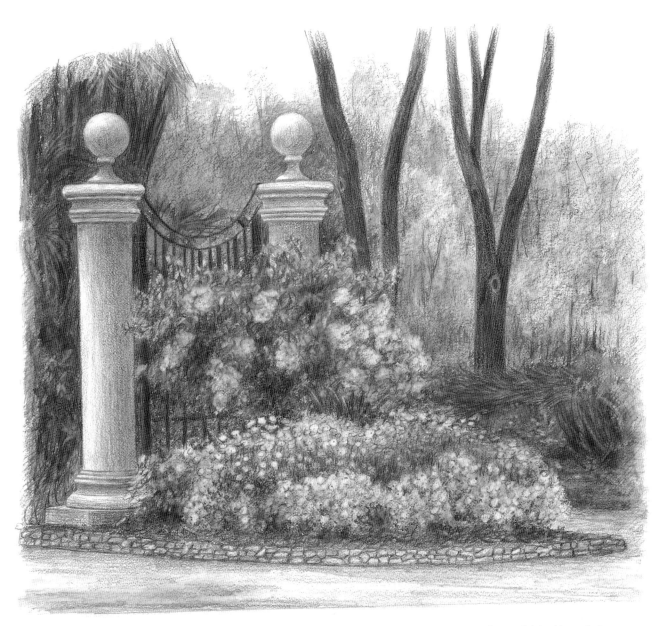

Step 7 I add another dark wash to the darkest areas; when the wash is dry, I finish the shading with pencils. I use the side of a 4B to lightly add some broken tone to the background. I shade the columns using the side of a 2B, switching to an HB for the columns' details. I use a 4B and a 6B to apply additional deep tone to the left side of the drawing and the foliage on the right, just behind the path. With the point of a 2B, I draw some vertical lines to indicate tree trunks in the background. Then I add texture to the two main trees with a 4B. I draw the ironwork with a 2B pencil. For the flowers, I alternate between a 2B and a 4B pencil, and then I lift out tone with a kneaded eraser. I use the point of a 2B to draw more of the stone detail, switching to the side of a 2B to add uneven tone to the stones.

Mixing Ink Washes

Occasionally I use India ink to add dynamism to my drawings. It can be used on its own to create a very black tone or diluted with distilled water to create different values. Adjusting the amount of water you use in your ink washes provides a range of values. When creating a wash, it is best to start with the lightest value and build up to a darker value, rather than adding water to a dark wash to lighten it. To learn how to mix various values, create a value chart like the one shown below. Start with a very diluted wash, and gradually add more ink for successively darker values.

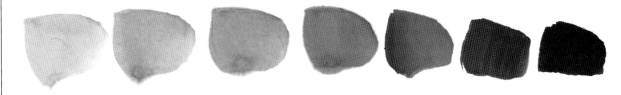

APPROACHING ARRANGEMENTS

When creating an arrangement of mixed flowers, I like to use a variety of shapes to build an interesting composition. By combining long, thin plants with leaves, flowers, and buds, my composition gains variation in height, depth, value, and texture. Don't be afraid to work with several different elements; everything can be broken down into simple shapes.

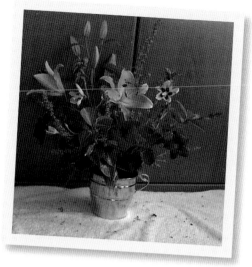

▶ **Keeping It Simple** When setting up a floral still life, keep the ground, background, and even the vase simple, using textural qualities that won't overwhelm the flowers.

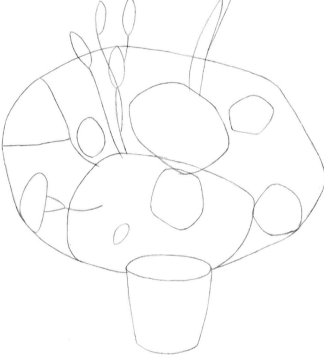

◀ **Step 1** Using my photo reference, I analyze this rather complex arrangement by looking for the largest basic shapes created by the flowers and leaves. On a piece of tracing vellum, I use an HB pencil to draw a simple cup shape for the copper pot and a large oval for the mass of foliage and flowers. I make sure the proportion of this shape is correct in relation to the size of the pot. Then I draw smaller shapes for the larger masses of leaves and flowers.

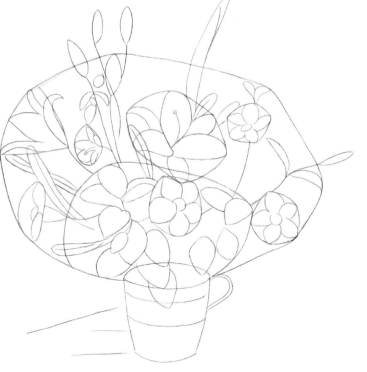

▶ **Step 2** Now I start to block in the main details, beginning with the basic shapes of the flowers. Then I draw the most prominent leaves. I also add long cigar shapes to represent the lavender stalks. I add the handle and a few more details to the pot and establish the angle of the cast shadow.

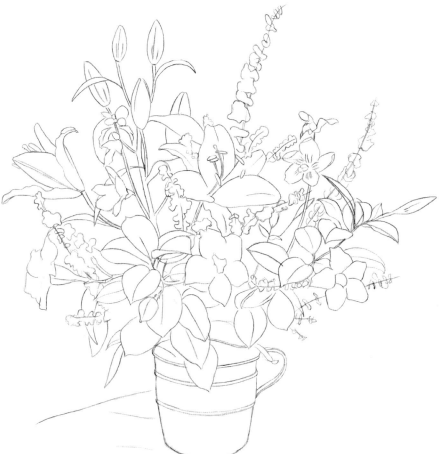

◄ **Step 3** I take a new piece of heavy tracing vellum and place it on top of the initial drawing. Using the previously drawn areas as a guide, I create a very detailed drawing of the flower arrangement. I draw the shapes of the lavender, add detail to the buds, and carefully refine the petals. Then I add more detail to the leaves and draw some of the smaller leaves. I also draw a few more lines to indicate the details of the pot.

▶ **Step 4** I transfer my drawing to a sheet of smooth-finish Bristol paper and erase any unwanted lines, and then I look at the arrangement while squinting. This blurs the details and helps me see the variations in value. Using a large stump and graphite powder, I place some tone where I see the deepest values, mostly at the base of the foliage.

Step 5 I return with the stump and graphite powder and begin to establish a darker tone for most of the leaves, except where they are in the strongest light. I darken the shadowed foliage, and then I use a smaller stump to apply some tonal variation to the buds and the flowers. For the lavender stalk, I use a 6B pencil and make small, irregular, circular strokes. Using the large stump again, I begin to add tone to the shadowed side of the pot.

Step 6 Now I use a 2B pencil to deepen and refine the tones. I start with the darker leaves, using strokes that follow their forms. With tiny circular strokes, I add tone to the stamens. Then I shade the buds and the lighter flowers with an HB pencil and a very light touch. Using the side of a 2B and very short, quick strokes, I create a rough texture for the lavender stalks. For the pot, I use long, curved strokes, paying attention to the distinct reflections of the metal. Where the light hits the pot, I leave the paper white. (See "Reflective Surfaces" on page 75.)

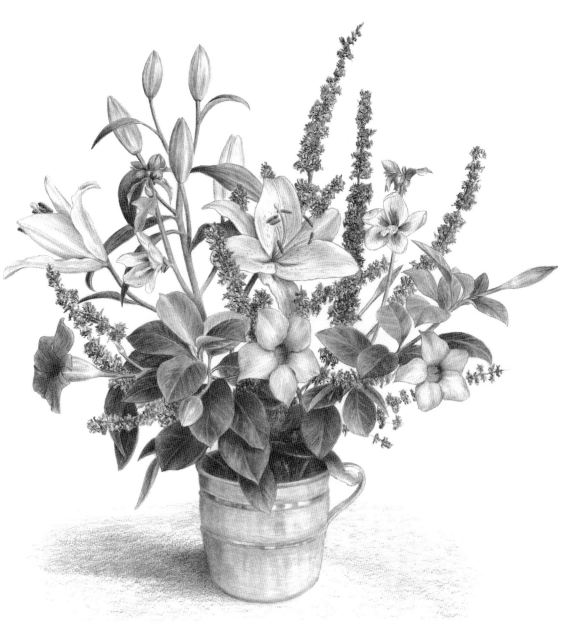

▶ **Step 7** I continue refining the drawing, alternating between an HB for lighter tones and a 2B for darker tones. For the darkest areas, I work with both a 4B and a 2B. I also refine the pot, working with an HB for sharp details and a 2B for darker tones. With an HB pencil, I stipple the spots of the lily. For the leaves, I alternate between shading with a 2B and lifting out tone with a kneaded eraser to create the venation. I lightly shade the cloth with the side of a 6B, allowing the grain of the paper to break up the strokes. When I am satisfied, I erase any stray marks.

Reflective Surfaces

To capture the realistic surface of a vase, it is important to study how the vase reflects light. The highlights on an object help give it form and depth and define its shape. On shiny objects, such as glass or polished metal, highlights are very distinct with sharp edges. On dull materials, such as wood or unglazed ceramics, the highlights are not well-defined. Try setting up a metal object under a strong light and look for the highlights. Replicate the highlights in your drawing, either by leaving that area of the paper white or lifting out tone with an eraser. Here the first vase is slick and has a sharp, defined highlight, whereas the second vase is dull and the highlight is very blurry.

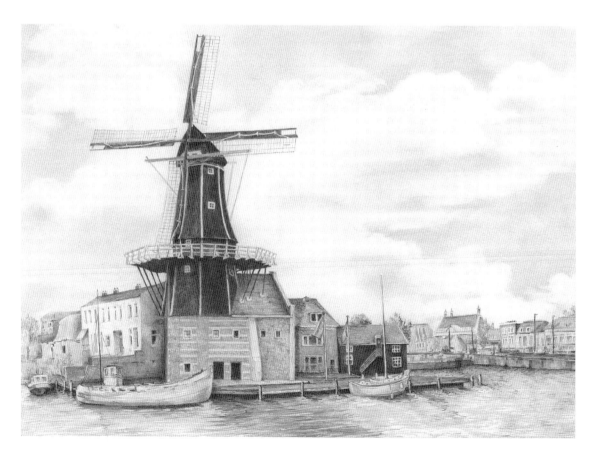

CHAPTER 3

BEAUTIFUL LANDSCAPES

with Diane Wright

Discovering a passion for your subject matter is the first step in expressing yourself through art. Really observe the scenery around you; take a child's viewpoint and see anew. Drawing what you see every day is so important—all those underlying feelings can't help but be reflected in your artwork.

The next step in learning to create art is choosing a medium. I use graphite pencil for my finished artwork—it is simple and direct and an incredible tool for artistic expression. The pencil is an extension of the hand, and the flow to the paper is seamless. Effective use of value and textures can evoke as much color and drama as any painting. The black-and-white graphite medium also has a timeless quality to it. The process of drawing provides learning opportunities, appreciation for the wealth of detail in the world, and a feeling of personal connection to a landscape. I love what I can achieve with just a pencil.

Drawing landscapes can seem intimidating, but it becomes much easier by breaking down each element into separate, more manageable tasks. Before you know it, a landscape will unfold before your eyes. The goal of this chapter is to review each aspect of drawing landscapes, one step at a time. By sharing my personal approach and techniques with you, we are going to explore creating beautiful landscapes together. The world is ready and waiting to be drawn.

—*Diane Wright*

Diane Wright received a bachelor's degree in fine art with a teaching certification from the University of Northern Iowa in 1981. With her children, Matt and Becky, in college, Diane keeps busy with creating commissions, selling her artwork on her website, building online tutorials, and conducting drawing classes. She also provides printing services for graphite artists. Diane and her husband, Les, reside in Mitchellville, Iowa.

TEXTURE

The concepts of light, shadow, and texture are closely related. You have to understand the effects of light and shadow to create the illusion of texture in a drawing. By cleverly applying highlights (light) and shading (shadows), you can depict any texture—from rough wood and craggy rocks to wispy grasses and rippling waters.

Smooth, shiny surfaces like metal or glass have little or no texture, so the pencil strokes should be as smooth and fine as possible. The highlights and shadows on smooth surfaces generally have sharp, distinct edges. On the other hand, rough textures, such as rusted metal or certain types of rocks, are dull with small pits in the surface. As light hits each of the small pits, a tiny cast shadow is thrown, so the pencil strokes should be irregular with varying values. Highlights and shadows on rough surfaces generally have softer, more indefinite edges.

Wood

Although it is tempting to use the blending method (see page 7) to get an even-toned value for a texture like wood, it is not the best way because blending will dissolve any details that you have worked so hard to develop. Use the burnishing method instead to create the illusion of wood grain—simply apply a harder lead over a softer lead for a smooth look.

▶ **Burnishing** For the first layer, use a 2H lead and vertical strokes. To create the second layer, use an F lead to draw the horizontal lines of the grain, as well as knots and nail holes. Finally, use a 6H lead to burnish an even layer of tone over the first two layers. Add details as needed and lift out highlights using a tacky eraser.

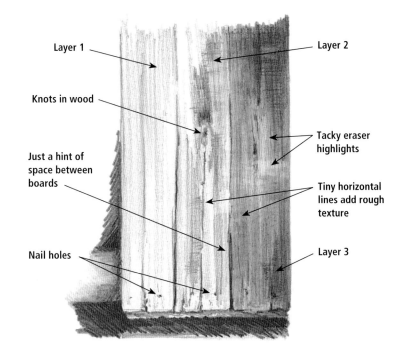

Layer 1

Knots in wood

Just a hint of space between boards

Nail holes

Layer 2

Tacky eraser highlights

Tiny horizontal lines add rough texture

Layer 3

Rocks

Reducing the forms of rocks to their most basic shapes—rectangle, circle, or triangle—will give you a perfect base to build on. You can then "morph" the shapes into angular planes and indicate reflected light and cast shadows for depth.

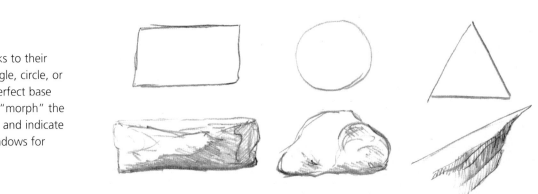

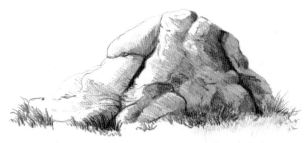

Identifying Basic Shapes This rock cluster is much easier to create once I have determined that the basic shape of the rock is round.

GRASS

With some experimentation and practice, you can achieve effective results when drawing grass. By creating multiple layers, you can achieve a sense of depth. Here are four points to consider: (1) Draw the shadows behind the grass to quickly create distant grass. Just suggest the grass with a few spikes. (2) When drawing foreground grass, provide enough detail to keep the viewer's interest without drawing every single blade. Showing spaces between the weeds and overlapping the layers helps create foreground grass. (3) Use different textures to depict various species of grass and weeds. Introducing a few broadleaf weeds among bunches of long grass can add variety and interest. (4) The direction in which weeds are drawn is an effective and subtle way of leading the viewer's eye through the drawing and can really bring a whole scene together. Never let your weeds point out of the picture plane, as this will also lead the eye right out of the picture.

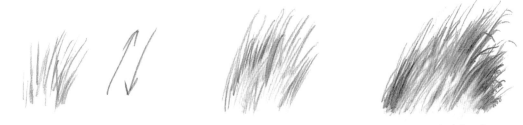

Grass Use layers of vertical pencil strokes to show patches of long grass. Pay careful attention not to create a single line of grass. Working from back to front and drawing the shadows between just the tips of the weeds creates a flowing patch.

Water

By overlaying horizontal pencil strokes, you quickly can create an effective representation of still water. Exaggerating the rocking motion suggests waves. Add more layers with defined highlights to show reflections in the water.

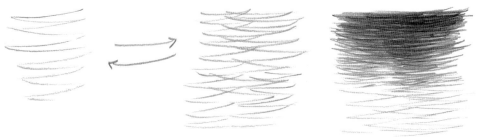

Creating the Feel of Motion Use a horizontal, back-and-forth stroke to depict moving water.

Contrasting Textures

This rendering of a brick wall is a good example of contrasting textures in a composition. The slick, smooth texture of the window nicely contrasts the rough texture of the bricks. I use a circular motion and burnishing to create the rich, even texture for the window, and I use reverse burnishing (applying a soft lead over a hard lead) to create the uneven texture of the bricks. By emphasizing the extremes of texture, the brick wall takes on a dramatic, sun-baked atmosphere.

DRAWING TREES AND FOLIAGE

Trees and foliage are some of the most challenging and complex objects to draw—but nothing can add more expression, mood, and life to a drawing. Combining a philosophy of practice, patience, and perseverance with the texture basics covered on page 78 will give you the stepping stones to explore and draw the awesome beauty of trees. It's important to study trees and understand their differences before drawing them, so use the examples on the next five pages to become comfortable with depicting these essential aspects of landscapes.

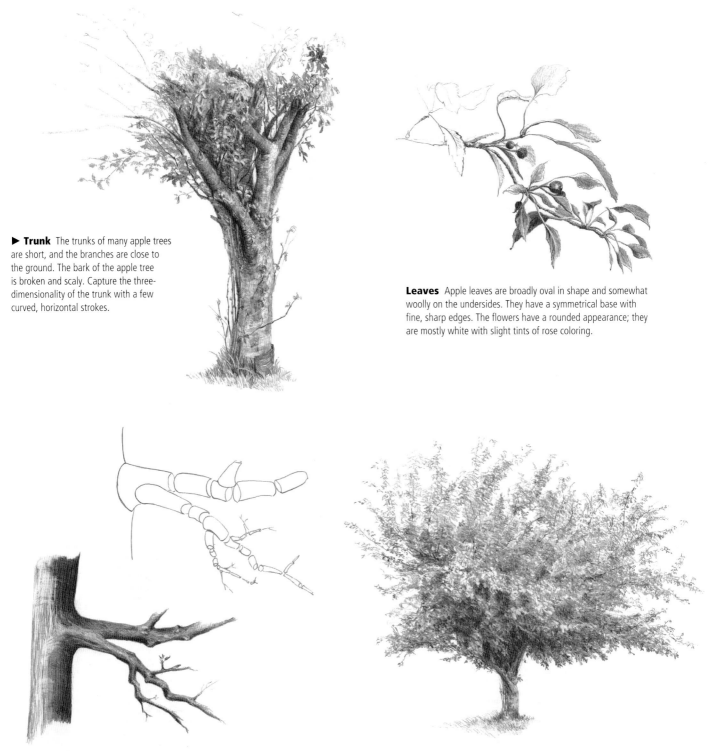

▶ **Trunk** The trunks of many apple trees are short, and the branches are close to the ground. The bark of the apple tree is broken and scaly. Capture the three-dimensionality of the trunk with a few curved, horizontal strokes.

Leaves Apple leaves are broadly oval in shape and somewhat woolly on the undersides. They have a symmetrical base with fine, sharp edges. The flowers have a rounded appearance; they are mostly white with slight tints of rose coloring.

Branches Depicting branches as cylinders is an excellent exercise. By shading and creating texture, the cylinders evolve into realistic, three-dimensional tree branches.

Overall Appearance Correct proportions and angles convey a tree's unique characteristics. Use the texture of the bark to provide the illusion of a cylindrical object. Be conscious of the type and shape of the leaves and how they attach to the branches. Apply light and shadow consistently for realism.

▲ Capturing the Essence The term "strength" best expresses the large, solid, and robust stature of oak trees. There are many spaces between branches, which make it easier to study the armature (structure). In this tree study, I exaggerate and accentuate the unique curvature of the main trunk with special attention to the flow of the branches, emphasizing and de-emphasizing areas to complement and show off Mother Nature's handiwork. After carefully sketching the branches with all their intricate curves, I use a 4B lead to boldly draw them with one stroke. I add the small leaf bundles with the scribble method, keeping them close to the trunk.

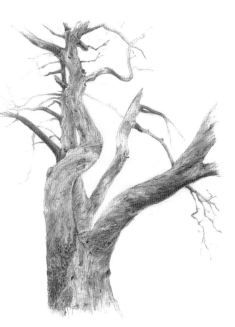

▶ Tree Anatomy
Drawing a bare winter tree is an excellent way to learn the anatomy of a tree. Pay particular attention to how each limb attaches to the trunk, each branch to its limb, and each twig to its branch. A common mistake in drawing branches is to make them too straight. Details like knots, kinks, and bends add life. Observe the spaces between the branches and follow every branch through. Don't let a branch grow out of nowhere or at an unrealistic angle.

Pinecone

Pine needles

◀ Oak Tree Bark Oak tree bark is deeply furrowed. It is enjoyable to follow the interesting patterns and flow of the bark. To draw this bark, I use a 2B lead, followed by 4H and 2H chisel-point leads to create the even midtone shadows.

▲ Pine Trees Pines are distinctive trees with needles, cones, and unique shaping. Pine trees have a natural calming effect and make great supporting backgrounds for landscapes.

▶ Oak Tree Leaf First I indent the fine leaf veins into the paper using the metal tip of a mechanical pencil with the lead retracted. After drawing the outline of the leaf, I place the paper on a hard surface and press the metal into the paper where I want the veins to be. When I shade over the indentations, thin white lines appear. (Practice this on scrap paper first.) For the texture of the leaf, I use a hard 2H chisel-point lead to apply one layer and then a softer F lead to apply another layer in a random, circular motion. A light touch of tacky eraser brings out the highlights, and a battery eraser adds light flaws.

◀ Grounding a Tree If the tree you are drawing doesn't have a solid foundation, it will look like it is floating on the paper. So how do you plant the tree firmly in the ground? Here are some tips: (1) Draw grass around the roots and behind the tree; (2) use shading to develop the form; (3) flange out the base of the tree; and (4) show parts of the roots.

DRAWING LEAVES

How do you create the illusion of leaves without drawing every leaf? Simply concentrate on the shadows and textures and not on the individual leaves. Define the leaves by filling in the areas around and between them (negative drawing). Below is a three-step illustration that shows my method of drawing leaves.

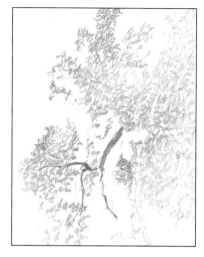

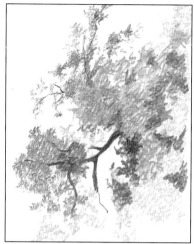

Step 1 Using the underhand grip (see page 7) and a scribbling pencil stroke allows me to create controlled marks on the paper. This first layer is a general shaping of the tree and leaf bundles. I identify and sketch the branches that are not hidden by leaves.

Step 2 I start building layers, slowly working my way from the darkest shadows to the lighter areas.

Step 3 With each layer, I add more definition, texture, and structure to the leaf bundles.

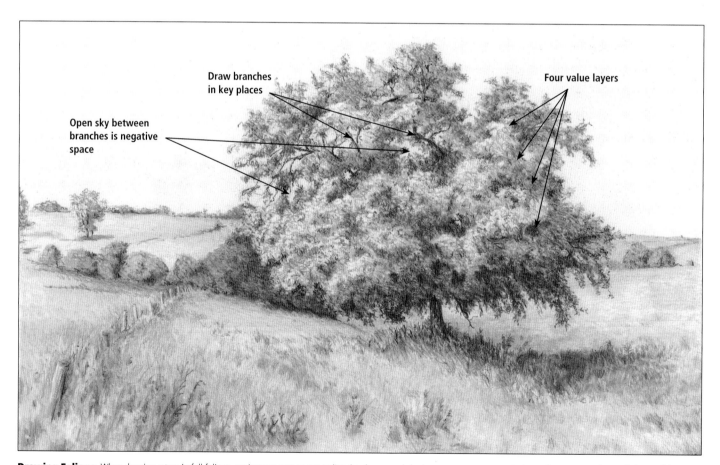

Draw branches in key places

Four value layers

Open sky between branches is negative space

Drawing Foliage When drawing a tree in full foliage, squint your eyes to generalize the shapes and shadows so you can concentrate on the texture and overall shape of the leaf bundles. The distance of the tree—background, middle ground, or foreground—determines the amount of detail to include. The direction of your light source will determine the highlights and shadows.

SKIES AND CLOUDS

"There aren't any clouds in the sky, so why should I shade it?" I used to ask myself. Many of my earlier works do not include a toned sky. But I have learned that adding values to the sky broadens the range of tones available in a drawing. The white of the paper can be used to represent highlights or sun-kissed areas. A sky tone lends uniformity to a composition, adds a sense of reality, and provides atmosphere. Don't underestimate the importance of the sky, as it offers many moods that will impact the feeling of your drawing. Whether they're soft and misty or dramatic and cumulous, I create clouds by following the four-step progression shown below.

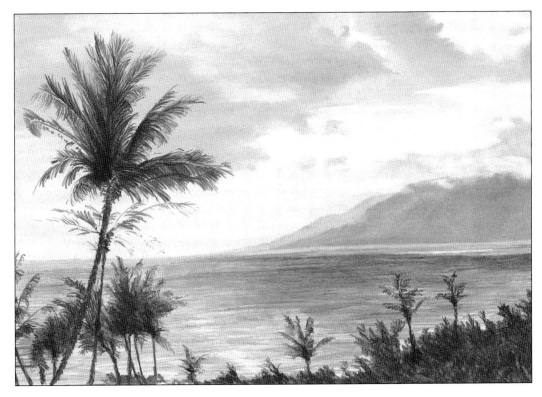

◄ **Backlighting** This tropical sunset scene is a wonderful example of backlighting. The sky grows lighter as it approaches the horizon, and the clouds are backlit as the sun sets.

◄ **Step 1** I lay down a light layer of crosshatching using an F or B lead. Using the loose-hold grip (holding the pencil loosely between my thumb and first two fingers) and allowing the weight of the pencil to determine the pressure of the pencil stroke creates an even layer. I crosshatch three to five layers.

◄ **Step 2** I use a chamois in a light, circular motion to create a smooth, even base, taking care to avoid overburnishing the paper. (Flattening the paper fibers will prevent building additional layers of graphite.)

◄ **Step 3** After the sky is blended smooth, I use a plastic eraser and sculpt out the clouds. Then I use the tacky eraser to create soft edges for the wispy clouds.

◄ **Step 4** Now I layer graphite and blend with a tortillon to build up the cloud formations. When I have completed the sky area, I use a plastic eraser and a T square to clean up the edges and borders.

KIRKWALL HARBOUR BASIN

Fellow artist Jim Fogarty sent me this beautiful photo of Kirkwall Harbour Basin in Scotland. The buildings in the background and the water in the foreground make up two of the three distinct surface planes in this scene. These are secondary or supporting components of the drawing. The middle-ground plane containing the boats holds the detail as well as the central focal point.

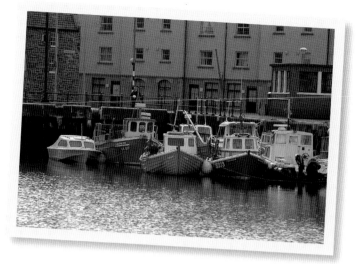

▶ **Adjusting a Scene** In the reference photo, the two boats in the center are the same size; to add a little more variation, I slightly enlarge and bring forward the one on the left.

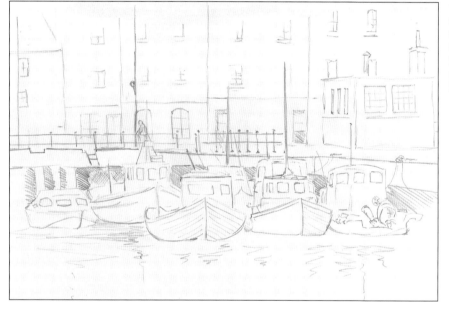

◀ **Preliminary Sketch** With a 2H lead, I lightly sketch the outlines of the boats and buildings on a sheet of tracing paper. Then I transfer the sketch to smooth-finish Bristol paper as described on page 5. I use an HB pencil and take care not to use too much pressure, as I don't want to leave any hard lines on the art paper.

▶ **Step 1** I use the retracted metal tip of a mechanical pencil to indent lines into the paper where two thin anchor ropes string across the fronts of the boats. When I shade over them later, they will remain white. (See "Oak Tree Leaf" on page 81.) I shade the boat in the front center first, using an F .5 mm mechanical pencil and strokes that follow the curves of the hull. Focusing on the cab, I lightly sketch the windows with a 2H pencil and a circular stroke, and I lay in some shadows with a 4H lead. Then I use a tacky eraser to lift out window reflections, and I create the general shapes inside.

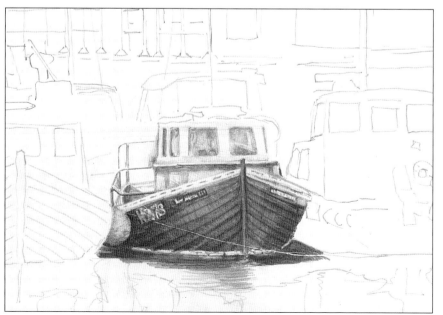

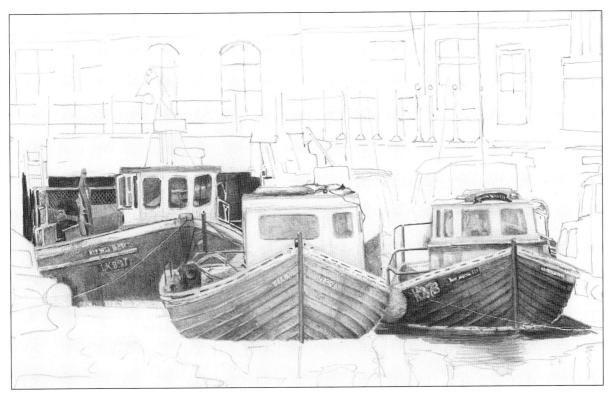

Step 2 I shade the front left boat using the same method as in step 1 but with lighter values and less pressure. Then I move to the second boat from the left in the back row, which has wire mesh at the back that is lighter than the background. I use a form of indenting here: I take a 6H .5 mm mechanical pencil and draw each line of wire with firm pressure. Then I use a B lead and shade over it. The wire mesh appears as a lighter value but not white like the anchor ropes in step 1.

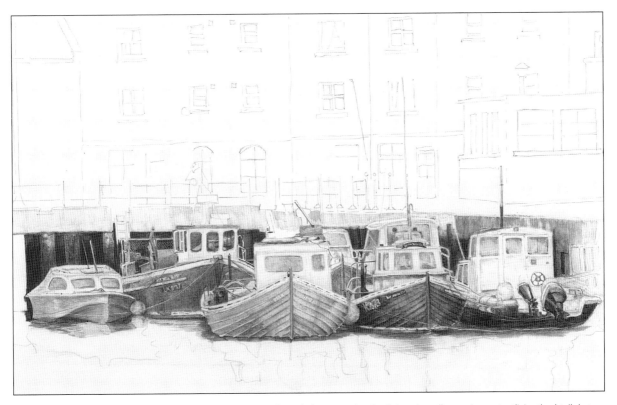

Step 3 As I shade each boat, I concentrate on the negative shapes. This is the key to creating details in such small areas. I am not outlining the details but rather shading around the lighter sections. I start shading the background behind the railings, leaving the railings white. Then I use a 4H to lightly shade the undersides of the boat railings, making them appear cylindrical. Returning to the boats, I simplify some of the details and try to capture just enough so the viewer can interpret the rigging and fishing equipment on the boats.

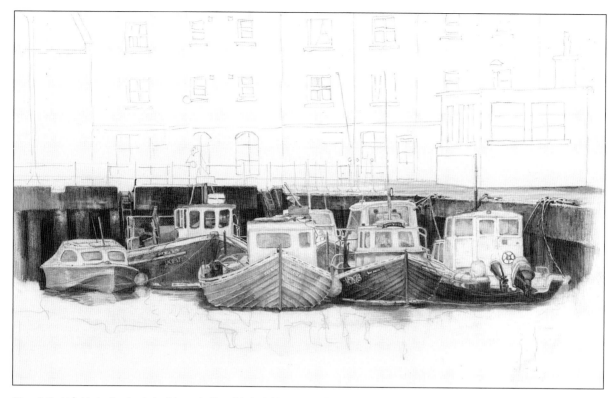

Step 4 Next I finish shading the dock edging and pillars. (Much of this area was already laid in as I detailed the boats.) The dark background helps push the lighter boats forward. Now I take the time to ensure that the dock is straight and that the perspective is correct. Then I create the concrete sections of the dock, using an HB lead with a downward vertical pencil stroke. I lift out the highlights with a tacky eraser, build up the darkest areas between the pillars with crosshatching and a 2B lead, and add the dock flooring with horizontal strokes using a 2 mm clutch pencil with a chisel-point 2H lead. I also add the coiled ropes on the right side, using an H .3 mm mechanical pencil in the shadowed areas.

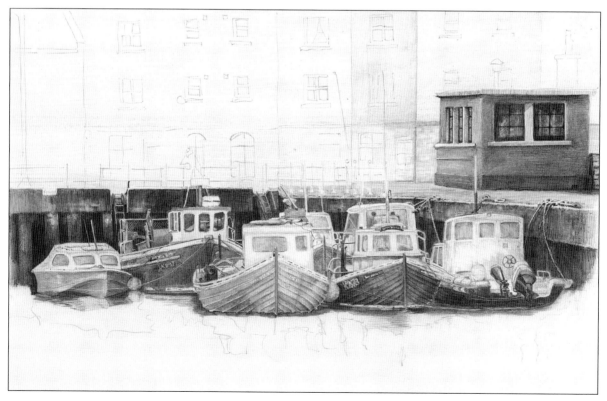

Step 5 For the building on the right, I use a T square to make sure the walls and window frames are vertical and straight. Then I render the solid, midtone grays using an F lead for the base layer, followed by a 2H burnished layer. I lift out the window reflections with a tacky eraser.

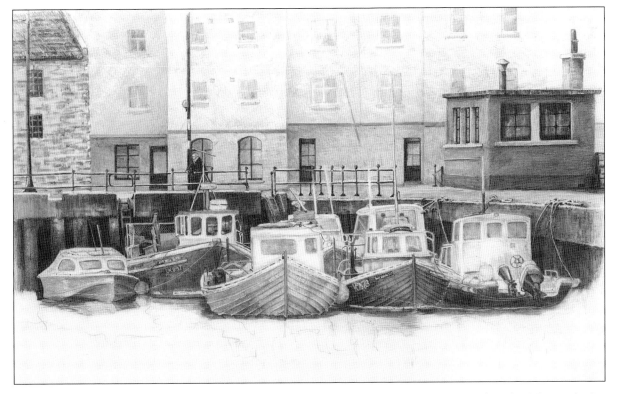

Step 6 I don't want to include all the details of the building in the background, as they would compete with the boats, so I leave the windows nondescript on the top and a bit more solid on the first floor, deciding to omit two windows. I use random crosshatching and a 2 mm clutch pencil with a chisel-point 4H lead for a stucco texture on the upper half of the building, switching to a 2H lead in the clutch pencil for the lower half. Slightly more pressure and more layers create light shadows on the walls. The lone human figure leaning on the railing along with the stone building at left provide just enough darks to counterbalance the building on the right. I shade the stone building first with a 2 mm clutch pencil and a 4H lead, followed by short, broad strokes with a 2 mm clutch pencil and a B lead.

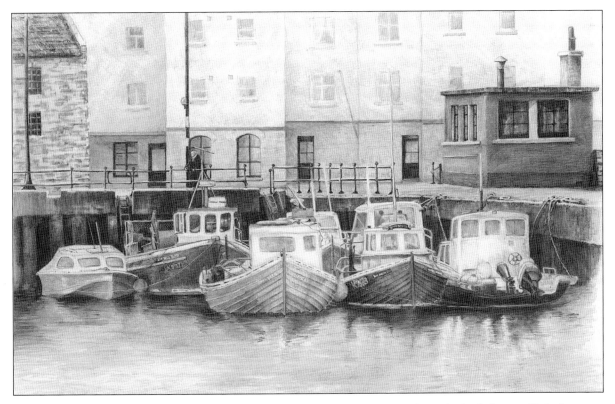

Step 7 To create the foreground water, I use a 2mm clutch pencil with a 2H chisel-point lead and the rocking stroke described on page 79. For the shadowed areas of water near the boats, I use a 2 mm clutch pencil with a 2B lead. I leave the water with minimal reflections and waves so it doesn't compete with the boats. To emphasize the soft, hazy effect of the drawing, I gently fade away the edges of the drawing.

HOUSE PORTRAIT

Many homeowners enjoy drawings that capture the beauty of their homesteads and all the memories that they invoke. After talking to the owner of a house I wish to draw, I try to channel the homeowner's pride and enthusiasm into my drawing, as my goal is to capture the essence of the home. This house, a beautiful Queen Anne Revival, was built in the late 1890s.

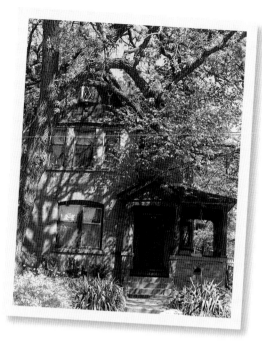

▶ **Creating a Mood** The close cropping of the house creates an intimate setting for this quaint scene; the porch invites the viewer right into the drawing. The tree arching over the front of the house and its strong cast shadows are added bonuses to this charming composition.

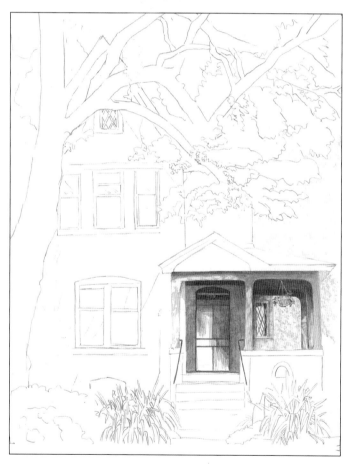

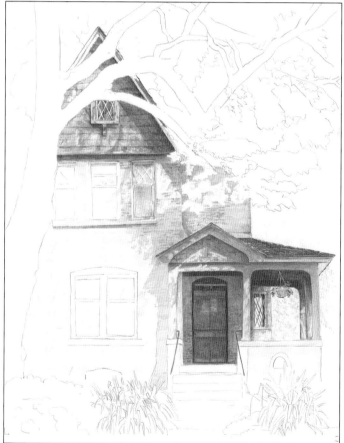

Step 1 After transferring my sketch of the house and foreground vegetation to smooth-finish Bristol paper, I use a 2 mm clutch pencil with a 2H lead to add just a hint of trees behind the house. I create the darkest part of the porch with a 4B .5 mm mechanical pencil. I switch to 2B and B leads as the tone of the porch supports lightens. I apply smooth, even shading inside the porch so there aren't any visible pencil strokes. I lift out the areas where the sunlight is cascading across the surfaces using a tacky eraser. I use a T square to make sure the doorjamb is perpendicular and straight, but I lightly draw the lines and then freehand over them. I don't want the perfect straight and rigid lines created by the ruler but rather the softer, less precise lines that freehand drawing provides.

Step 2 Light and shadow are not the only aspects that determine the tone of an area—color is a consideration as well. The gable of this house is a dark green that becomes a rich, dark value when seen in black-and-white. I usually draw from color photos for this reason and use a black-and-white reference only to match values. To capture the tone of the gable, I shade it with heavier pressure. Then I use a 2 mm clutch pencil with an H lead to block in a light layer of graphite on the rest of the house. I begin to lay in shadows on the roof and fascia with 2B and HB leads. Using a battery-operated eraser, I lift out the areas where the fascia is splashed with sunlight, softening up the edges of the erased sections with a light touch of graphite.

▶ **Step 3** I suggest the bricks with horizontal strokes, using a 2 mm clutch pencil to burnish a softer 2B lead over a harder 6H lead, creating an uneven texture. I add just enough detail to give the impression of bricks. Next I use heavier pressure and an H lead to add more of the shadows cast by the branches and leaves. The key to making realistic shadows is to make them conform to the underlying object so they become a part of it. I keep the window treatment simple—only an impression of window edgings and curtains is needed. I use a 2 mm clutch pencil with an H lead to create a smooth surface for the windowpanes and then add shadows from the tree branches with an HB lead. I lift out reflections using a tacky eraser. Then I draw the bushes and plants by shading the negative shapes around them with an HB .5 mm mechanical pencil. I lightly shade the centers of the plants with a 2 mm clutch pencil and a 2H lead, leaving the tips lighter to show that they are in direct sunlight. I use a 2B .5 mm mechanical pencil to draw the darker plants in the background with scribble strokes.

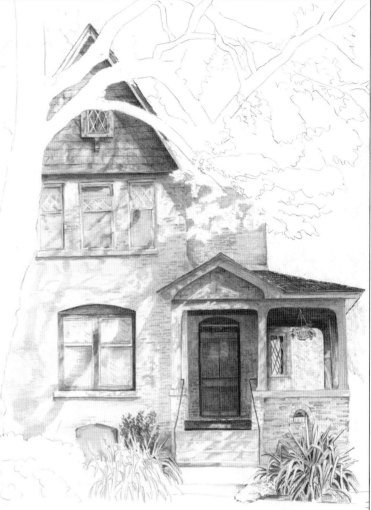

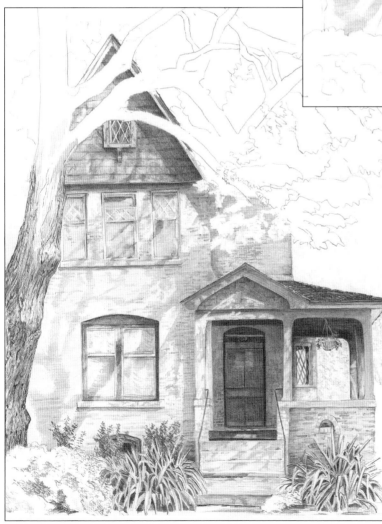

◀ **Step 4** The old oak tree adds a lot of character to this scene. The grooves in the oak bark are strong. Without drawing every groove, I am able to create enough texture to give the impression of the rough nature of the bark. I achieve this by using a 2B .5 mm mechanical pencil. I make the grooves in the bark closer together at the edges where the bark wraps around the tree. This provides the general three-dimensional cylinder effect of the tree trunk. I lay down the overall shading of the trunk using a 2 mm clutch pencil with an HB lead. Then I begin touching in shadows to the bush at the base of the tree.

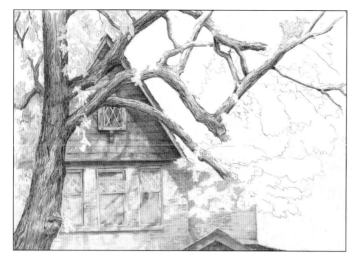

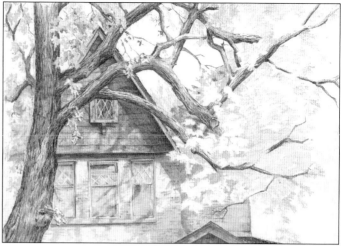

Step 5 When shading the branches of the oak tree, I use a 2B lead, keeping in mind that the branches are stocky and angular. I pay careful attention to the joints of the branches, also remembering that the bark is rough and visible even on the smaller branches. With an F .5 mm mechanical pencil, I continue to apply consistent shading on the underside of the branches to create a uniform light source.

Step 6 Using the steps on page 82 and an F .5 mm mechanical pencil, I create the leaves. The branches remain largely visible with just a few overlapping bundles of leaves. I also add a darker tone to the background foliage.

▶ **Step 7** I draw the remaining leaves in four stages. Holding a 2 mm clutch pencil with a chisel-point HB lead in the underhand grip, I lay down the general bundles and shading. Then I remove the lightest leaves with a battery-operated eraser. Next I define and shade the undersections of the leaves to get them to come forward on the page and add depth. Finally, I add just a touch of detail to give the impression of leaves. With the leaves now finalized, I add more tone to the background foliage to increase the contrast.

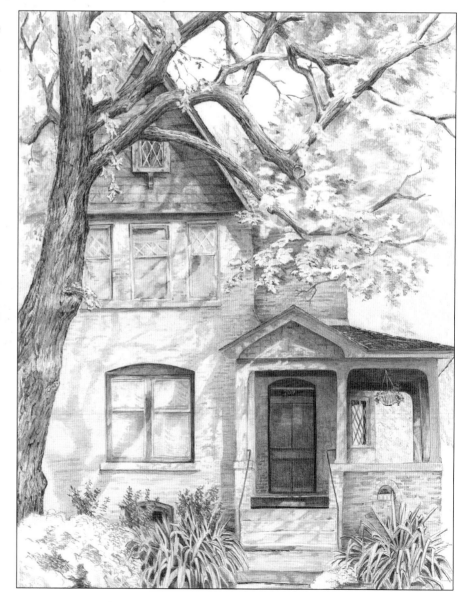

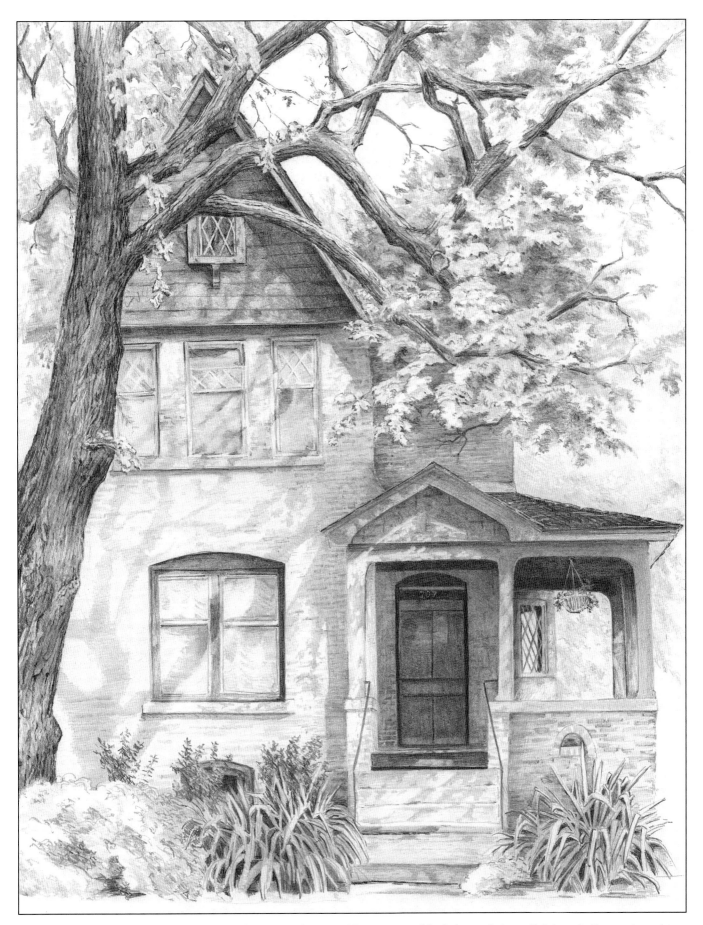

Step 8 After adjusting the trunk shadows, shading more of the plants and leaves, and deepening some of the shadows on the house, this intimate, inviting scene is complete.

MOLEN DE ADRIAAN

This is a picturesque scene of Molen de Adriaan, located in Haarlem, the Netherlands. My good artist friend Tonia Nales has graciously shared this photo from her hometown. This molen, or mill, was originally built in 1778 but burned to the ground in 1932. Seventy years later, the citizens of Haarlem restored it to its original beauty. Its graceful, spinning sails dominate the skyline along the Spaarne River.

 The focal point of this drawing is the windmill, so most of the detail is located in this area. I use the rules of aerial perspective to fade the background elements into the distance.

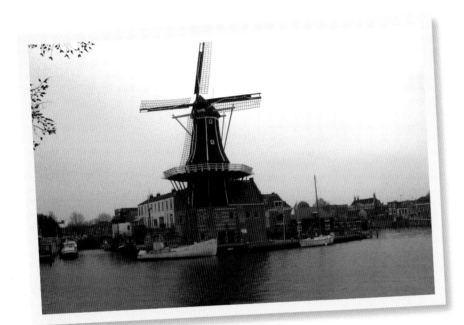

◄ **Adjusting Atmospheric Conditions** Although the reference photo shows an overcast day, I alter the composition to include puffy clouds. A few clouds add interest to the drawing without overwhelming the scene.

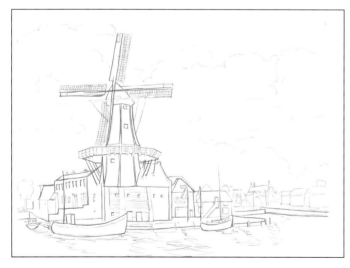

Preliminary Sketch First I use a 2H lead and sketch an outline of the composition on a piece of tracing vellum to work out the positioning of the buildings. Then I transfer the sketch to smooth-finish Bristol paper.

Step 1 Using an F .5 mm mechanical pencil, I lay down three layers of crosshatching on the upper two-thirds of the paper, keeping them smooth and even and extending them well into the areas designated for the windmill and other buildings. (It is far easier to erase excess areas of tone than to add tone later.) I use only two layers where the clouds are going to be. I use a chamois to blend to a smooth finish and then use a plastic eraser to "draw" the cloud formations. I darken the areas of the sky next to the whitest tops of the clouds using a 2H lead and then blend the graphite with a chamois. This adds depth to the sky and brings out the clouds. I repeat this process to slowly build up the clouds. I leave the sky fairly rough for a painterly, impressionistic look. I use a straightedge and erase a clean border around the image area. I also erase the edges of the windmill and buildings.

◀ **Step 2** I start detailing the armature and the sails of the windmill. I want these to be sharp and crisp, with straight angles, so I use a ruler to guide me. The fine mark of an HB .3 mm mechanical pencil is perfect for the thin lines of the sail's grid. The grid should not be the same line strength throughout, so I erase lightly here and there with a tacky eraser. This gives a realistic feel of the sun and sky bleaching out the details.

▶ **Step 3** I continue to use the HB .3 mm mechanical pencil as I shade the top of the mill. Using a B lead works well to render the dark structure, leaving the edges and windows white. The thin lead allows me to create crisp corners and edging in these small areas. The railed walkway forms an octagonal shape as it wraps around the building. I carefully shade the dark building behind the lighter boards of the railing. I draw the boards lightly where they overlap the sky.

◀ **Step 4** I shade the roof of the main building with short, downward-angled strokes using an HB .5 mm mechanical pencil. By concentrating on the varied tones, I make the shadows and textures appear. I build up the brickwork on the side of the building with short vertical and horizontal strokes, using a 2 mm clutch pencil with a chisel-point H lead. I draw the window openings with an HB lead, using a ruler to keep everything nice and straight. I take care to make the windows square.

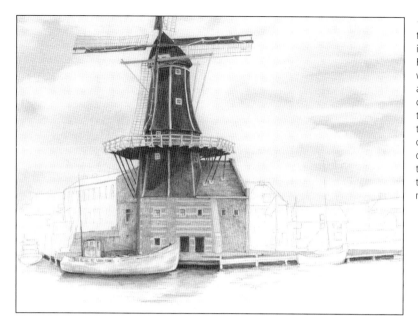

◄ **Step 5** I develop the darkest areas under the dock to create the general form of the dock as it protrudes out into the water, using a B lead for the darkest areas and an F lead for the top of the dock. Because I am working only with tone, it is easy to carry over into the other objects and areas. I leave the boat on the right as a white shape to be completed later, but the development of the area around the boat on the left demands that I work the values of the boat, the dark shadows of the deck, and the water in one step. This is a technique that I use frequently. It is not drawing the objects separately that is important but rather the relationships of the tones and textures that separate the objects. I will return to the boat and water later to add more detail.

► **Step 6** I shade the buildings on the left with lighter values and fade them out in the background. I keep detail to a minimum; general shapes provide the impression of buildings. The buildings at right have a bit more detail in them as I identify the windows and staircase. I use a .5 mm mechanical pencil with an F lead on these buildings. I draw around the flagpoles and then lightly shade them using a 2 mm clutch pencil with a 2H lead. I keep the buildings and dock simple and leave out many of the miscellaneous crates and unknown objects that appear in the reference photo.

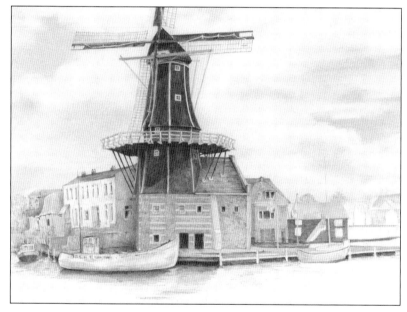

◄ **Step 7** I use aerial perspective to create depth in this scene, making the buildings in the background lighter and less defined. A few treetops, steeples, and chimneys form the skyline of the remaining backdrop for this majestic scene. General shapes of roofs and windows give the impression of buildings. Using a 2H .5 mm mechanical pencil, I shade the water next to the retaining wall in front of the background buildings. The water texture consists of small, horizontal, rocking strokes. I keep reflections minimal so the water doesn't compete with the sky.

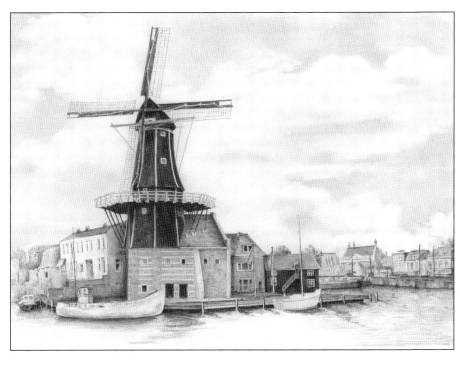

◄ **Step 8** I continue creating the water in the foreground by slightly lengthening my horizontal strokes. Using an HB .5 mm mechanical pencil, I add the shadows and reflections made by the dock pillars as well as the reflections of the boats. To emphasize the aerial perspective, I adjust the values on the structures in the center, darkening the buildings and the surface of the dock.

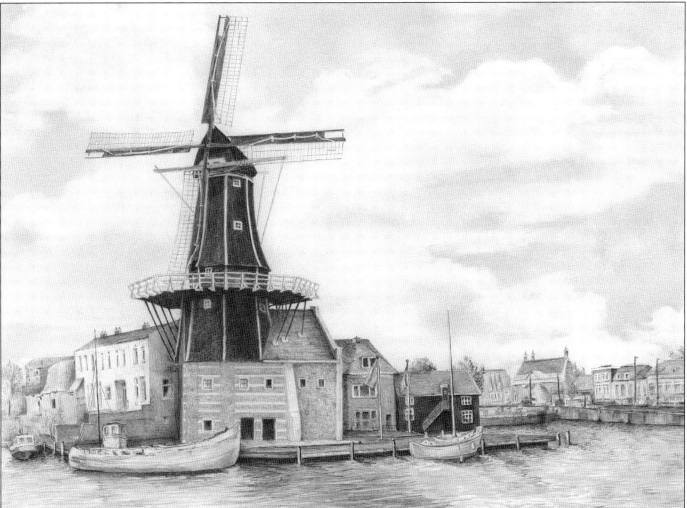

Step 9 The water in the center foreground area has the darkest reflections from the windmill. I create these with an HB .5 mm mechanical pencil, placing the darks on the undersides of the waves. The diagonal line of the reflection leads the eye right into the scene. The highlights and shadows on the boats give them shape and form. Using an F .5 mm mechanical pencil, I add just enough details to the boats to fit them into the scene without drawing too much attention to them. They complement the scene, but the viewer's attention comes to rest on the beautiful splendor of the Molen de Adriaan.

HONEY CREEK

This peaceful, idyllic scene holds many wonderful childhood memories for me. Many hours of fishing and lying in the grass daydreaming and watching the clouds go by were spent "down by the creek." To me, this scene allows us to see nature at its finest.

This scene also is ideal compositionally. The gently winding creek leads the viewer's eye into and around the scene, and the large foreground tree on the left keeps the eye from straying off the page. The smaller trees in the distance give the appearance of depth and dimension, also leading the eye back into the scene.

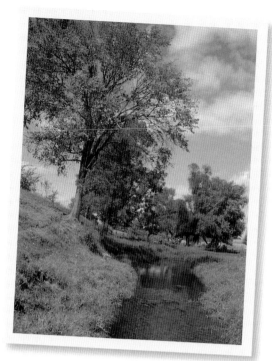

▶ **Depicting Stillness** This scene, with its mostly still water, provides a great opportunity to create a calm, quiet atmosphere. As you learned on page 79, you can represent still water by layering horizontal pencil strokes.

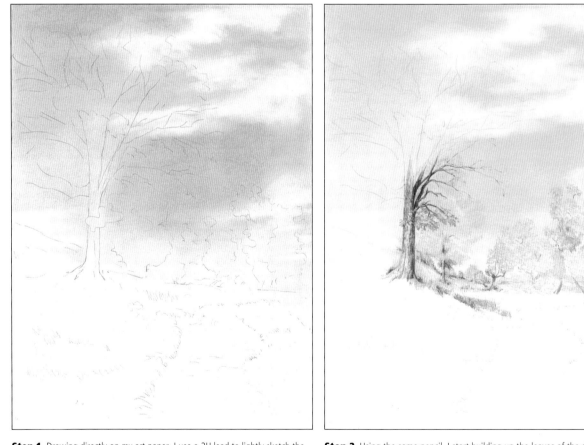

Step 1 Drawing directly on my art paper, I use a 2H lead to lightly sketch the bank and the shape of the creek—I don't sketch the trees yet, though. Next I lay in the sky with light tones that get progressively lighter as the sky reaches the horizon. Now I lightly sketch the outlines of the trees on top of the tone of the sky.

Step 2 Using the same pencil, I start building up the leaves of the distant trees using the progression shown on page 82. I use the underhand grip and the scribbling stroke, focusing on the mass of leaves as a whole. Next I shade the base of the foreground tree's trunk with an F .5 mm mechanical pencil, using short strokes to begin the grass along the creek.

► **Step 3** I continue using the F .5 mm mechanical pencil to shade the tree trunk and begin developing the branches. Once I've completed a few branches at the lowest part of the tree, I work on defining the focal point—the shadowed area under the foreground tree where the creek bends. I use my darkest tones here to really define this area, contrasting it with the light grasses that surround it. To create the patches of long grass near the bend, I build up layers of short pencil strokes. I use up-and-down motions to create these longer spikes (see page 79). I merely suggest the distant grass by hinting at the spikes. Then I start defining the distant curve of the creek by creating short strokes along the edges, making my strokes shorter and less detailed as the creek recedes into the distance. This is another good example of aerial perspective—objects in the distance appear less detailed and more blurry than objects in the foreground.

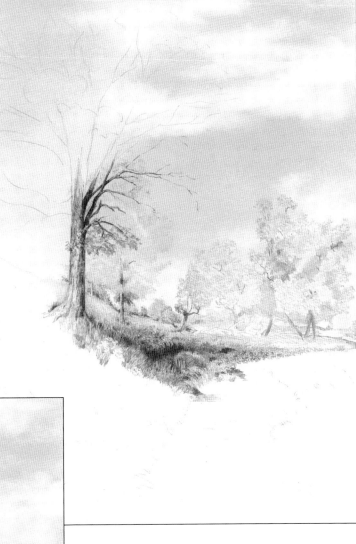

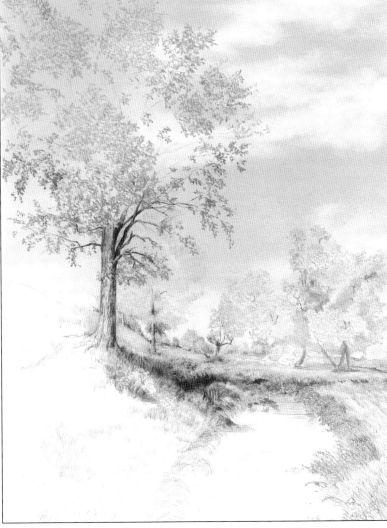

◄ **Step 4** Using an HB .5 mm mechanical pencil, I lightly sketch the grass along the banks of the creek. The grass closest to the water is broadleaf water grass, which nicely contrasts with the long, wispy weeds. For the grass in the foreground, I need to show enough detail to keep a sense of realism without drawing every single blade. To do this, I deliberately leave spaces among the weeds and overlap the layers. Next I use horizontal strokes to begin the water in the creek. Taking a break from the water, I start building up the leaves of the foreground tree, again using the steps from page 82.

► **Step 5** After creating the first layer of leaves in the foreground tree, I realize that the trees look too straight and perfect, so I make some adjustments. Still using the HB .5 mm mechanical pencil, I thicken the foreground tree trunk and put a slight curve in the trunk of the middle-ground tree, making it lean to the right a bit. I also make some small changes to the trunks of the background trees. I lift out the graphite with a tacky eraser and then use a kneaded eraser to make my changes. (Using an eraser without first lifting the graphite will grind the graphite into the paper—by lifting first, you can save the paper's tooth.) Now I develop the leaves of the middle-ground tree, and then I gradually darken the leaves of the background and foreground trees. I also start creating the grass and foliage of the hill on the left. Then I refine the grass on either side of the creek and continue to develop the water with horizontal strokes. I add a few rocks in the creek in the near foreground.

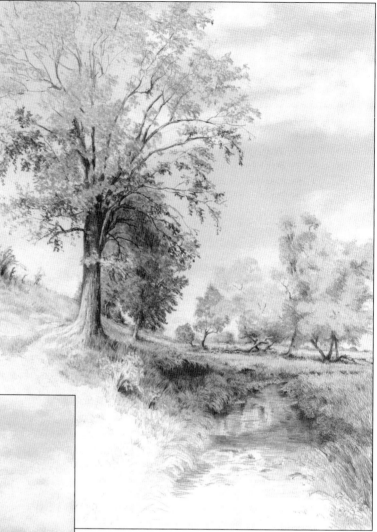

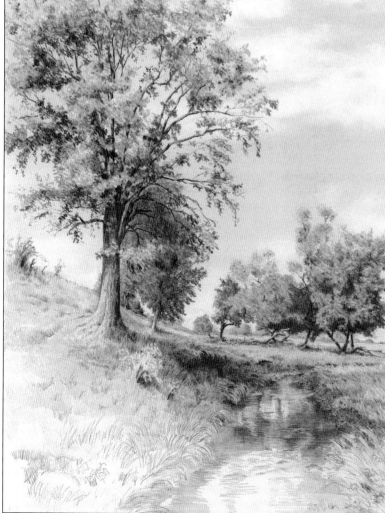

◄ **Step 6** With the same HB .5 mm mechanical pencil, I continue to shade the background trees, making them appear more three-dimensional. I make sure all the cast shadows fall to the right of the trees, showing that the light source is coming from above and left. Even the shadows of the grass are tilted to the right. I continue developing the water, making it darkest in the middle of the creek to show the shadow cast from the foreground tree. I also pull out some highlights in the water near the foreground grass to show its reflection in the water. I make some quick strokes around the rocks in the water to show the water's movement. Then I work on the grass on the left bank.

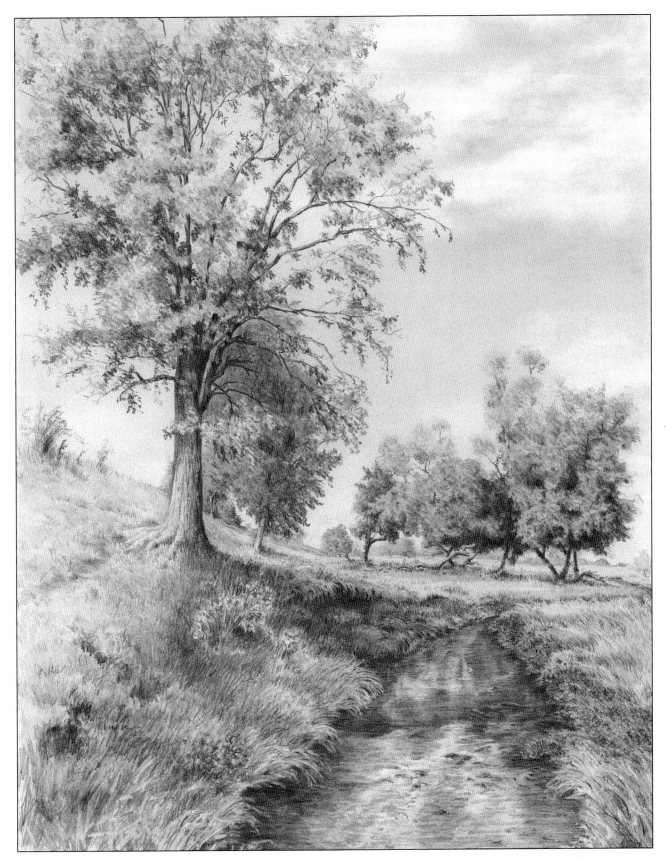

Step 7 Returning to the sky, I use a tortillon to darken the tone of the sky and reshape the clouds. When I'm satisfied with the shape and volume of the clouds, I concentrate on bringing out the textures of the grass and water. I add layers of grass to both sides of the creek, using longer strokes in the foreground and shorter strokes as I reach the middle ground and background. I deepen the tone of the water, defining some of the rocks and curving my strokes around them to show movement. I lift out some highlights in the water to show the reflections of the grass. Then I return to the trees, using a 2B lead to darken areas and define the leaf bundles. I add small details to the foreground tree leaves, pulling out highlights in some of the leaf bundles to make them stand out. Lastly, I refine the foreground grass, making the grass closest to the creek darker and more detailed.

VENICE CANAL

I always enjoy when my co-worker Dave Neal goes on vacation—because when he returns he shares his photos with me, and I feel like I've been on vacation too. Venice, with its rich and beautiful buildings, is known as a home to artists. It is a real treat to draw the same subject matter many of the old masters have portrayed over the ages.

Even though they are in the foreground, the water and boats are secondary features. The gentle ripples and reflections of the water, as well as the placement of the boats, slowly draw the viewer into the picture plane. The sharply angled perspective directs the eye through the drawing. The buildings lead the eye around the corner. In contrast, the bridge directs the eye to the foreground and middle ground and prevents instant travel into the background and out of the picture plane. The most detail is applied to the focal point—the bridge.

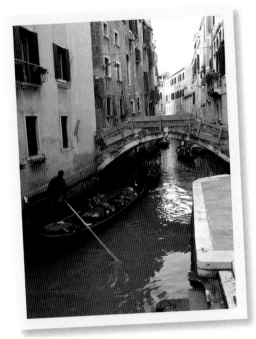

▲ **Breaking Down the Composition** This photo is composed wonderfully, with the off-centered bridge, the depth and strong angles of the buildings, and the perfectly positioned gondolas. There are many fascinating details and rich textures. There is a lot going on in this scene, but by taking one section at a time, we can break it down into its basic compositional components.

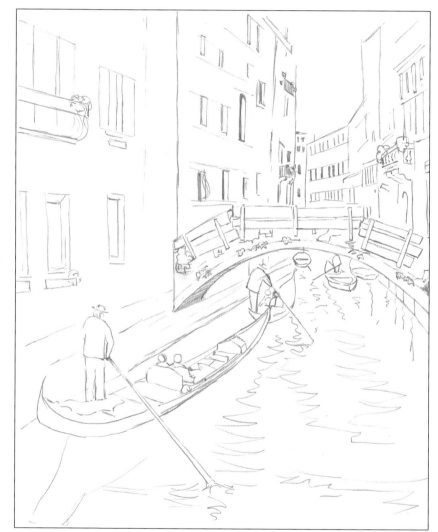

Preliminary Sketch On a sheet of tracing paper, I use a 2H pencil and light pressure to block in the major areas of the scene, beginning with the buildings. These old buildings don't seem to follow a single perspective, as each has its own unique lean and angle. To force them to comply strictly with the rules of perspective will cause them to lose their character; however, some perspective needs to be followed to ensure that the buildings look logical and believable. I pay extra attention to verticals and the sharp perspective angles of the window openings. I add small details, such as the windows, but don't get carried away with them. I will attend to the details later in the drawing process. Next I sketch the bridge, the boats, and the water. When I'm satisfied with the drawing, I lightly transfer the lines to smooth-finish Bristol paper.

Step 1 I begin shading the old wood-and-brick bridge, keeping the right side of the bridge darker to contrast with the lighter buildings to the right while keeping the left side of the bridge lighter to contrast with the darker buildings on the left. I create the wood and brick textures as described on pages 78–79. First I draw the outline with a 2H .5 mm mechanical pencil; then I shade the boards and add knots in the wood with an F .5 mm mechanical pencil. Next I burnish with a 6H pencil until I achieve an even-toned gray. Lastly, I make downward strokes with a tacky eraser to create highlights.

Step 2 The boards are worn and weathered smooth in comparison with the textured bricks, which contain dark areas in the corners and where the mortar has deteriorated. I use an HB .3 mm mechanical pencil and a thin, circular stroke that's perfect for the textured brick surface. A light layer of 6H gives the bricks a gray value that is slightly darker than the lower concrete bridge molding but lighter than the wood, resulting in a pleasing contrast of the three surfaces. I use a tortillon to smooth the curved concrete area edging the bottom of the bridge. I make tiny disjointed marks with an HB .5 mm mechanical pencil to depict the weeds growing out of the cracks.

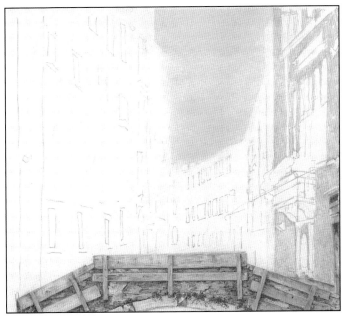

Step 3 Now I add the sky to the background. Although it is tempting to leave the sky white, I give it a light value. As well as adding depth to the landscape, adding a value to the sky allows me to save the white of the paper for highlights. Using an F .5 mm mechanical pencil in the loose-hold grip, I turn my paper upside down and lightly lay down three layers of graphite. Then, using a chamois, I smooth the graphite, making it lighter as it approaches the buildings. Shading over the edges of the buildings ensures an even value.

Step 4 Now I begin to focus on the buildings on the right of the picture plane. Using random crosshatching with a 2 mm clutch pencil with a chisel-point 2H lead, I create a fine texture to represent the stucco on the buildings.

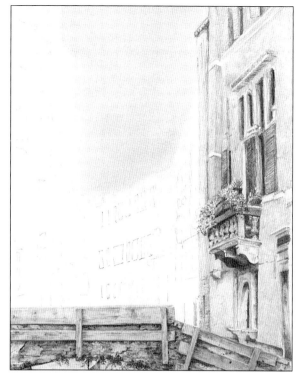

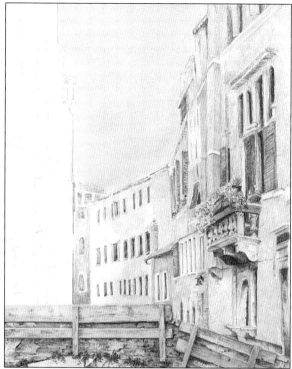

Step 5 I continue developing the buildings on the right, using the 2 mm clutch pencil with a 2H lead and a ruler to produce crisp edges as needed. When drawing realistic landscapes, it is not necessary to meticulously put in all the details. In fact, I find that the more I merely suggest the details (rather than drawing all of them), the more comments I get about how much detail I've captured! I put in only enough detail to hint at what is there—the viewer's mind fills in the rest (see "Suggesting Details" on page 103). It's not always easy to minimize the details, though—here I feel that I may have included too much detail on the balcony, so I'll try to counterbalance it by adding areas of detail on the left side of the picture plane.

Step 6 As I shade the buildings in the background with the same pencil as in step 5, I mainly concentrate on values, textures, and shapes. The more distant buildings receive less and less detail and appear almost blurry. I leave the white of the paper for the left side of the center background building to show that the light is hitting it. Now you can see the importance of adding a value to the sky—if I had left the sky white, I couldn't create the illusion of the sun hitting the center building without it looking washed out.

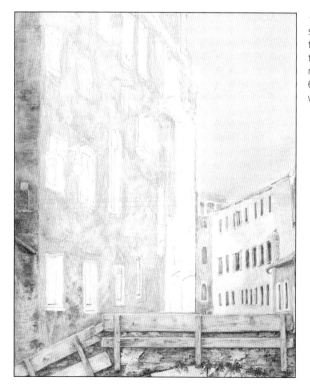

◀ **Step 7** Working from the detailed to the less detailed seems to be a good approach for these buildings. So I use the same method on the left side of the picture plane. I shade the dark corner just to the left of the bridge with a .5 mm mechanical pencil, using HB and F leads. Then I burnish with a 6H lead to give it a nice middle tone. Subtle hints of bricks and worn areas help add interest.

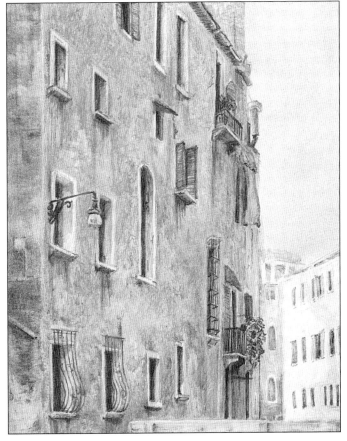

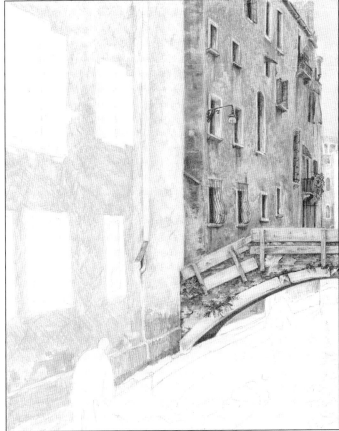

Step 8 The walls on the left side of the picture plane hold a host of wonderful details that I want to capture. Whereas I used 4H and 2H leads on the right, I start with an H lead on the left. The building beyond the bridge is darker because it is in shadow. I add details such as iron bars and railings to the top background window and another in the middle center. This helps counterbalance the ornate bannister on the right (shown in steps 5 and 6). A light pole attached to the building adds a pleasing detail. These details also provide good perspective keys.

Step 9 Having completed the background area behind the bridge, my focus shifts to the foreground. Because I included a few intricate details in the background, I will need to take additional care with details in the foreground. The left foreground building may not appear to have much detail, but I can create rich textures in the stucco. Careful to preserve the outline of the gondolier, I use the same random crosshatching I employed for the background but use a 2 mm clutch pencil with softer H and HB chisel-point leads. By using a tacky eraser and then re-applying softer and harder leads, I create a convincing texture. Next I add a drainage pipe running down the side of the building, and the watermarks at the base of the building begin to emerge.

Suggesting Details

When drawing the windows, I reduce them to two lines—one lighter, one darker—with a tad of a triangle on the top for shadows. This isn't much detail, but the results "read" as windows. The challenge is to render a window with sills, panes, edgings, etc., in terms of basic shapes. Understanding this concept is not as difficult as figuring out the key components that will allow the viewer to interpret an object as a window.

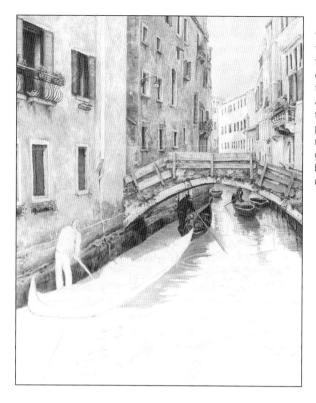

Step 10 Now I use an HB .3 mm mechanical pencil to shade the windows on the foreground wall and add the moss growing on the building. (The small lead is perfect for this detail work.) The plants and wrought-iron railing around the upper left window balance the composition. Next I use a 2B .5 mm mechanical pencil to shade the base of the wall, extending it into the darkest shadowed area under the bridge. Again, I preserve the outline of the gondolier as I shade the base of the wall. With the buildings finished, I move to the water and boats. Starting under the bridge, I use a 2 mm clutch pencil with a 2H chisel-point lead to shade the background gondolas and the water around them. With a B .3 mm mechanical pencil, I make the middle-ground gondola and gondolier a bit darker in value, also indicating more detail than I did with the background boats. Notice that the tip of the foreground gondola overlaps the middle-ground gondola. (I draw around the outline of the foreground boat to create the back end of the middle-ground boat.) Next I continue creating the water using the rocking stroke shown on page 79, alternating 4H and 2H leads.

▶ **Step 11** Still using the rocking stroke and a combination of 4H and 2H leads, I complete the water, making it look still and murky, almost oily. I leave patches of white to show the slight ripples that are created by the oars, but I add a slight value to even the whitest reflections—this will subdue the glare so it doesn't hold the viewer's attention. To add the reflection of the bridge in the right front corner, I apply a layer of graphite with an F .5 mm mechanical pencil and then burnish with a 2 mm clutch pencil with a 2H lead to smooth out the ripples.

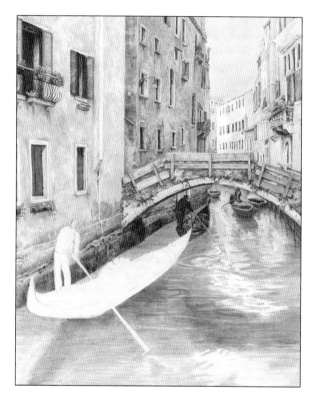

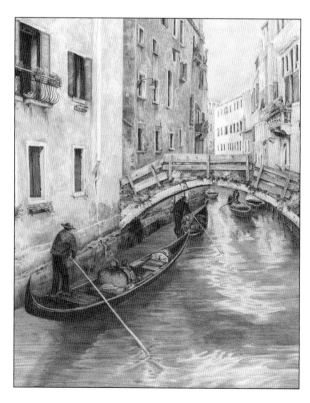

◀ **Step 12** Now I use an HB .5 mm mechanical pencil lead and burnish with a 6H lead to shade the foreground gondola, the gondolier, his passengers, the objects inside the boat, and the oar. These are all supporting elements, so I reduce the objects and passengers inside the gondola to simple shapes, shaded only for depth. The viewer's eye recognizes these foreground elements, briefly gives them attention, and then travels back into the scene. A key approach to keeping objects fresh and not overworked is to apply the graphite at the correct value in the first layer. I do this by using just a few strokes for the objects within the boat.

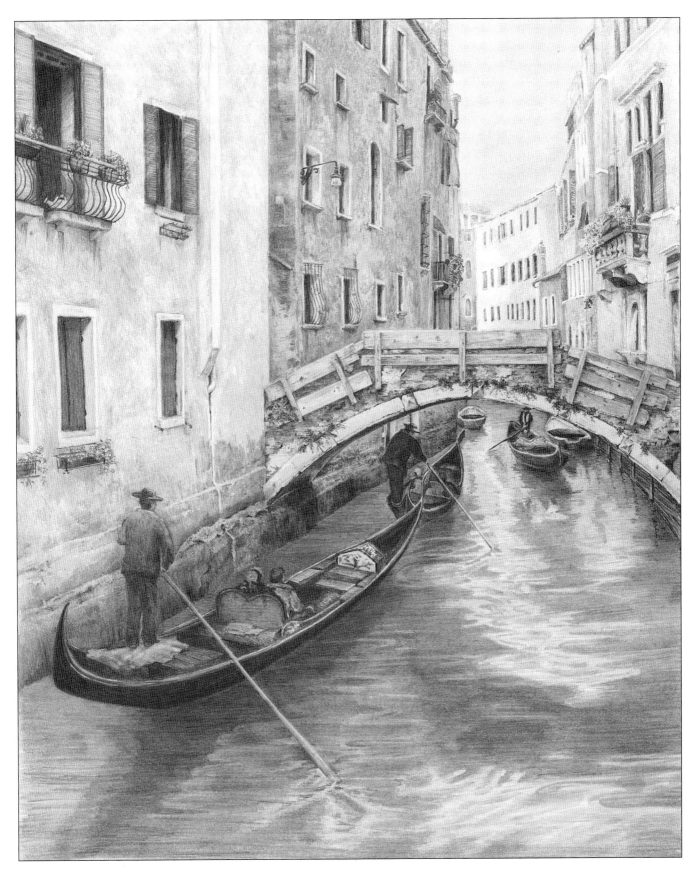

Step 13 I realize that in giving the gondolier a different position from that in the reference photo, I have not compensated for the shifting of his weight and have ended up with an awkward figure. I try to resolve what doesn't look right. After some research, I decide that he needs to stand more upright, with his legs closer together. I also discover that most gondoliers stand on a swatch of fabric on the edge of the boat. I change his stance by first carefully removing the graphite using a tacky eraser. I switch to a white eraser, taking care not to damage the tooth of the paper. After redrawing the figure to my satisfaction, I finish the composition by making minor value adjustments to bring the entire drawing together: With a .5 mm mechanical pencil and a 2B lead, I emphasize the darkest areas of the drawing, such as the foreground boat, the upper left window shadows, and the shadows under the bridge.

BEFORE THE STORM

Landscapes can evoke strong emotions by setting an atmospheric mood. The effect can be subtle or dramatic—the choice is completely up to you. To me, this landscape depicts nature's battle between serenity and turbulence. The dark rain clouds competing with the bright sunlight creates a dramatic contrast of values.

This scene also holds special meaning for me, as it was originally drawn as a tribute to my father-in-law, John Wright, who at the time was battling cancer. This rendition is dedicated to the remembrance of his strong spirit.

▶ **Making Changes** To create a more pleasing composition, I will make a few adjustments to my photo: I will tuck the foreground tree behind the barn to emphasize the focal point (the barn), add a dirt road to provide a visual path for the viewer, and place a plow in the foreground to keep the viewer's eye within the scene.

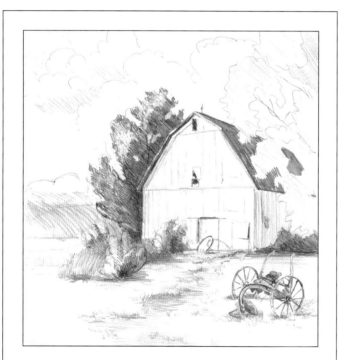

Studying Values

Here you can see that the darkest values are on the roof of the barn and the right side of the middle-ground tree. The middle values are in the bands of rain on the left side and on the dirt path. The lightest values are on the face of the barn and in the foreground grass. Preplanning the placement of your values will strengthen your composition by creating uniformity and balance.

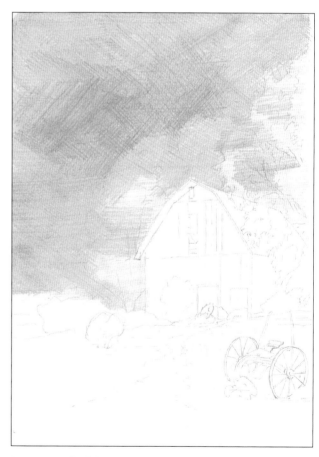

Step 1 First I sketch the scene on tracing vellum. Because I'm adding the plow from another resource, I experiment with its placement until it fits naturally into the scene. When I've found a pleasing composition, I do a quick value study on scrap paper (see box at left). After transferring the sketch to smooth-finish Bristol paper, I lay down the first layer of the sky—I use an F pencil and the loose-hold grip to lightly crosshatch, darkening the tone in the sky's center.

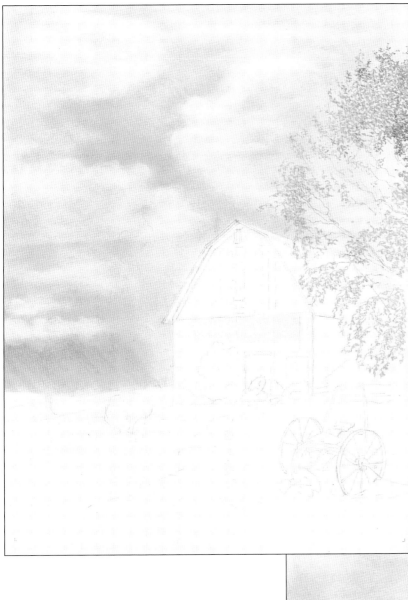

◄ **Step 2** I continue crosshatching the sky area, keeping my strokes light and consistent. Then I wrap a chamois around my index finger and use light, small, circular strokes to blend until the tone is even and I can't see any individual marks. Once the sky is blended, I use a plastic eraser to lift out tone for the clouds. For lighter, softer cloud areas, I use a tacky eraser. Now I use a tortillon to burnish over the tops of the clouds and detail in the darkest areas where the sky and clouds meet. I am careful never to rush this process; I actually spend quite some time concentrating only on the sky. I extend the sky well into the areas designated for the horizon, trees, and barn. Now I take a harder 3H pencil to refine the sky, blending the tone to smooth it. Then I begin putting down the first layer of the foreground tree, following the steps on page 82. Using a B .5 mm mechanical pencil and the underhand grip, I start indicating the leaves with the scribble stroke.

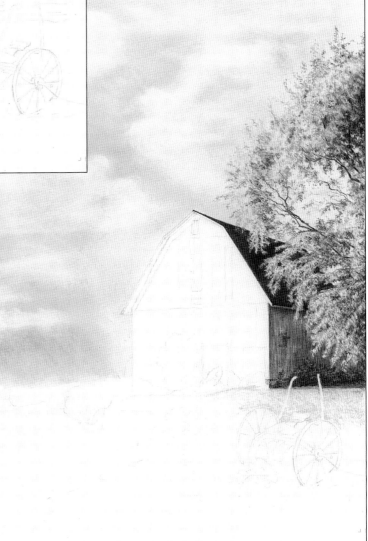

▶ **Step 3** I use a 2B .5 mm mechanical pencil and crosshatching to create an even, dark tone for the roof of the barn. I use a much lighter touch for the side of the barn, making vertical strokes to represent the wood. I use a ruler to create the edges of the barn. Returning to the foreground tree, I shade the branches. Then I use a B .5 mm mechanical pencil and the underhand grip to add more scribbling strokes for the foliage. I work from dark to light, concentrating on the areas of shadow among the leaves. As the shadowed areas develop, the lighter areas also begin to form. I lightly drag my tacky eraser over the leaf areas to create highlights. I pay particular attention to the leaves at the edge of the tree, as these are the most distinct. To keep the tree realistic, I create an uneven pattern of foliage, leaving open areas so the branches are visible. For the lighter branches, I switch to a 2 mm clutch pencil with a chisel-point 2H lead.

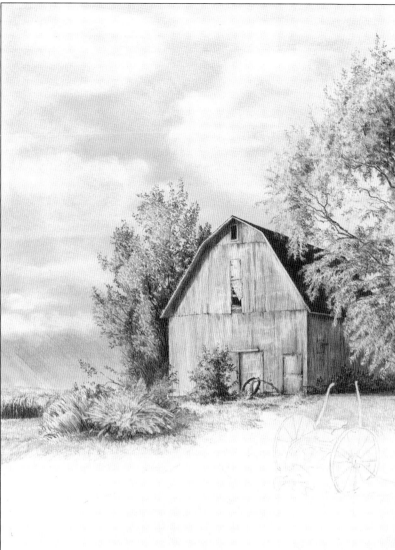

◄ Step 4 I continue developing the roof, using a ruler to create straight lines. For the barn's wood texture, I lay down a light, vertical layer of tone with an F pencil. I use heavier strokes to depict the grainy texture of the wood, and I use a B pencil for the darkest areas. Then I burnish a layer of tone with a 6H pencil on top and lift out highlights with a tacky eraser. Next I use the same steps as I did with the foreground tree to create the middle-ground tree, but I darken the tone where the tree meets the barn. I use the same scribbling strokes for the small bush near the barn door. For the middle-ground weeds, I use a 2B .5 mm mechanical pencil and quick, spontaneous strokes. Then I use short strokes and a 2 mm clutch pencil with a chisel-point H lead to start filling in the grass, being sure to preserve the plow handles. I accentuate the dark area of sky in the distance and create bands of rain by lifting out diagonal streaks with my tacky eraser. I also use long strokes to indicate a cornfield at the horizon.

► Step 5 Using an F .5 mm mechanical pencil, I create the grass around the dirt path. The grass has multiple layers of texture, which I achieve by changing the direction of my strokes and erasing to create uneven, spontaneous lines. With a 2B .5 mm mechanical pencil, I form the worn path by gently blending my strokes in a U-shaped motion with a tortillon. Then I lift out highlights with my tacky eraser to depict the variations in the dirt. I go back over the grass again, making sure that the foreground grass has more detail and is darker in tone than the middle ground and background grass. Next I use an HB .3 mm mechanical pencil to begin detailing the plow, keeping the tone a middle value.

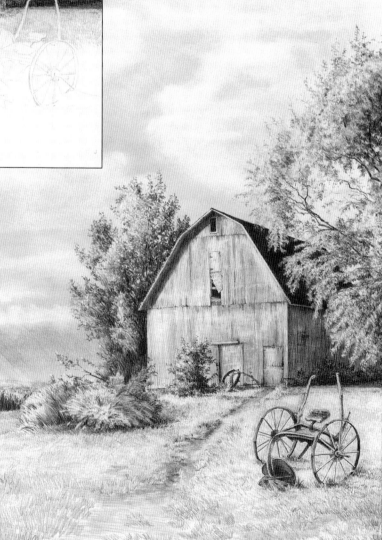

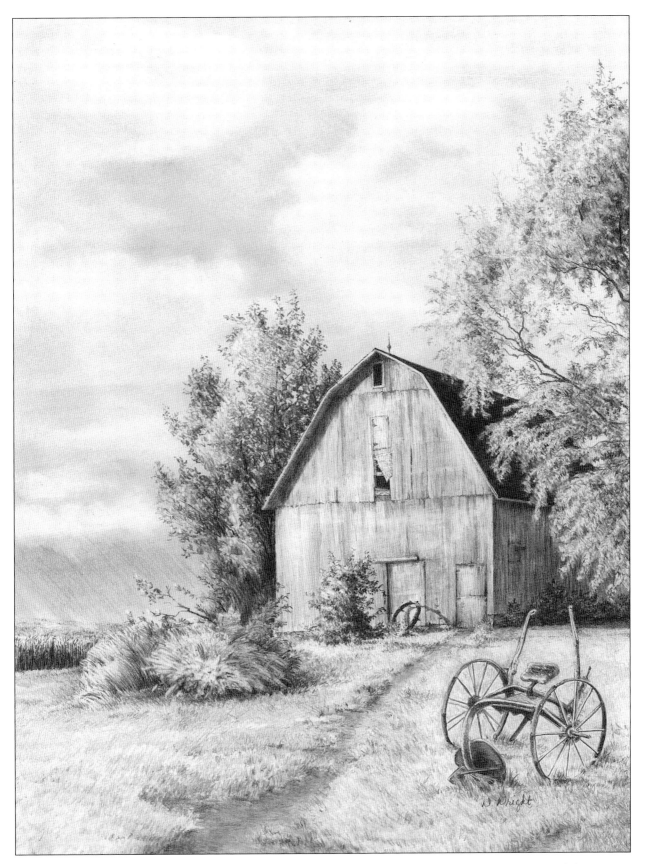

Step 6 Once I'm satisfied with the wooden texture of the plow, I use additional horizontal strokes to finish the dirt path, creating a smaller dirt path that seems to lead to the plow. I do this by erasing a line of tone and then layering horizontal strokes over the erased area, using a 2B .5 mm mechanical pencil and the same U-shaped motion and blending with a tortillon. I detail a few more areas of grass, paying particular attention to the direction of my strokes. Notice that the grass on the right side of the picture plane is angled toward the right side of the barn, and the grass on the left side of the picture plane is angled toward the left side of the barn. The weeds on the left side of the picture plane, however, are angled to the left. These directional differences help lead the eye into and around the scene, making for a pleasing composition. Now I add another layer of shading to the barn's face and side. After a few more adjustments in tone, my landscape is finished.

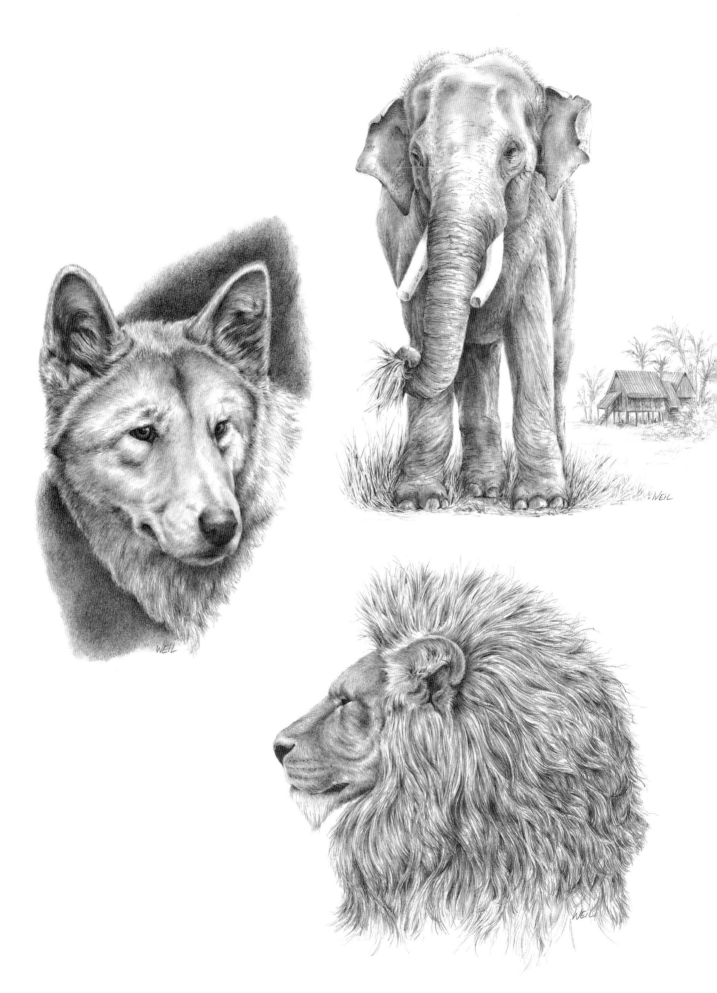

CHAPTER 4

LIFELIKE ANIMALS

with Linda Weil

Drawing is my first love, and pencil is my favorite medium. Although I have worked with many different media, I always return to graphite pencil with joy. The natural world is my preferred field, especially wild animals. In a successful drawing, the personality of the animal will shine through to make a statement about the animal's place in the world, its specific environment, and its relationship to others. Every animal is unique, and I try to show this in my drawings.

In this chapter, I'll share with you the various techniques and methods I use to create finished artwork in graphite pencil. Other artists may use different methods and techniques to achieve similar results. You should explore many different ways of drawing until you find those you are comfortable with and that suit your personal style.

There are two secrets to a successful drawing. The first is to have fun doing it, as your enjoyment will show in your work. The second is practice—the more you draw, the more confident you will become, and the more accurate your drawings will be. Remember, every drawing is a learning experience, and not every drawing needs to be a masterpiece. I hope you enjoy reading and using this chapter as much as I have enjoyed writing it for you. Happy drawing!

—Linda Weil

Linda Weil lives and works in Melbourne, Australia. A graduate of RMIT University, Linda began her career in graphic design, primarily in the print industry. She has been art director and illustrator for a number of Australia's national magazines, and has specialized in botanical and natural history illustration. Linda teaches drawing locally to both beginners and advanced students. Her work has won numerous awards and she exhibits in galleries and shows throughout Australia.

ANIMAL TEXTURES

There is a vast range of textures you can create for skin and hair, and each requires a slightly different technique to achieve a realistic effect. Here I break down the process of drawing six different textures into steps so you can see how they are created. I use these techniques throughout this chapter, so you may want to refer to these pages when following the step-by-step projects.

Short Fur

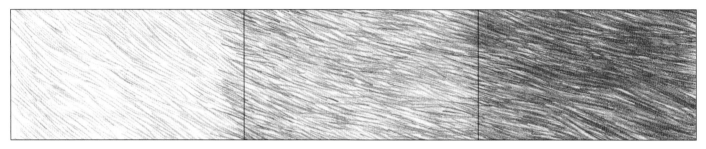

Step 1 I create a light undercoat with a series of swift, short pencil strokes and a very sharp 2H .5 mm mechanical pencil. (Every pencil must be very sharp to achieve this effect.) I draw the strokes in the direction of the fur growth and avoid forming obvious patterns.

Step 2 Now I use a sharp HB lead to create the second layer, using the same technique as in step 1. I don't fill in the entire area; instead I leave some of the paper showing through the lines for highlights.

Step 3 I switch to a 2B pencil to work over the area again with the same short, swift strokes. This deepens the tone of the fur and creates a realistic texture. The darker 2B helps make the untouched areas "read" as lighter, individual hairs.

Short Patterned Fur

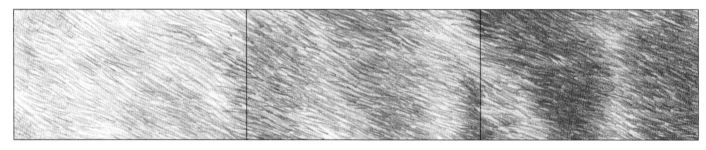

Step 1 I use a blunt F pencil to fill in spots with very light, solid tone. Then I switch to a 2H pencil to work in a similar manner as in step 1 of "Short Fur" but build up dark areas by placing dark 2H strokes close together.

Step 2 Now I switch to an HB pencil to make short strokes following the direction of fur growth. In the spotted areas, I keep the strokes close together; in the lighter areas, I keep the strokes farther apart. I leave some paper showing through for highlights.

Step 3 I intensify the dark spots with a sharp 2B pencil and many closely placed strokes, varying the pressure on each stroke. I build up the tone a bit more in the lighter areas with a sharp HB. This technique is used for the tiger's fur on page 123.

Long Hair

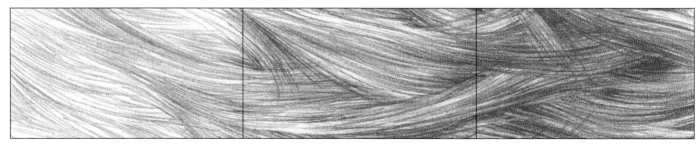

Step 1 I use a very sharp HB .5 mm mechanical pencil to draw a series of long, curved strokes to make a "clump" of 20 to 30 lines. I draw all the lines in a clump in the same direction and at about the same length. Each clump varies in direction and length and often overlaps another clump.

Step 2 As with the short fur, I use a sharp HB lead for the second layer, making my strokes more random than with the short fur. Again I leave areas of white showing through the strokes.

Step 3 I switch to a 2B pencil to build up dark areas using long strokes. I create the darkest areas near the lightest lines and in areas where I want the deepest shadows. This contrast forms natural "hairs" and highlights. This method is used for the lion's mane on page 136.

White Hair

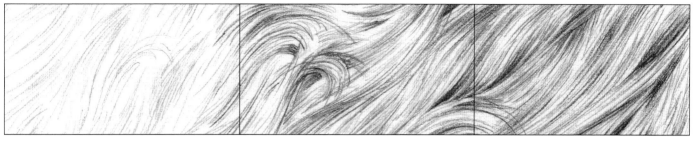

Step 1 Many artists are intimidated by drawing white hair, but I love drawing it! The white of the paper does most of the work for you. You really only need to draw the shadows and the negative areas. I create the undercoat with a sharp 2H lead, but I lay down strokes only in the cast shadow areas. I keep my strokes very, very light.

Step 2 With a sharp HB lead, I carefully create the shadows cast by the hairs, following the direction of hair growth. I don't draw too many lines, as I don't want to fill in all the white areas.

Step 3 I switch to a sharp 2B to carefully create the darkest shadow areas. These dark values sharply contrast with the white of the paper, creating the illusion of white hair. Now I use the tip of the 2H to add some light strokes here and there to give the hair a little more definition. This technique is used in the lightest areas of the koala on page 129.

Rough, Wrinkled Skin

Step 1 With a blunt F pencil, I lay down a light, even tone. Then I use a clean tortillon to blend and soften the tone, eliminating much of the "grain" of the paper. I try to keep some areas lighter and some darker so I don't create a flat tone.

Step 2 To add wrinkles on top of the smooth tone, I use what I call a "scrumbling" technique. With a sharp 2H lead, I cover certain areas with a squiggly line that I make without lifting my pencil. This line sort of wanders about, creating the illusion of a bumpy texture. Then I switch to an HB to draw slightly darker horizontal lines over the scrumble lines. These lines of varying lengths represent the wrinkles.

Step 3 Now I alternate between an HB and a 2B, adding more lines and scrumble lines over the first layer of tone. This loose technique works well for elephant, rhinoceros, and some reptile hides. It can also be used to create leathery effects for noses and footpads if the undercoat is created with a darker B pencil.

Reptile Skin

Step 1 With a 2H pencil, I lightly draw a series of lines in one direction and another series of lines in the opposite direction to form a diamond pattern. I use a blunt F pencil to fill in each diamond with a series of lines placed close together. I leave a slight white outline and a highlight in the upper left corner of each diamond.

Step 2 Switching back to the 2H, I stroke in the opposite direction on top of the layer of F strokes. This creates a blending effect without smudging the graphite with a tortillon. Now I add circular strokes with an HB in each diamond, concentrating on the lower right of each shape. I also use the HB to fill in the white outline around each diamond, creating a shadow between each shape.

Step 3 Finally, I use a 2B to create the darkest shadow areas in the lower right of each diamond. Then I use an HB to add circular strokes over the previous layer, evening out the tone.

DRAWING FROM LIFE

To draw animals realistically, it is important to observe them and sketch them from life. By watching how the animal moves and relates to its environment and other creatures, you can better portray the animal's character and appearance. Drawing an animal in the wild is difficult and possibly dangerous, so zoos, wildlife parks, animal sanctuaries, and rescue centers are the preferred source of subjects. If none of these are available to you, you can resort to a video, but this is a very poor second to seeing, hearing, and smelling the living creature.

▶ **Drawing on Location** Author Linda Weil (left) sketches with her niece (right) at the San Francisco Zoo.

What to Take

Your kit can be as simple or as complex as you wish and are capable of carrying. Here's a list of the items I always take when drawing on location:

1. A range of pencils (start with at least an HB and a 2B)
2. Sketchbook
3. Appropriate clothing and a hat
4. Insect repellent
5. Sunscreen
6. Water bottle
7. Pencil sharpener
8. Camera (if you're drawing an animal you've never seen before or don't have many references of)
9. Something to sit on (if you're going to be in front of one animal for an extended period)

What to Do

1. **Be prepared for uncooperative animals.** It seems inevitable that whenever I go to study one particular animal, that is the *one* animal that is hidden all day or not on display. If I am after a particular animal, I have learned to always call first to ensure that the animal will at least be on display—whether it performs is a matter of luck. But there is nothing more frustrating than turning up on the one day of the year that the animal is getting its annual medical checkup and isn't on view!
2. **Be aware of the animal's habits.** Many animals are most active in the early morning or evening and will sleep out of sight in the afternoon. Is the animal nocturnal? If so, check with the keeper to find out the best time to view it, or arrange a private visit. Find out its feeding times and try to be there then.
3. **Be patient.** If the animal isn't moving or visible when you arrive, wait a while. Animals operate on their own schedules, not yours, so be patient and you will be rewarded.
4. **Be flexible.** Patience didn't work? Why not check out the animal next door? I guarantee you will see something interesting elsewhere if you keep your eyes open.
5. **Expect an audience.** People are always curious about what you are doing, especially children. If you are shy or hesitant about being watched, try to find a good spot that is discrete and out of the way. Some people will show great interest and ask questions about what you are doing. This is a wonderful opportunity for you to tell them about your artwork. If you are confident enough, give them your business card; you could be pleasantly surprised with a commission opportunity!
6. **Be polite.** Animals can be sensitive and shy, so don't shout or tap on the glass or wave your arms to attract the animal's attention. This can frighten the animal and make you look foolish, especially when the animal disdainfully ignores you! Also, don't hog the best viewing spots. Share these with the public, especially children. Do all you can to encourage their interest and allow them to see what you have been watching so carefully.

Simplifying with Shapes

When you're just starting out, drawing animals from life can be very confusing. Often your first time drawing from life results in something that doesn't look anything like the animal in front of you. Don't be discouraged; you might just be drawing your preconceived notion of what the animal *should* look like instead of what it *really* looks like. The best way to avoid this is to make a deliberate effort not to draw the animal but, instead, to draw the shapes that compose the animal. By breaking down the animal into simple circles, ovals, squares, or triangles, you not only lessen the confusion, but you also make it easier to get the correct structure and proportions. Below are several animal drawings that are made up of simplified shapes. As you can see, cylinders, circles, and ovals form the basic structure of each drawing. I often use this technique to begin a drawing. When you take your sketchbook out into the field and begin to draw, start with these simple shapes and lines. Work quickly and freely, and keep the drawing simple. Don't be worried if the animal is moving; just start another drawing on the same or next page. An animal will usually pace and return to its previous position so you can continue where the first or second drawing left off. Fill your page with several different views and angles of the moving animal. Don't fuss over small details; try to capture the overall form and feeling of the animal. Your aim is to take a quick "snapshot" in pencil.

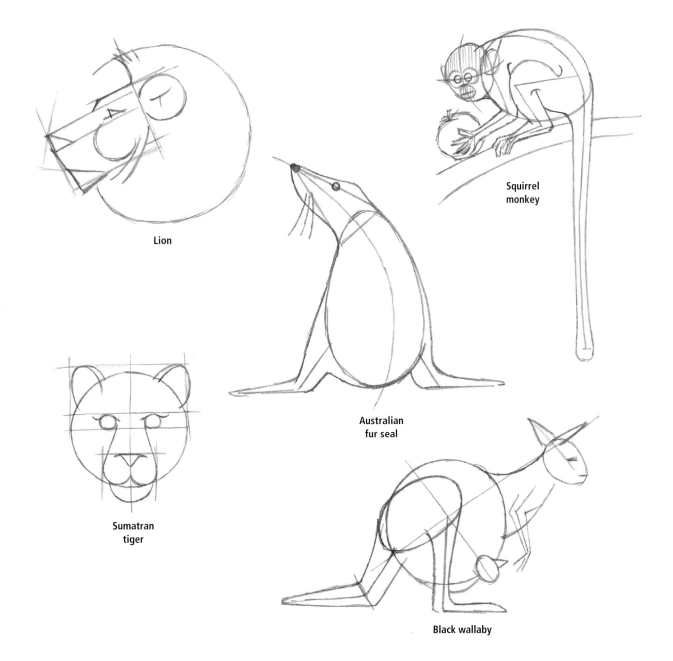

Lion

Squirrel
monkey

Australian
fur seal

Sumatran
tiger

Black wallaby

Sketchbook Selections

I frequently visit the local zoo and wildlife sanctuary. Whenever I go, I take my camera and sketchbook along. Sometimes I get so enthralled with watching the animals that I may do only one or two drawings. My books are filled with incomplete studies. My sketchbooks are not meant to be "finished" art but studies and observations of animal forms and behaviors. I never come away without having learned something. Here is a selection of drawings from my sketchbook that were made using the techniques discussed on page 115.

Alpha Baboon The Alpha Baboon in a troop has the most wonderful coat of luxurious hair that is assiduously tended to by his harem of females. His eyes are deeply set and brooding, and he is a rather proud animal.

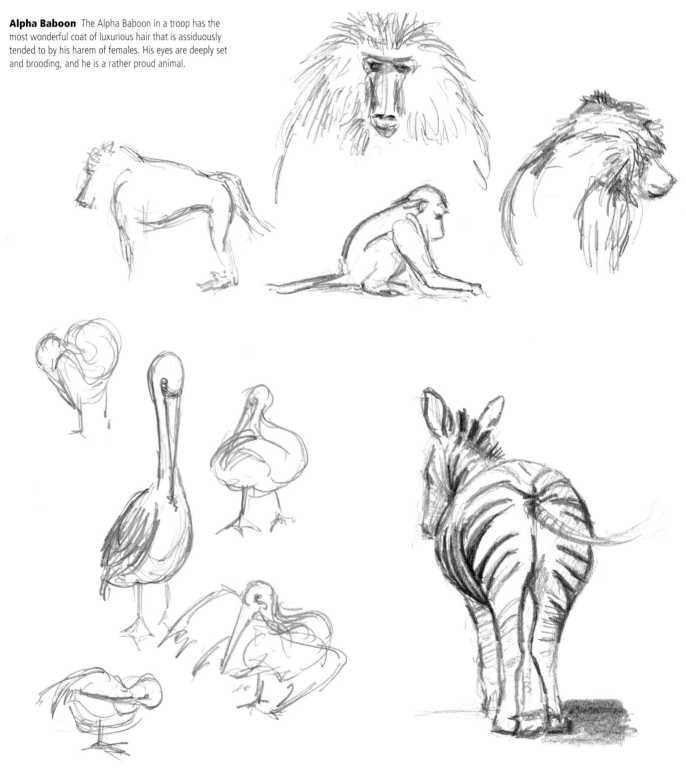

Pelican These preening birds have beautiful curves in their necks. I find it amazing that they can manipulate that huge beak so delicately to reach the most out-of-the way areas on their bodies.

Zebra This zebra was most obliging and stood still for several minutes. He too was enjoying the spring warmth.

Red Kangaroo Called the "Old Man of the Desert," the kangaroo has a big, blocky head with large, upright ears and is heavily muscled around the shoulders and forearms. The kangaroo is tall and graceful in movement and languid in repose.

Tamar Wallaby Wallabies are very similar in structure to kangaroos. It is important to note the wallaby's smaller size, rounder body, and smaller head.

Hairy-Nosed Wombat Wombats are often called "bush bulldozers" because of their solid, sturdy, round bodies that can plow through almost anything.

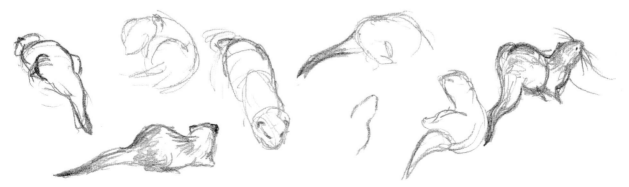

Three-Clawed Otter Otters are some of my favorite animals to draw, but they never sit still. They often return to similar positions, though, so I captured them progressively, drawing several different positions at once. This helped me successfully depict their wriggling bodies.

ASIAN ELEPHANT

Large animals such as elephants are great subjects for your first attempts at drawing wildlife. The big, round forms are easy to understand, and the texture of the skin is less daunting than fur. This project features an Asian elephant, which differs slightly from an African elephant in that it has a smaller body and ears, as well as a more rounded back. It also has a fourth toenail on its rear feet and only one "finger" at the end of its trunk. The head and body are sparsely covered in wiry hair. Because they are working animals, their tusks often have been cut short to prevent damage to their surroundings. Noting these characteristics will help you accurately portray this type of elephant.

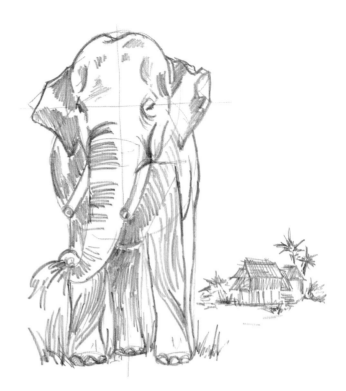

▶ **Rough Sketch** I start with a rough sketch as a plan for the final drawing. Using a soft 2B pencil, I define the general forms of the elephant. I also indicate the lights and darks, keeping in mind that the light is coming from above right. I want the viewer to know that this elephant is Asian, so I decide to add a Malaysian-style house in the background.

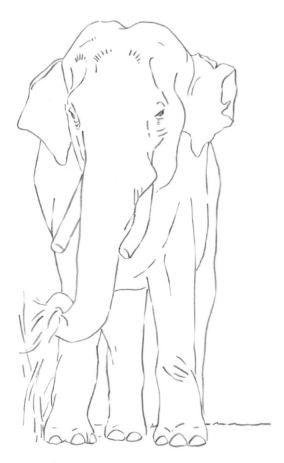

Step 1 Now I transfer only the outline of my sketch to my final art paper. I tape the sketch to a bright window and place a piece of art paper over the sketch. Then I use an HB pencil to carefully trace the outline on the art paper. I do not include any details or the background at this time. For reproduction purposes, the outline you see here is much darker than I would use in my work. I will erase much of the outline by dabbing at it with a kneaded eraser as I work.

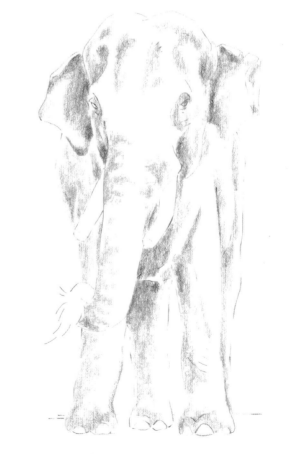

Step 2 I need to create a very soft, smooth tone to represent the underlayer of skin prior to adding the rough, cracked texture. Using a 2B woodless pencil, I make small circular strokes to fill in the darkest shadow areas. I leave large areas of white, as I will blend the graphite into these areas in the next step. To help protect the white of the paper, I wear a cotton glove with the tips of the fingers cut off. I also rest my hand on a sheet of paper that covers part of the drawing surface.

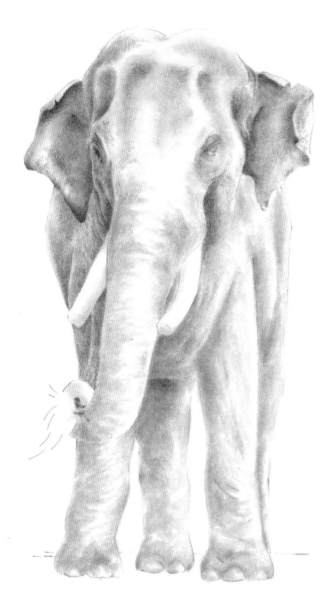

◄ Step 3 Using a tortillon and light, circular motions, I slowly blend the dark graphite into the white areas of the paper for a smooth, satiny look. I use this residual graphite on the tip of the tortillon to "paint" lighter tones over the white areas of the elephant. Then I use a 2B and circular motions to darken the shadows from step 2.

► Step 4 I use the graphite on the tip of the tortillon to "paint" softer tones into the whites of the tusks, across the forehead and ears, and on the trunk and chest to form ridges and folds of skin. Working over the head, ears, and a bit of the trunk, I add some wrinkles using a sharp HB mechanical pencil. I sharpen the edges of the curls in the ears and use circular strokes around the eyes and brows. Then I continue down the body, adding wrinkles and creases. I refer to my reference to see how the wrinkles flow over the legs. I add details to the toes and trunk, and I darken the ends of the tusks. I blend this linework slightly with a tortillon. I realize that something is not quite right with the legs, but I keep drawing. Using a sharp 2B mechanical pencil, I further darken and enhance the wrinkles, as well as areas around the eyes and inside the ears. I use adhesive putty to lift out tone from the outward side of the elephant's front left leg, as well as areas on the head and trunk.

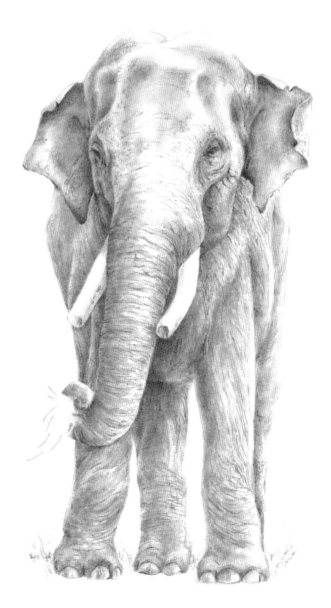

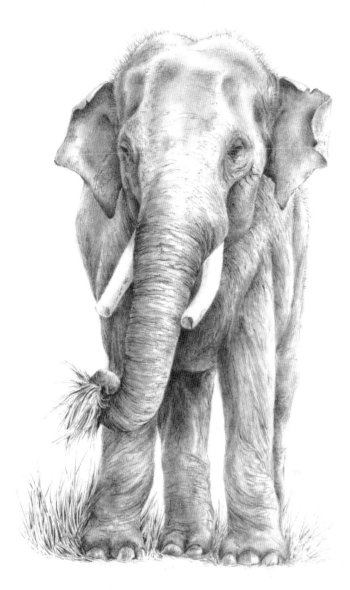

◄ **Step 5** With the 2B pencil, I continue to build up the form of the tough, wrinkled skin. I also deepen the tones in the darkest shadows, and I add some dark hairs on the elephant's head and back. With a very sharp HB pencil, I draw strokes of various lengths to represent the grass on the ground as well as at the end of the elephant's trunk. Then I use a sharp 2B to fill in dark areas between the strokes, giving the grass some depth. Next I add further detail in the feet and toes.

▶ **Step 6** After adding more dark values to the grass, I switch to an HB pencil and return to the elephant, emphasizing darks and adding more wrinkles where needed. At this point I still am not happy with the legs; they seem too long and out of proportion. Then I realize my error—I was fooled by the photographic distortion of perspective in my reference, which resulted in the elephant's rear right leg appearing too long. I need to raise the elephant's rear right foot and shorten the leg. I very carefully erase the bottom portion of the rear right leg with a kneaded eraser. As the graphite has been blended, I cannot quite remove all the tone. As you can see here, there is a faint "ghost" foot remaining. I will need to hide this under grass in the next step.

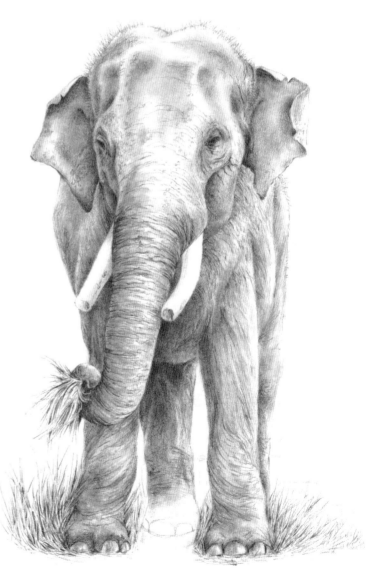

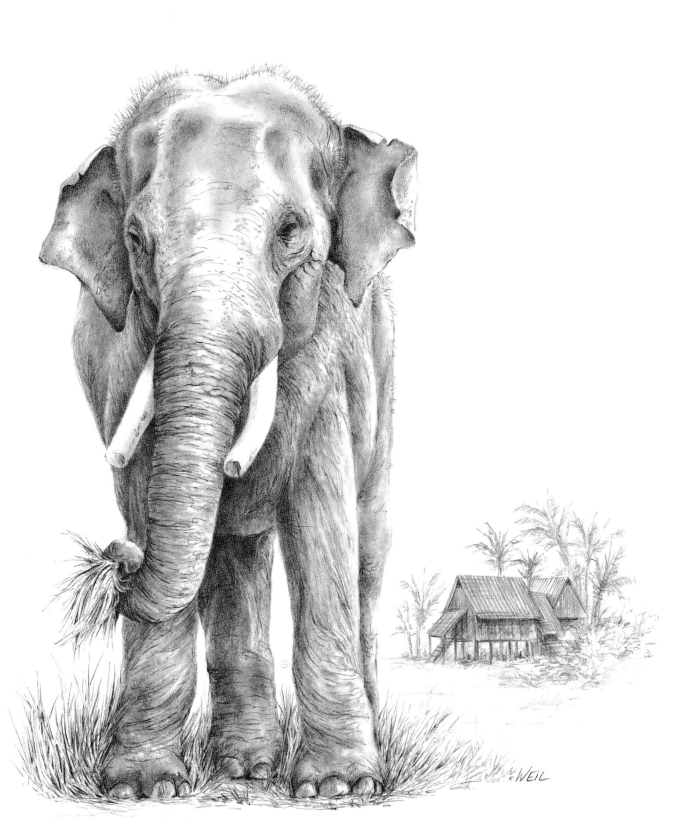

Step 7 I lightly redraw the foot, setting it back farther in the picture. Then I draw grass over the areas of the original foot that I couldn't entirely erase. Now I turn my attention to the background, using an F pencil to draw the shapes of the house freehand. Then I sketch some palm trees and vegetation around the house. After switching to an HB pencil to develop the details of the house and vegetation, my drawing is complete. Overall, I'm happy with the drawing; I like how the animal is placed in an environment that identifies its location and also hints at its working life. The correction to the length of the back leg has certainly improved the work.

TIGER CUB

Young animals have specific traits that can be very engaging—large eyes and ears, fluffy fur, oversized feet, and gangly limbs. To accurately represent a young animal, it's important to observe the proportions of the head to the body when drawing, as these measurements are very different from an adult's. The success of your portrait will depend on the accuracy of the proportions. In this drawing, I employ the technique of *negative drawing,* which involves drawing the area around an object to create the form of the object itself. I also introduce the technique of *incising,* which allows you to create fine white lines in a dark area.

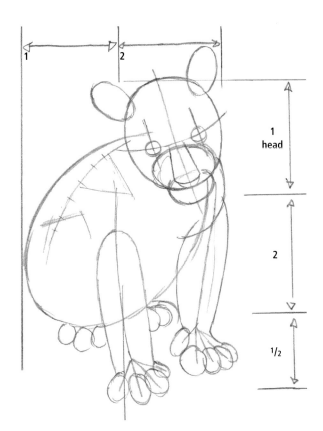

▶ **Basic Shapes** I start by drawing a circle for the head. After bisecting the circle vertically and horizontally, I block in the eyes on the curved horizontal line. Then I add ovals for the ears, as well as the muzzle. I add the bridge of the nose using a simple cylinder. Looking at my photo references, I see that the torso is about 2 heads wide. I use a larger oval for the torso. Then I block in the front legs and paws, remembering that the tiger is about 2¹/₂ heads tall.

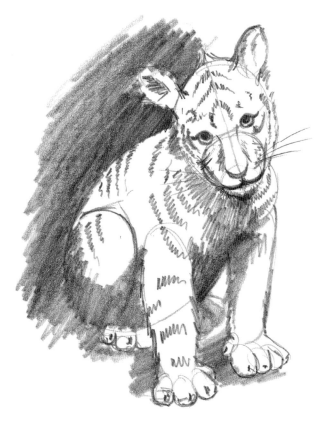

Rough Sketch Using my basic shapes as a guide, I sketch and define the facial features and other details with a 2B pencil. I constantly refer to my photographs to check positions and proportions. I decide that I want the cub to be lit dramatically, so I quickly add a dark background that also functions as a cast shadow. This background forms the edges of the cub's back and back leg (see step 2). Then I roughly place the stripes and shadow areas. Although very rough, this sketch familiarizes me with the subject and the chosen pose.

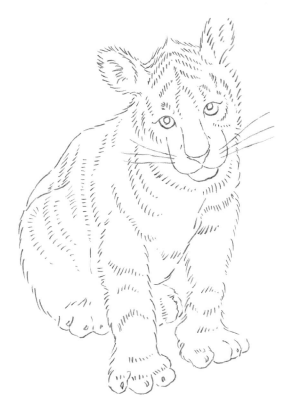

Step 1 I place a piece of tracing paper over the sketch and carefully trace the outline of the body and major features. Then I use a light box to transfer the final outline onto my art paper. I indicate the stripes with short linear strokes. For reproduction purposes, the lines shown here are much darker than I usually draw them. As I draw, I will carefully erase the outlines with a kneaded eraser. I include the whiskers in my initial outline for placement, but I immediately erase them, instead impressing (or incising) them into the paper with a knitting needle. (See "Incising" on page 124.)

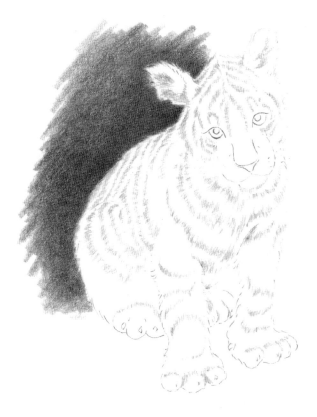

◄ **Step 2** There are few actual lines in nature; instead, shapes are formed by an object's reaction to light. To show this, I create a dark background that will form the edge of the tiger's back. This is an example of negative drawing. First I lightly erase the outline of the tiger's back from step 1. Then I hone the tip of a 2B woodless pencil by rubbing it on scrap paper. I draw broad, flat strokes to build up the background, leaving the edges loose and ragged. (See "Using Woodless Pencils" on page 125.) To even out the tone, I add a layer of circular strokes with an HB mechanical pencil. Next I use a sharp HB pencil and short strokes to draw the tiger's stripes.

▶ **Step 3** To even out the tone in the background, I add another layer of circular strokes with a blunt H pencil. This has the same effect as using a tortillon to blend tones. Now I use a very sharp 2B to develop the stripes further, using the same short strokes that follow the direction of fur growth. I also use the 2B to create the shadowed areas on the back leg, inside the ears, under the chin, and the area beneath the animal. I switch to a sharp HB pencil and place short fur strokes all over the cub's body, as well as more fur and shadowed areas in the ears.

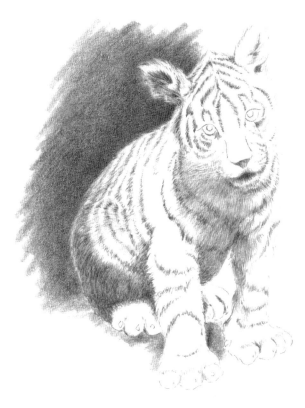

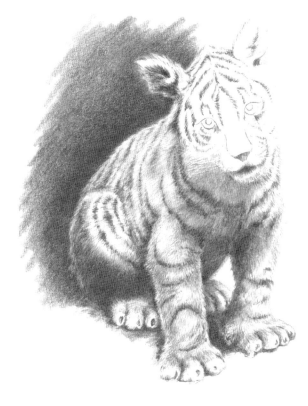

◄ **Step 4** With a sharp 2H pencil, I add layers of short strokes over the entire body, smoothing and blending the previous layers. I know I need to add several more layers of blended tone to the fur to make it appear soft and fluffy. After studying my reference photo again, I use a slightly blunt F pencil and layer very light, circular strokes on top of the shadowed areas of the coat. Then I use a 2B pencil to deepen the tone of the background, as well as the dark areas on the back leg and paws. I also use the sharp 2B to create darker areas in some of the stripes. I leave areas of the coat free of tone to create the strongest highlights. Then I use a very sharp HB pencil to add more short lines all over the body, enhancing the fur texture.

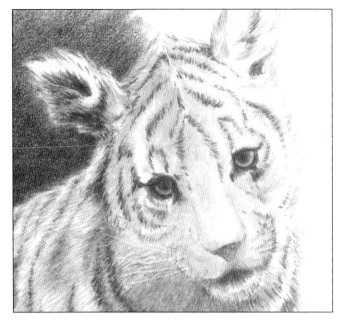

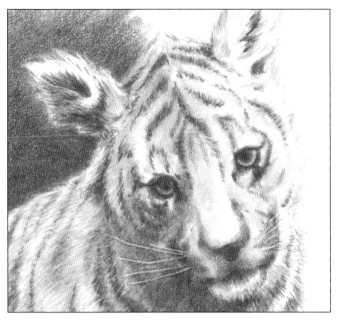

Step 5 Now I use a sharp 2B to draw the dark, thick lines around the eyes, emphasizing the upward curve on the outer edges. I draw the pupil at the top of the eyeball to show an upward gaze. Then I draw lines that radiate from the pupil with a sharp 2H pencil. With an HB pencil, I add more strokes to the dark rings around the eyes. Then I add short, sharp 2H pencil strokes all over the top of the head and around the mouth to create more fur. I use a blunt F pencil to add circular strokes down the left side of the nose and over the muzzle.

Step 6 Here I build up the shadow areas on the left side of the face and under the chin to create form. I do this with the 2B pencil and circular strokes. I also use this pencil to darken the tip of the nose, as well as the soft fur around the mouth. Notice how the incised whiskers really start to stand out. After sharpening the 2B, I use it to carefully darken some of the stripes on the head using short strokes. I also add more detail on the ears, using the 2B to "cut" into the white area of the paper, which forms little white hairs.

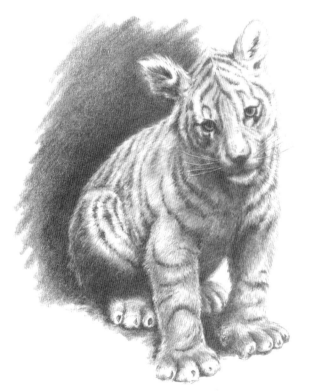

Incising

It is very difficult to create fine white lines in areas where you have already added tone. An easy way to create white lines is to indent them into the paper before you start drawing. This is called "incising." Use a smooth, slightly blunt object such as a knitting needle, but make sure the point is not too sharp. Once you've visualized where your white lines will appear, "draw" the lines with your implement, using a steady pressure that is hard enough to indent the paper but not hard enough to gouge it. Pay attention to where you have already indented, as the lines quickly seem to become invisible. When you draw over the incised area, the graphite will "skip" over the indentations and leave behind clean white lines, as shown in the examples here.

Step 7 After taking a step back, I decide to add more contrast by creating darker fur in places. I don't want to overwork the drawing and lose the detail, though, so I sharpen the HB pencil almost every fifth or sixth stroke to keep my lines crisp. I slowly build up the linework around the mouth, ears, and neck. I also pick out the underside of the incised whiskers, giving them a bit more form and dimension. With a blunt F pencil, I add some circular strokes to the paws, creating a soft tone. Then I use the 2B pencil to add shadows between and underneath the toes, as well as to darken the claws.

▶ **Step 8** Now it's time to add final details. Using a woodless 2B pencil, I draw some loose scrumble lines around the tiger's paws. (See page 113 for more on scrumbling.) I don't try to create any detail here; I just want to give the impression that the tiger is sitting on some loose leaf litter. I hold my pencil loosely and at a slight angle as I scrumble. I am careful to keep the division where the ground meets the paws crisp and sharp. Finally, I return to my sharp HB pencil and work over the entire drawing one last time. I add a bit more detail to the claws; build up some more fur around the neck, both sides of the face, and around the ears; add a bit more tone to the back paw to make it recede more; and refine the fur on the toes and around the mouth. I decide that any more "tweaking" will overwork the drawing, so I declare it finished by signing my name.

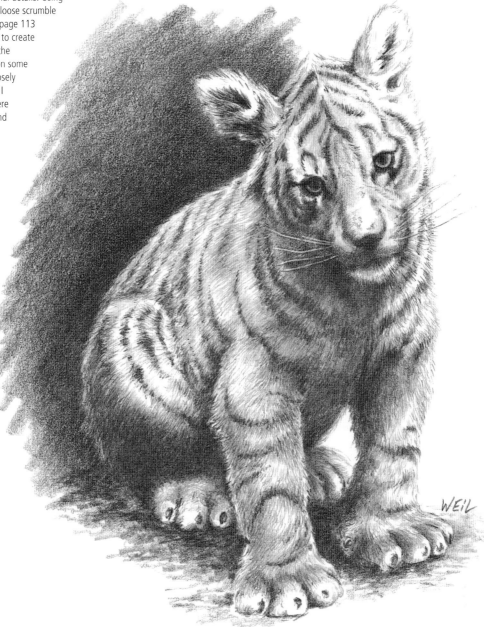

Using Woodless Pencils

A woodless pencil is a solid core of graphite covered with a thin sheath of plastic. It is great for creating broad areas of tone (such as the background of this drawing) or for making quick gesture sketches. You can achieve different results by holding the pencil at different angles to the paper. By holding the barrel lower to the paper and using more of the side of the lead, you'll create a broader stroke. The more upright you hold the pencil, the finer the lines become.

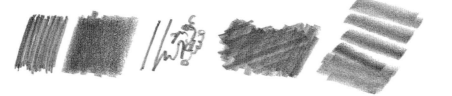

KOALA

Koalas are one of my favorite subjects to draw. Their faces have such character, and their simple, round bodies are easy to draw freehand. Koalas don't move about much—in fact, they sleep more than 18 hours a day! So if you see a koala awake, be sure to take a photo because it is a rare opportunity.

When drawing a koala, you will need to use a number of pencil techniques to create short and long fur, white and dark fur, and the varied textures of the nose, claws, and eyes.

Taking Multiple Photos I spent several days taking photos at a local koala sanctuary, but I couldn't get a "perfect" shot. The best-posed animals were asleep or squinting, and those with their eyes open were in awkward positions. So I took as many photos as I could of koalas both asleep and awake, and I combined multiple references for the final composition.

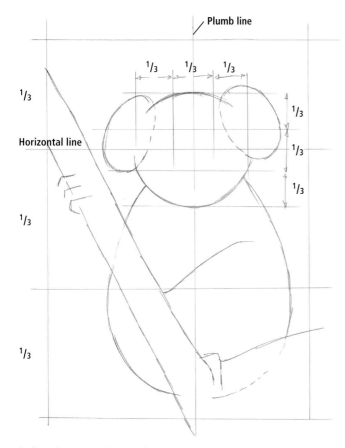

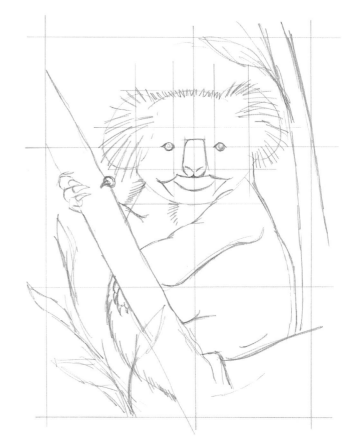

Finding the Proportions To figure out the correct proportions of the koala, I first draw a 6.5" x 9" rectangle on a sheet of tracing paper. I divide this shape horizontally into thirds; then I draw a vertical plumb line that is slightly off-center down the length of the rectangle. Referring to my main reference photo for the scale and size of the head, I center the head circle exactly where the plumb line and the first horizontal line meet. Then I roughly divide the head circle into thirds horizontally and vertically—this will help me correctly position the facial features. I do not need to use a ruler to measure this; I just use my eyes to judge the correct distances. Now I use simple oval shapes to block in the round shapes of the body and ears. Using my reference as a guide, I sketch the arms, fingers, and tree branches.

Blocking in the Features Now that I have the proportions down, I place another sheet of tracing paper over my drawing and begin refining the shape of the koala. Constantly referring to my main reference shot, I block in the nose, noting where it starts and finishes in relation to the grid. Using my other reference shots as a guide, I position the open eyes almost exactly on the top horizontal line of the grid. Now I place the mouth and cheeks, which are a series of arcs within the bottom third of the head circle. I build up some fur in the ears, on top of the head, and on the chest; then I develop the arms and legs, adding the long claws and noting where the heel of the foot rests against the upright branch. I decide to omit the back foot that awkwardly overlaps the chest area in the main reference photo. I know enough about koalas to know that my drawing will be believable if the foot is tucked out of sight behind the branch. Finally, I add a few more tree branches and leaves.

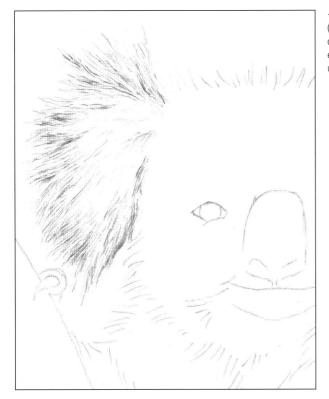

◀ **Step 1** After transferring the outlines of my sketch to a piece of 300 gsm (140 lb) hot-pressed paper, I start developing the ear on the left, as I plan to work down and across to the right. First I lighten the outline of the ear with a kneaded eraser. Then I use a sharp 2H clutch pencil to draw long, smooth lines for the undercoat, varying their lengths and directions.

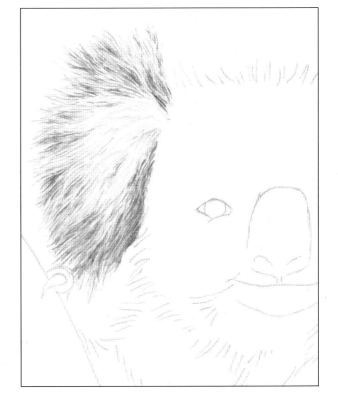

▶ **Step 2** I switch to an HB clutch pencil and draw more long, broken strokes around the 2H strokes, carefully leaving the paper white in areas. As I work in the dark strokes, the white of the paper begins to form the white hairs. (This is a form of negative drawing.)

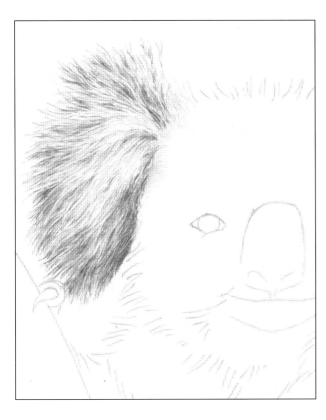

◀ **Step 3** Using a sharp 2B clutch pencil, I begin to intensify the shadowed areas of the fur under and on the edge of the ear. This dark tone creates a high contrast and makes the white areas stand out, increasing the impression of long, white fur. I return to the ear again with the 2H clutch pencil, refining and smoothing out the detail. By completing ear on the left first, I have established a value range for the rest of my drawing; the ear will act as a visual gauge.

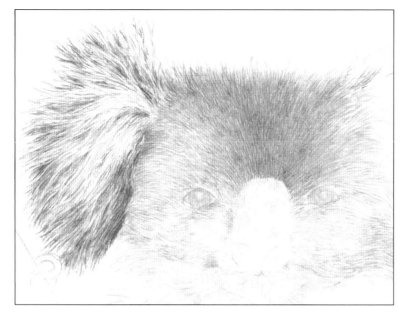

◄ **Step 4** After lightening the outline of the rest of the head with a kneaded eraser, I use a 2H clutch pencil to create short, quick strokes all over the head, avoiding the eyes and the nose. I draw in the direction of fur growth, placing my strokes very close together and using a tight, controlled movement. My wrist does not move at all; my fingers do all the work. When I've covered the face, I go back in with an HB pencil and darken the areas across the forehead and above the nose, using the same short strokes as before. Then I use a 2H to add a quick layer of fur to the ear on the right, as well as to build up the fur around the cheeks, chin, and mouth. I form the shape of the iris in the each eye with a light layer of 2H, and I add some tone to the nose.

▶ **Step 5** After dulling an HB pencil by rubbing it on a piece of scrap paper, I add circular strokes to the nose, leaving some areas white. I switch to a 2B and use short strokes above and below areas of the nose to create more contrast. I also use the 2B to darken the nostrils. Switching back to the HB, I create short lines in the mouth and under the nose. At this point, I realize that the pupils look too human in my sketch—a koala actually has a narrow, vertical slit for a pupil. I sharpen the HB and use it to redraw the pupils and darken them. I also use the HB to form the eyelids and brows with short, directional strokes. I use the 2B to darken the irises and areas around the eyes.

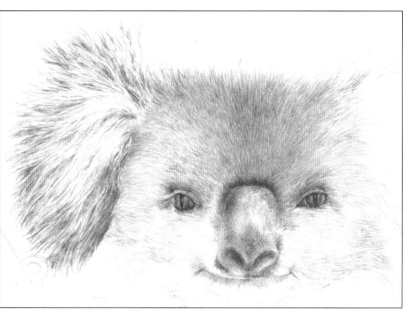

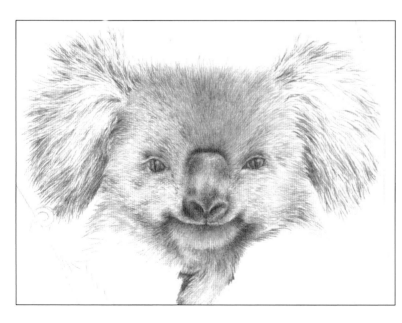

◄ **Step 6** Alternating between my sharp HB and 2B pencils, I build up the fur all over the face and chin. I use the 2B to create dark shadows around the mouth, nose, chin, and cheeks; then I use the HB like a tortillon to blend the tone. Using both pencils and circular strokes, I further develop the tone on the nose, creating a dark, leathery texture. Turning to the eyes, I define the darks with the 2B and accentuate the shape and form with the HB. I also slightly widen the eyes by darkening the lower lids. Then I carefully lift out a highlight in each eye with adhesive putty. Now I concentrate on the ear on the right, repeating steps 2 and 3. I don't finish the ear completely.

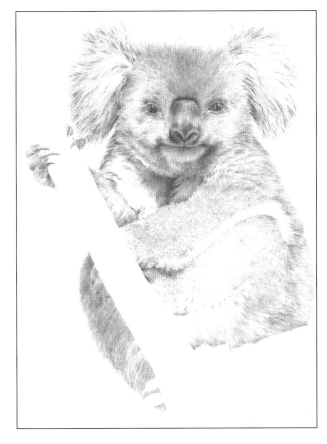

◄ **Step 7** After lightening the outline of the body with a kneaded eraser, I use short, light strokes with a 2H pencil to create the undercoat for the entire body. Again, I always draw in the direction of the fur growth and avoid creating patterns. I leave the chest and underarms white, but cover the rest of the body with a light network of interlacing 2H strokes. The fur on the arms is the shortest and most random in direction, so I make my lines reflect this. I notice that I've made the fur on the koala's leg (near the main branch) too patterned and regular; I will remedy this by adding some overlapping strokes as I darken this area in the next step. Now I add tone to both paws with the HB pencil, and I draw the long claws.

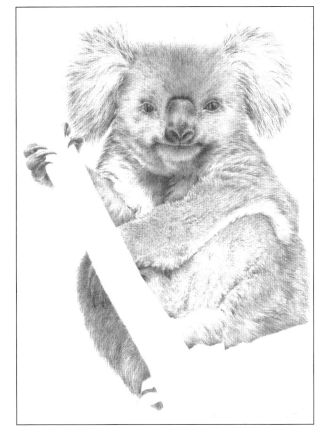

▶ **Step 8** I work over the entire body at once with very sharp HB and 2B pencils. I use the 2B to create the blackest areas near the white fur—the 2B "cuts" into the white areas, forming white "hairs"—I refer to my reference photo to see how the fur curls and swirls over areas of the body. I add some overlapping strokes on the left side of the body to avoid creating a pattern.

◄ **Step 9** I create a light background at the top of the image with a dull F wood-cased pencil. Then I begin adding tone to the main tree branch with 2H and HB pencils, using my entire hand and wrist to create long, smooth strokes. I build up the tone of the branch as a series of long lines of different values, creating the lined texture of a eucalyptus tree. I also add some spots and nicks with the HB to add more texture.

▶ **Step 10** Now I use an HB pencil to add the slightly curved shadows cast on the branch by the koala's fingers and claws. Then I use the 2B to deepen the tone of the shadows, as well as darken and intensify the hand and claws to create more form. I continue working down the branch, alternating between the 2H and 2B pencils. I add tone to the fattest part of the branch, where the koala rests, and create the three strips of bark hanging over this wide section. The tree branches in this drawing frame the work nicely; they also keep the viewer's eye from straying out of the picture by forming a visual "wall" that leads the eye back into the center of the work.

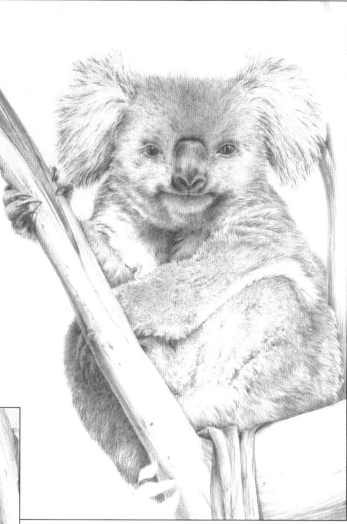

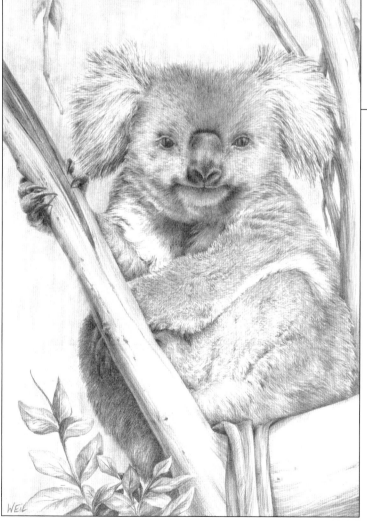

◀ **Step 11** Now that my drawing is nearly finished, I just need to complete the background and foreground leaves. I create the foreground leaves with an HB pencil and loose, soft lines. I am not too concerned with accuracy and detail here; these leaves simply add compositional balance. Now I add tone to the branches behind the koala, using the technique from step 9. I make the branches behind the ear on the right fairly dark, as this makes the white fur of the ear advance forward. Then I finish the ear by adding a bit more detail, allowing the hairs to overlap the branch. I switch to an F pencil to add more tone in the background. Instead of creating defined shapes, I use circular strokes and let my hand sort of wander about the area. I add a short, hanging branch in the upper-left corner. This branch has less contrast than the others, making it recede behind the koala and providing a sense of depth; it also adds to the framing effect and helps complete the composition.

130

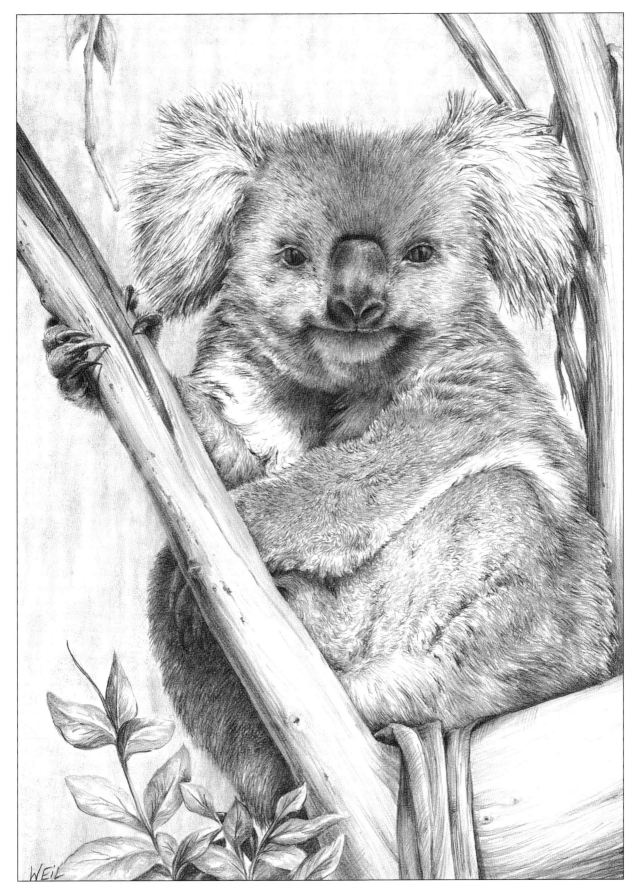

Step 12 To finish, I add final touches with an HB pencil—I deepen some tones for more contrast, add detail lines in the eyes and nose, and build up just a bit more fur texture all over the body. I am very pleased with this drawing and the "framed" composition.

DINGO

A portrait is a drawing of the head of a human or animal that shows the subject's face and expression. A good portrait will reveal something of the subject's character or personality. In human portraiture, the subject is often drawn from a straight-on view. This viewpoint can be exceedingly difficult when drawing animals due to the amount of foreshortening that would be required in rendering the nose, muzzle, or beak. I prefer to use a three-quarter view, where the head of the animal is turned slightly, as I find it easier to correctly portray the length and proportions of the nose from this angle. This portrait is of a dingo, which is an Australian wild dog. These beautiful animals share many features with domestic dogs, but I find that their eyes look slightly feral and untrusting. It is this wild, undomesticated look that I want to portray in my drawing.

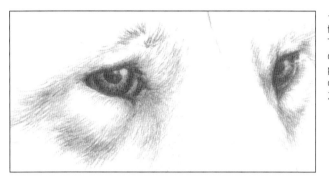

◀ **Step 1** After carefully tracing the shape of the head and the major features from my reference photo, I transfer the outline to my art paper. Then I establish the eyes (see "Drawing the Eyes" on page 133). Now I start developing the surrounding fur. I lay down light, short strokes with a sharp 2H pencil, drawing in the direction of fur growth. Then I build a layer of HB pencil on top of this lighter layer, keeping the point very sharp. Next I softly blend the 2H and HB strokes using linear strokes with an F pencil.

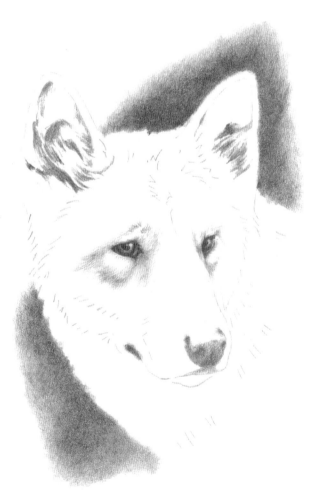

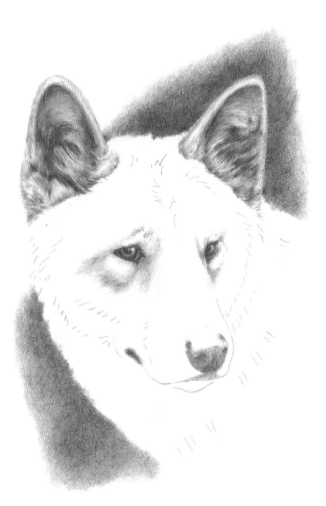

Step 2 Using a 2B woodless pencil and circular strokes, I create the dark area behind the dingo's head (similar to the background for the tiger cub on page 123). I use the same pencil and technique for the nose and mouth, adding layers upon layers until I achieve a soft, dense black. I also use the 2B woodless pencil to lay down dark, thick linear strokes in the ears.

Step 3 I secure a sheet of clean paper over the eyes. Then I use a sharp HB pencil to layer linear strokes over the entire ear area, varying the lengths of the strokes and leaving areas of the paper white. When finished, I use a sharp 2B to deepen these shadow areas. Then I use an F pencil and soft, circular strokes to blend the tones along the edges and within the inner "cups" of the ears.

▶ **Step 4** Now I carefully move the clean sheet of paper down to protect the lower half of my drawing. Then, using a sharp 2H mechanical pencil, I apply quick, short strokes over the top of the head and around the forehead and eyes. I leave large areas of the paper white to depict the dingo's light, straw-colored fur. Next I use a well-sharpened HB mechanical pencil to layer strokes on top of the 2H undercoat, creating variations in tone and a sense of texture. Where the fur flips up around the ears and for the crease down the center of the forehead, I use a blunt F pencil to softly blend and deepen the tones.

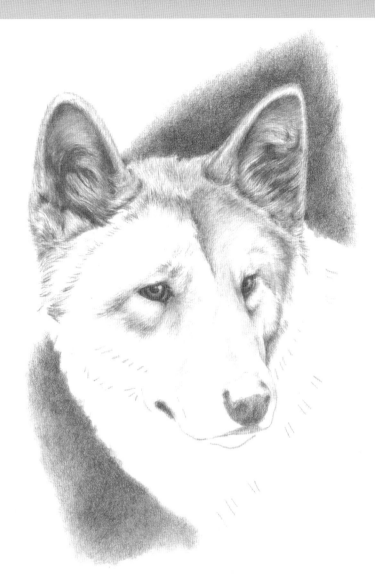

Drawing the Eyes

Step 1 *I start by making very light, circular strokes with a blunt H pencil over areas of the eyeball in shadow. This is done very lightly; I just want a faint base to start with.*

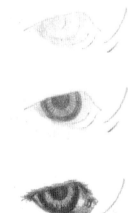

Step 2 *Now I use a sharp (but not fine-pointed) HB to create radiating lines in the iris. I use the same pencil to create the outer dark ring of the iris, as well as a solid tone that fills the pupil. I am not too worried about highlights at this stage.*

Step 3 *With a 2B pencil, I deepen the dark areas of the pupil and the ring around the iris. I use an HB pencil to deepen the tones of the whites of the eyeball with soft, circular strokes. I also use the HB to define the "eyeliner" around the eye, as well as create the round area in the corner of the eye.*

Step 4 *I use a 2B to darken the "eyeliner," pupil, and the ring around the iris. With a blunt F pencil, I add a light tone over the entire surface of the eyeball, blending the softer 2B back into the irises. Then I use the HB to go over the lines in the iris and the hair surrounding the eye. I also hint at eyelashes. I knead a bit of adhesive putty into a sharp point and lift out the highlight.*

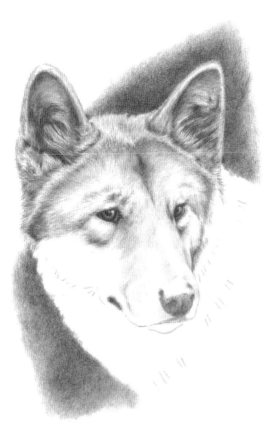

Step 5 I continue the same technique on the left side of the face. When finished, I add sharp 2B strokes around the forehead crease, eyebrows, and temple ridges for added contrast and texture. Then, using a slightly blunt F pencil, I add soft circular strokes across the forehead and down the muzzle, creating a soft tone that blends into the linework.

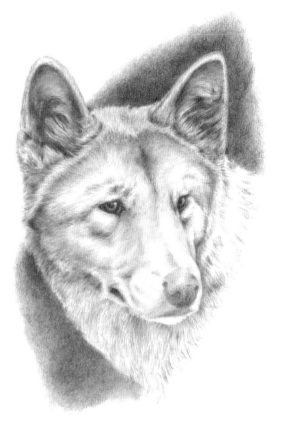

Step 6 I repeat step 5 over the bottom half of the face and on the muzzle, slowly building up the tones. Using circular strokes and an F pencil, I blend the tones over the muzzle and nose. Then I use a 2B pencil to fill in the corner of the mouth; I also create some linear strokes around the jaw. I switch to an HB and create denser, thicker, longer lines for the undercoat of the neck, adding darker strokes over the shadowed part of the neck. I leave quite a bit of white paper exposed to suggest the fur on the upper right side of the neck.

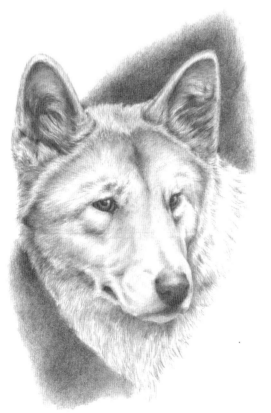

◄ **Step 7** Returning to the nose, I use a blunt 2B with a rounded tip and light, circular strokes to create the leathery surface. I am careful to leave a highlight on the tip of the nose. I lightly work this area again and again with the 2B pencil, being careful not to use too much pressure and keeping the pencil on the paper's surface at all times. Then I add one more layer of graphite to the entire nose area using an F pencil, blending the underlying 2B layers. It's better to build darks with successive layers of graphite rather than using heavy pressure, as too much pressure will create a shiny area in the tone. Switching back to the sharp 2B, I add some darker linework under the chin and on both sides of the neck. Once the 2B pencil point has dulled a little, I start to increase the depth of the tone around the lips and on the crease of the upper lip.

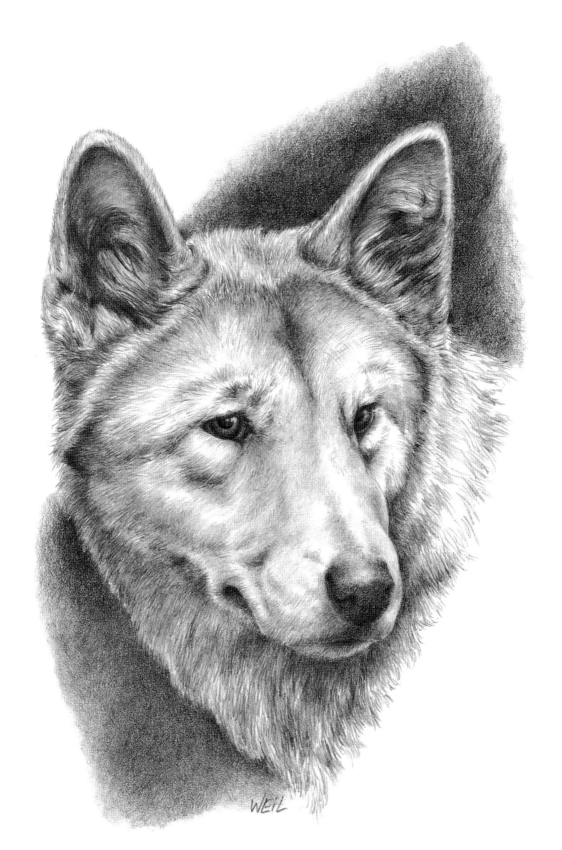

WEIL

Step 8 Using the 2H and HB pencils, I work over the face, refining and building up the texture of the fur with additional linework. I do the same with the HB and 2B on the neck and around the nose. Note how the darker fur of the neck in the lower right area defines the shape of the muzzle. Although I do not add much detail to the fur on the right side, the eye perceives the impression of fur. Now I use the 2B to add several more layers of circular strokes to the left side of the background near the neck. After sharpening the 2B, I intensify the dark edges all over the face: the corner and front of the mouth, under the mouth, the nasal openings, the "eyeliner" and pupils, the dark fur on the forehead, and the darkest fur in the ears. When you've reached the final stages of a drawing like this, it is always difficult to know where to stop. If you overwork the drawing, you'll create unsightly shiny spots, and if you add too little shading, it will appear unfinished. It helps to walk away from your work for an hour or two and return to it later with a fresh eye. After doing so, I decide that I'm happy with the dingo at this stage. He has a certain air of suspicion about him that I like, so I declare the drawing finished.

LION PROFILE

A profile view of an animal can be very dramatic. Seeing only one side of the face can bring out the animal's distinctive features, such as a long muzzle or magnificent mane, as seen here in this profile of a lion. Because parts of the face appear more prominent in profile, be careful not to allow any one feature to dominate the drawing. Take your time working out the proportions before drawing the complete portrait.

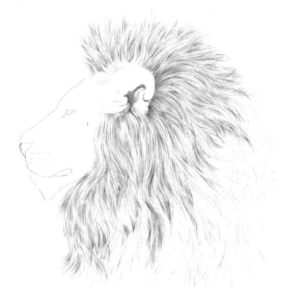

◄ **Step 1** After using the rough sketch from page 115 to create the basic outline of the lion, I transfer the outline to hot-pressed paper and use a sharp 2H pencil to start the mane. Following the technique for drawing long hair (see page 112), I quickly draw clumps of long strokes over the entire mane area. Then I use a sharp HB to build up a second layer of hair. I keep my strokes long and am sure to overlap clumps. The hair needs to be messy and chaotic (I don't want my lion to look like a pampered poodle), so I allow my lines to move in different directions. After creating the second layer over the top three-quarters of the head, I switch to a sharp 2B and add a few darker strokes here and there for shadows. I also fill in some of the ear.

▶ **Step 2** With an always-sharp HB, I work over the entire mane, building up clumps and swirls. Once I'm satisfied with the mane, I place a sheet of paper over it to protect it from smudging. Still using the sharp HB, I build up the fur around the ear with short, tight strokes. Then I use a blunt F pencil to create darker tone inside the ear, followed by even darker strokes with the 2B. I add more strokes on top of this with the 2H. Now I remove the paper and return to the mane, developing more contrast by deepening the shadows between the individual hairs (the white of the paper) with a 2B pencil. Next I use a blunt F pencil to lightly fill in areas between clumps, again creating darker areas of shadow. These darker areas help make the white and light areas advance, giving depth to the mane.

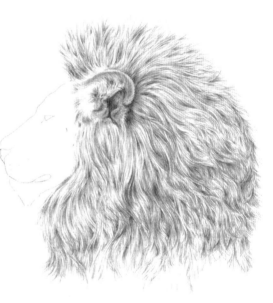

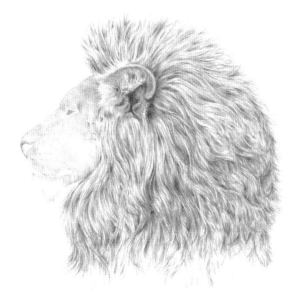

◄ **Step 3** I repeat the technique from step 2 over the entire mane and ear, increasing the contrast and depth. After covering the mane with a sheet of paper and lightening the outline of the face with a kneaded eraser, I use a sharp HB to draw very short strokes all over the face. For darker areas, I draw the strokes very close to one another; for lighter areas, I draw them farther apart. The hairs on the temple and around the ears cross one another and fall across the face in different directions for a messy look. The longer hair of the "beard" is lighter than elsewhere on the face, so I leave white areas of paper showing through. Now I softly fill in the eye with a blunt F pencil.

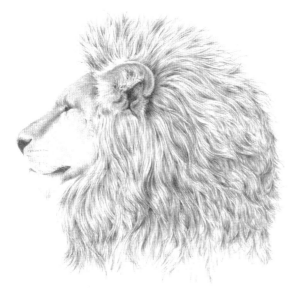

◄ **Step 4** Using the 2B pencil, I create a flat tone on the nose and around the corner of the mouth. To create lighter areas in the mouth, I lift out tone with a bit of flattened adhesive putty, holding the putty so the edge follows the direction of the hair. I use a sharp HB to layer short strokes all over the face, using the same technique as in step 3. This builds up different depths of tone on the face, helping form the structure. I use the crosshatching technique to form the brow and the corner of the eye. With a very light touch and a 2B pencil, I add the whisker dots. Whiskers are as individual as fingerprints and are used by field biologists to identify lions.

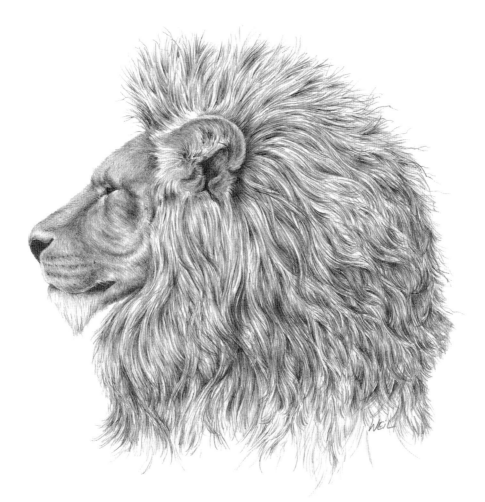

Step 5 I continue to use the sharp HB pencil to stroke lightly over the face, building up more layers of fine fur. I also crosshatch over the cheek to enhance its tone and texture. I use a 2B to darken the inner edge of the eye and the tip of the nose, as well as add some details to the whisker markings. Still using the 2B, I create some darker lines around the eyes, on the cheek and forehead, under the jaw, and in the "beard." I also carefully shade underneath the top lip to enhance the light fur of the "beard." Now I remove the protective paper and work over the entire drawing with sharp 2B and HB pencils, adding dark values and details around and inside the ear and in select areas of the mane. Finally, with a very sharp HB, I add a few crinkly hairs around the edge of the mane to create a less-sculpted edge. Looking at this completed profile drawing, I am pleased with the result. The lion's classic pose and full mane make him look very proud.

GIRAFFES IN A LANDSCAPE

Many of my animal drawings are portraits with little or no surrounding backgrounds. But sometimes I want to show more of the relationship between an animal and its environment, so I'll place the animal in a larger landscape. There are several important aspects to carefully consider when creating this type of composition:

1. How and where is the animal placed in its environment?
2. How do dominant features such as large trees, rocks, and mountains affect the size and placement of the animal and its visibility?
3. How do the animal(s) and other dominant features affect the balance of the composition?

4. Does the vegetation directly relate to the animal? Does it match the animal's natural habitat?
5. Is there a distinct foreground, middle ground, and background?

For this study, I chose to draw a group of giraffes in a savannah of South Africa. I wanted my landscape to emphasize the vastness of the savannah, the extreme height of the giraffes, and the glowing heat of the midday sun.

▶ **Thumbnail Sketches** To work out the composition, I start by drawing several thumbnail sketches. I create these small sketches quickly, showing only the basic elements of the drawing. My first attempt seems too static and staged, and the composition is too symmetrical. I like the second thumbnail better, but the large giraffe head detracts from the rest of the landscape. The third sketch is the most pleasing—the page is divided into thirds horizontally and vertically, and the broad sky produces a sense of vastness.

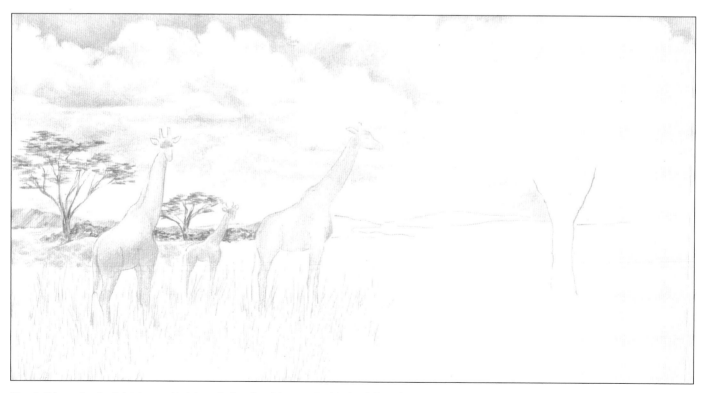

Step 1 Using my thumbnail sketch as a guide, I draw a basic outline of the scene. Working from left to right, I begin shading the sky with a light layer of F pencil. I leave many areas white to represent the clouds, lightly shading their undersides with an HB to suggest form. I create the trees in the background with both 2B and HB pencils using crosshatching and scrumbling techniques. Then I begin to build up tone on the giraffes with an F pencil. I also use a 2H pencil to lightly create the grass in the foreground, using short, randomly placed strokes.

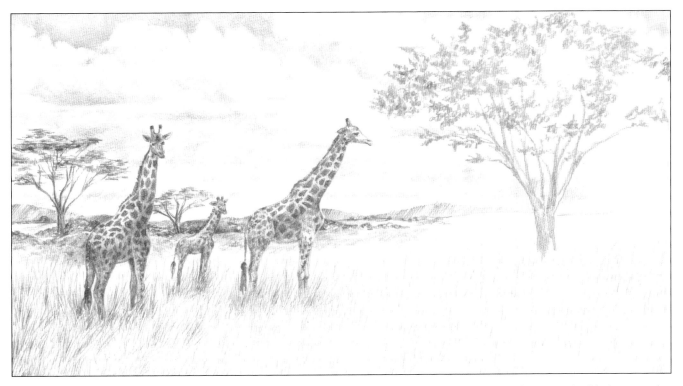

Step 2 I add more grass and detail to the left side of the background. Then I create the spots and details on the giraffe at left with a sharp 2B pencil and do the same on the young middle giraffe but with a sharp HB pencil. I add detail to the giraffe at right with a 2B and then use F, HB, and 2B pencils to slowly add tone to the distant bushes and mountains. I keep the detail very minimal in these distant areas. When drawing landscapes, keep in mind that objects closest to you will be sharper and have a greater amount of detail. As objects recede, they have less contrast and become more indistinct. (You can see how I've employed this phenomenon of atmospheric perspective by looking at the final drawing; notice how the sharp detail in the foreground tree brings it forward.) Now I work on the foreground tree. I start with a 2H and roughly draw across an area, then work over it in stages with an HB and a 2B. When drawing trees, try drawing "clumps" of leaf shapes, rather than trying to draw each individual leaf. Approach trees in stages, building up more and more "clumps" of tone to represent the leaves. This also applies when drawing large areas of grass.

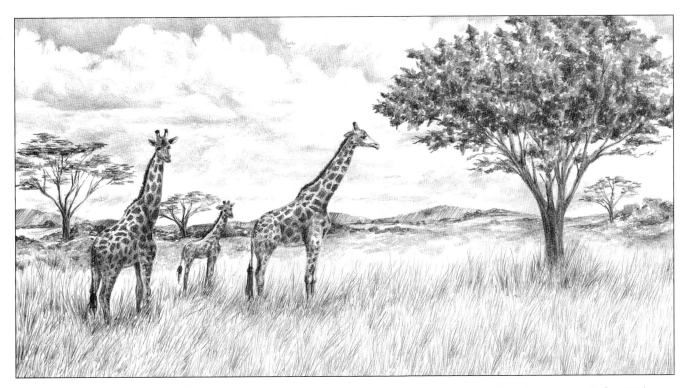

Step 3 Now I darken the fur, tails, ears, and faces of the giraffes with the 2B to bring them forward as focal points of the drawing. I add more grass to the foreground, loosely drawing long and short strokes. (I use the HB pencil for lighter areas and the 2B for darker ones.) I leave a band of white paper between the top of the grass and the background elements, as this helps create a sense of distance and the appearance of a slight haze from the heat. I add a few more leaf clumps to the left-hand tree, creating a leaf canopy for the giraffes to take shelter under. Finally, I create the right-hand side of the background, making these elements the smallest and most distant. Although this drawing is small, it produces a sense of depth and space. It also succeeds in creating a natural environment for the animals.

ZEBRA IN MOTION

Animals are always moving! Photos can capture animals "frozen" in action; referring to them while drawing is easier than trying to capture movement in progress. You can depict an animal's action by adding a few clues in your drawing. For example, one or two feet may be off the ground, the head may be erect, the tail may appear to sway, the ears and eyes may appear alert, and there may be visible muscle tension in the moving limbs. You may also use other clues relative to the surrounding landscape: the grass may be bent and the animal's feet may kick up dust. You can also use staggered movement lines and blurred edges to enhance the feeling of motion.

◄ **Step 1** After transferring an outline of the zebra to drawing paper, I use a sharp 2B pencil to create an even, dark tone on the thick stripes over the back of the animal. I add two or three layers to darken the tone where the animal is rounded out and in shadow. I also draw the thinner stripes with a 2B, but I do not layer them as heavily. I add dark tone between the haunches and loose, flowing dark lines along the tail. The tone on the lower leg stripes is not as sharp as it is along the haunches because the lower leg stripes will be blurred later in the drawing. With the stripes in place, I create muscle tension by lifting some areas of graphite with a kneaded eraser.

▶ **Step 2** I build up layers of tone to give the zebra's body a three-dimensional appearance. Using a blunt F pencil, I add softly graduated tones across the buttocks, haunches, legs, and flanks. I intensify the light F tone by layering some HB strokes over it. I also use the HB to build up the tail hair, and I intensify the stripes with a 2B. I don't add tone in the whitest areas because the white of the paper adds contrast to the stripes. I use a light tone in the shadow areas on the white stripes to give the animal form. On the lifted leg, I stagger some strokes to repeat the leg edge and bleed off the stripes; this creates the impression that the leg is in motion.

◄ **Step 3** I repeat the technique from step 2 on the face and the zebra's right front leg, working with F, HB, and 2B pencils. To emphasize rapid movement on the lifted leg, I keep the edges soft and draw several staggered strokes along the forward edge of the leg. I shade the hoof very loosely, which suggests motion. I then begin lightly shading areas of the zebra's front right leg and hoof. Next I sharpen the 2B and use short, swift strokes for the stiff hairs of the mane.

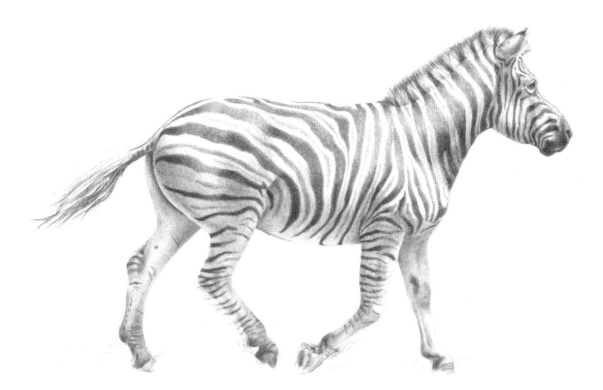

Step 4 With a very sharp HB pencil, I carefully add shadowed areas to the mane (even in the darker 2B areas), allowing plenty of white paper to show through for the white stripes. Then I work some tone into the zebra's left front leg with F and HB pencils. This leg has very little striping but is darker in tone than the upper body, as it is in shadow. The leg also is firmly planted as the zebra steps forward, so I do not draw any movement lines or blurred edges. I create the darker spot and hock with a 2B. Now, with my F and HB pencils, I concentrate on rendering the tones that create the three-dimensional qualities of the neck and face. Again I let the white of the paper show through with lightly contrasting tone in the shadow areas to create form. I intensify the deepest blacks of the shadowed stripes, the eye, and the nostril with a 2B. The body of the zebra is now complete.

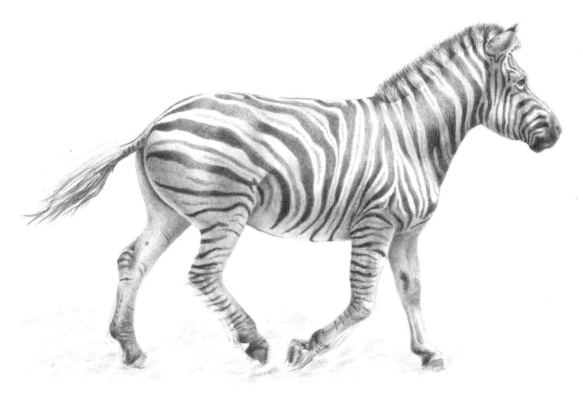

Step 5 Now I add some billowing dust under and behind the zebra's feet to suggest that she is kicking up dust as she moves. To do this, I use a blunt F pencil to lightly draw soft scrumble lines around the feet and behind the zebra.

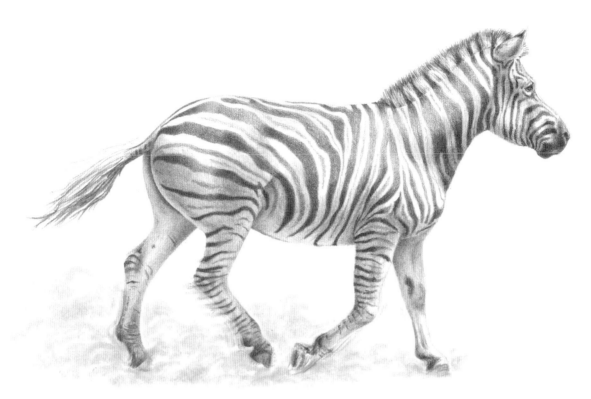

Step 6 I blur and blend the F tone from step 5 into swirling, puffy shapes. I also lightly and carefully blur the lower legs, softening the edges into the raised dust. If you don't have a tortillon, try using a cotton swab.

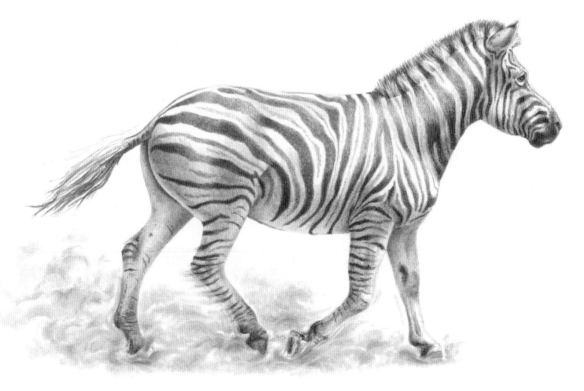

Step 7 I use a blunt HB pencil to add darker and lighter tones to the dust; then I blur and shape them using the tortillon. By now my tortillon has picked up a bit of graphite on its tip, so I use this to "draw" with as well. I use circular and curving motions with my tortillon to blend the graphite into swirling dust shapes.

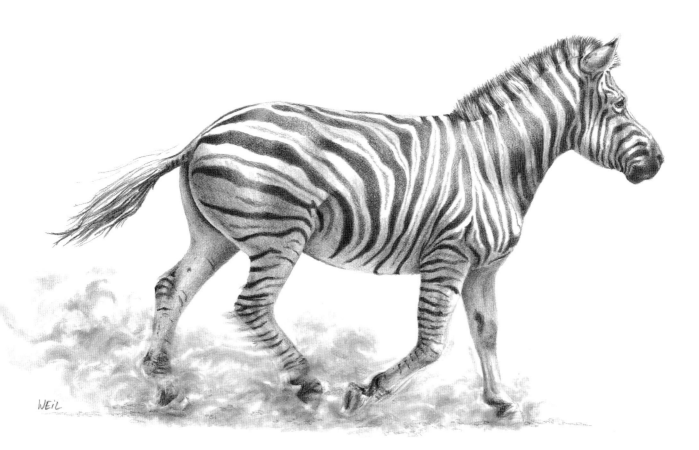

WEiL

Step 8 In step 6, the feet and legs are distinct; here you can see that the legs and hooves merge into the billowing dust. I mold a piece of adhesive putty into a rough cylinder shape and gently drag it across the feet, legs, and dust. This lifts off some of the graphite in the darker foot/leg area to match the tones of the dust. I use the tortillon to blur the dust back over the legs and feet and to further soften the edges of the lower legs. Dragging the tortillon across the darker stripes, I pull some graphite into the swirling dust; then I use the residue of the graphite on the tortillon to drag some tone back over the legs and puff up more dust around the hooves. (Practice this on a sheet of paper before trying this on your final work.) With an HB pencil, I scribble in the impression of small pebbles under the hooves. Finally, I use the HB and 2B pencils to intensify the stripes, shadows, and dust. Now my zebra is complete.

Depicting Animals in Motion

There are a few tricks to representing motion. Note how the pose and body language conveys action. The zebra at bottom left is at a slow walk. The head is lowered, three of the feet are on the ground, the tail is flicking back and forth, and the forward foot is slightly lifted. Everything about this pose suggests languid, relaxed motion.

The zebra at bottom center is just breaking out into a trot. The head is lifted, the ears and eyes are forward, and the tail is raised. Two of the feet are lifted off the ground, the third rear foot is just about to kick back, and the leading foot has stepped forward. This pose suggests brisk motion.

The zebra at bottom right is in a gallop. The head is up and thrown slightly back. The ears are back, the nostrils are open, and the tail is streaming behind. The back is arched and the feet are off the ground.

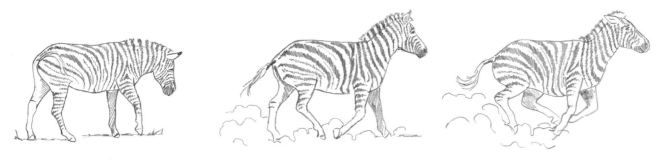

CLOSING WORDS

Dogs come in a range of shapes, sizes, colors, and personalities, offering a seemingly endless supply of inspiring subjects. Once you become comfortable with the techniques and drawing methods I have demonstrated in this book, I encourage you to experiment with other references, materials, and approaches to find which ones best suit your style. It's a magical experience to sit in front of a blank piece of paper, pick up a pencil, and watch an image come to life and look up at you from the paper!

—Nolon Stacey

It is my hope that the end of this book marks the beginning of your journey toward capturing the beauty of flowers and botanicals. With careful study, even the most complex flowers or flower arrangements can be broken down into basic shapes. By using these shapes as a guide for building tone and creating texture and depth, you will soon be growing a garden of beautiful drawings in your studio!

—Diane Cardaci

So where do you go from here? What's next? I recommend that you find a mentor to assist you or join an online art forum or local art group. I would like to thank a special group called "DrawingTogether2," an online group of artists from around the world who share a passion for drawing. They have stretched my imagination in many ways, and the world is a much smaller place because of them. I would also like to thank my mentor, Mike Sibley of England, as well as the following people for letting me travel and experience the world through their eyes and camera lenses: Jim Fogarty (Kirkwall Harbour Basin photo), Tonia Nales (Molen de Adriaan photo), and Dave Neal (Venice photo).

—Diane Wright

I hope you have enjoyed this book and "watching" me as I draw! I certainly had a lot of fun creating the drawings and describing how I achieved each effect. It has also been very enjoyable observing the subjects for this book. You'll find that half the pleasure of drawing animals is watching them. Remember that the key to drawing well is to practice as often as you can. Try to draw something every day—you will be pleasantly surprised by how rapidly you improve. But most of all, enjoy the journey and have fun along the way.

—Linda Weil